EDWARD W. REDFIELD

Just Values and Fine Seeing

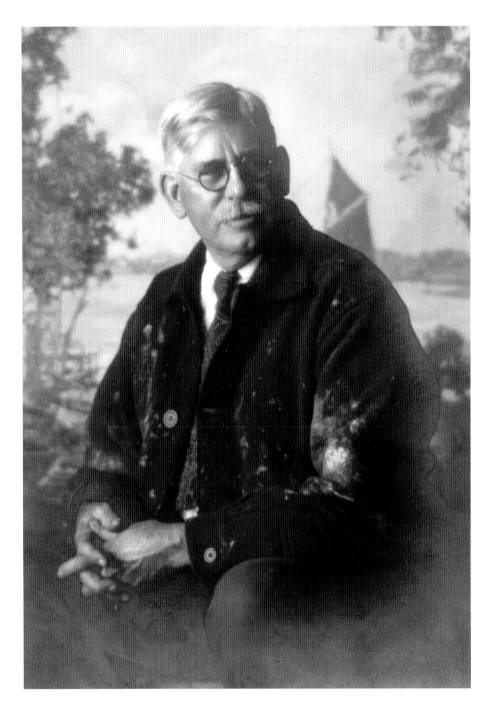

Peter A. Juley and Sons, EDWARD W. REDFIELD, ca. 1930, gelatin silver print on paper.
Courtesy of Mr. and Mrs. Edward W. Redfield II.

EDWARD W. REDFIELD

Just Values and Fine Seeing

Constance Kimmerle

James A. Michener Art Museum
Bucks County, Pennsylvania

University of Pennsylvania Press
Philadelphia

Published on the occasion of the exhibition
Edward W. Redfield: Just Values and Fine Seeing,
organized by the James A. Michener Art Museum

James A. Michener Art Museum—New Hope, New Hope, PA
May 1, 2004–January 9, 2005

Sewell C. Biggs Museum of American Art, Dover, DE
January 26–April 26, 2005

Copyright © 2004 James A. Michener Art Museum
138 S. Pine Street
Doylestown, PA 18901
www.michenerartmuseum.org

Copublished by the James A. Michener Art Museum and
University of Pennsylvania Press
4200 Pine Street
Philadelphia, PA 19104-4011
www.upenn.edu/pennpress

Library of Congress Cataloging-in-Publication Data is available.
ISBN 0-8122-3843-5

Designed by Becotte Design
Edited by Paula Brisco
Proofread by Sharon Rose Vonasch
Principal photography by Will Brown and Tom Dubrock
Printed and bound by Piccari Press

Note to the reader:
Dimensions of works are cited with height preceding width
Abbreviations: AAA: Archives of American Art, Smithsonian Institution,
three microfilm reels (1182, 1183, and 1184).

Cover: *Woods and Stream in Winter, Upper Delaware* (detail), 1916. oil on canvas.
38 x 50 inches. Widener University Art Collection, Gift of A. Carson Simpson and
Mrs. Peggy Simpson Carpenter, 1953.

Edward W. Redfield with daughters Louise and Frances, ca. 1918.
Courtesy of Edward Redfield Richardson.

Contents

6 Project Sponsors

7 Foreword

9 Acknowledgments

11 Lenders to the Exhibition

Edward W. Redfield: Just Values and Fine Seeing

13 Introduction

16 Redfield's Art and Life

52 *Catalogue*

111 Chronology

Appendixes

115 Critical Responses to the Work of Edward W. Redfield

133 Juror History

133 Honors, Medals, and Prizes

135 Solo Exhibitions

136 Memberships

137 Bibliography

This book was made possible by major gifts from Marguerite and Gerry Lenfest and an anonymous donor.

Project Sponsors

Louis E. and Carol A. Della Penna

Kathy and Ted Fernberger

In Memory of Margaret Hinde

In Memory of Earl H. Jamison

Newman Galleries

Bonnie J. O'Boyle

Edward Redfield and Jean Richardson

Aileen and Brian Roberts

Estate of Patricia Redfield Ross

Robert Bruce Ross

Schwarz Gallery

Drs. Willys and Abigail Silvers

Carolyn Calkins Smith

In Memory of Thomson E. Tompkins

Bob and Amy Welch

Additional support was provided by the
James A. Michener Art Museum Publication Fund

The Edward W. Redfield exhibition at the James A. Michener
Art Museum–New Hope is being sponsored by:

Journal Register Company / Intercounty Newspapers

Little River Resort, Pinehurst, N.C.

Penn Valley Constructors, Inc.

With additional support from Amy & Joe Luccaro, HollyHedge Estate

Edward Willis Redfield was endowed with great physical strength, an independent spirit, and a pure and uncluttered vision. His place as a legendary figure in Bucks County's artistic heritage was secured both by his canvases and by the many vivid stories that illustrate his character. In the midst of a winter storm, for instance, he would strap his large fifty-by fifty-six-inch canvases to a nearby tree, thin his paints with linseed oil to keep them from freezing, and use his gloved hands to paint the scene before him. His belief that a painting should be completed "in one go" caused him to begin work in early morning and stand in the cold until the picture was finished in late afternoon. When the time came to edit his work, he piled a group of canvases that he considered inferior outside his studio in Center Bridge, and then, with the flourish of a circus performer, he doused the pictures with gasoline and set them ablaze.

And there are more stories. To keep his family warm, he painted a bull's eye and placed it along the Delaware canal, which bordered his property. As barges passed by with loads of coal for Philadelphia, the barge operators entertained themselves by pitching lumps of coal at the target. In the early evening Redfield's family would gather the coal and use it to fire the stove. One day, when his future daughter-in-law was visiting, the artist became intrigued with a color in her skirt. Redfield concluded that the thread was exactly what was needed for a hooked rug he was creating. Young Dorothy left the house in borrowed clothes as "Pop" Redfield unraveled the cloth from her skirt and used the thread to complete his rug.

There are many talented artists among the Pennsylvania impressionists but none were more colorful or important than Edward Willis Redfield, a powerful man who achieved national recognition for his landscape painting. His work celebrates the physical beauty of Bucks County and serves as visual evidence of the past character of our once undeveloped and rural region. Although realism was his unwavering style, Redfield's vigorous brushwork foreshadows the gesture that was to become essential in the work of abstract painters who followed him. Redfield's work has always found a popular audience, and the growing interest in his canvases has stimulated a reevaluation of his place in twentieth-century American art.

The James A. Michener Art Museum has championed the work of the Pennsylvania impressionists through exhibitions, acquisitions, publications, and scholarship. This publication, which accompanies the exhibition *Edward W. Redfield: Just Values and Fine Seeing,* is another element in our long-term commitment to advance that cause. We are indebted to the careful scholarship of Dr. Constance Kimmerle, our curator of collections, who assembled the exhibition and authored this catalogue. We are also grateful to the many donors and lenders whose support made this publication and accompanying exhibition possible.

Bruce Katsiff, Director and CEO
James A. Michener Art Museum

Acknowledgments

This exhibition and its catalogue reflect the support of many people who have contributed their time, knowledge, works in their collections, and personal resources to the project.

Without the generous financial support provided by a number of individuals and institutions (listed in the front of this book), this catalogue would not have been possible. I am profoundly grateful to Gerry and Marguerite Lenfest and an anonymous benefactor for their substantial support. Many of the sponsors of this catalogue have been the Michener's partners in other projects, and I am grateful for their continued commitment to the museum and its projects. I would also like to thank the exhibition sponsors for their enthusiastic support.

To the lenders to this exhibition, all of whom are cited in the front of this catalogue, I am deeply grateful for their willingness to share their works and to part with them for the duration of the exhibition.

In 1949, at age seventy-nine, Edward W. Redfield noted in his journal that great painters not only possess skill in drawing and color, but they also appreciate beauty, give their best, and place family above art. While working on the Redfield exhibition and catalogue, I have discovered that Edward Redfield's deep commitment to family lives on today in his grandchildren's and great-grandchildren's desire to broaden the understanding of the artist and his work. Redfield family members have freely shared their rich collections of artwork and primary source material, and I would like to thank them for their support.

A special thanks must go to Judy Hayman for providing early guidance and access to "keepers" of the family treasures. I also want to recognize Bruce Ross, who was exceptionally cooperative in making available works from the family collection as well as providing access to the archival collection of his grandmother, Dorothy Hayman Redfield. Over her lifetime, Dorothy Hayman Redfield preserved a rich trove of manuscript material, photographs, catalogues, newspaper clippings, and audiotapes that proved to be invaluable sources of information for this project.

Both Ed and Norma Redfield and Ted and Jean Richardson deserve special recognition for their generosity in making available family works of art and archival collections for the catalogue and exhibition. I thank Ed and Norma for freely sharing their time, their memories, and their collection of artwork and archival materials. I am grateful to Ted Richardson, who, in addition to lending works for the Redfield exhibition, has provided copies of a broad range of primary source material that will become part of the Michener's archives. The Edward Willis Redfield Papers, a major source of reference material used in the preparation of this catalogue, were donated by Ted Richardson to the Archives of American Art in 1976.

I would also like to thank Patricia A. Ross, Laurent Ross, Robert Stephens, Lisa and Joe Walker, and Marty and Tom Redfield for lending works, providing assistance in securing loans, and providing source materials for the catalogue and exhibition.

Thomas Folk and J. M. W. Fletcher deserve special recognition. I have benefited from the scholarship and resourcefulness of their research and publications on Edward W. Redfield. Tom has been a substantial source of knowledge on the work of Redfield. His publications on Redfield and the Pennsylvania impressionists are invaluable references. John Fletcher's compilation of Redfield letters and monograph on the artist are significant contributions to the growing body of work on the artist. I thank both authors for their support and advice.

Many individuals have given their time to make Redfield works and research material in their collections available for the catalogue and exhibition. I am most grateful to Judith E. Throm and Anne Louise Bayly, Archives of American Art, Smithsonian Institution; Cheryl Leibold, Archives of the Pennsylvania Academy of the Fine Arts; Deborah Litwack, Ona Kalstein, and Marian Jahn, Art Department of the Free Library of Philadelphia; Susan Perry, Art Institute of Chicago; Melissa Hough and Sue Levy, CIGNA Museum and Art Collection; David Levy and Jacquelyn Serwer, The Corcoran Gallery of Art; Melanie Emerson, Detroit Institute of Arts; Sarah Holian, Grand Rapids Art Museum; Kimberly Nusco, Massachusetts Historical Society; Lu Harper, Memorial Art Gallery, Rochester, New York; Annette Blaugrund, Isabelle Dervaux, and Marshall Price, National Academy of Design; Ruth Wellner, New England Historic Genealogical Society; Michael Taylor, Kathleen Foster, and Amy Dowe, Philadelphia Museum of Art; Ronald Roth and Deborah Winkler, Reading Public Museum; Peter Morrin and Charles Pittenger, Speed Art Museum; Elizabeth Glassman and Cathy Ricciardelli, Terra Foundation for the Arts; Linda Durant and Rebecca Warda, Widener University Art Collection; and Michael Schantz and Douglass Paschall, Woodmere Art Museum. A special thanks to Malcolm Polis for freely sharing his time and expertise and providing answers to a number of research questions. Thanks also to Jennifer Krieger, Questroyal Fine Art, LLC, and R.H. Love Galleries, Chicago, for their assistance in providing research material. And special thanks to libraries of the University of Pennsylvania for their comprehensive collections of research materials, which were widely used in the compilation of this catalogue.

I am especially grateful to Paula Brisco for her sensitive editing and to Diane K. Becotte for her thoughtful design. A note of thanks needs to be extended to Sharon Rose Vonasch, proofreader, and to Will Brown and Tom Dubrock for their photography. I am also grateful to Piccari Press for their beautiful production. Thanks to Jay Poko, Frank Jablonski, and Dave Alkins for their attentive orchestration. Working with Jo Joslyn at the University of Pennsylvania Press was a pleasure, and I thank her for her support.

This catalogue and exhibition would not have been possible without the assistance of a number of individuals whose talents comprise a major resource for the James A. Michener Art Museum. A special note of appreciation to Faith McClellan, who assumed a major role in assisting research and tracking down countless details for the catalogue, assembling photographs, and managing rights and reproductions issues for the project. I am indebted to museum registrar Carol Rossi for providing her multifaceted expertise in securing loans for the exhibition; overseeing packing, insurance, and transportation; and managing the installation. I also want to recognize Bryan Brems for his important contribution in framing and installing artwork, designing and constructing exhibition furniture, and providing lighting.

The Redfield catalogue and exhibition are the result of the collaborative efforts of a number of other talented staff of the Michener. I extend my thanks to Brian H. Peterson and Erika Jaeger Smith for sharing their insights and expertise throughout the project. A note of appreciation goes to librarian Birgitta H. Bond. Birgitta's passion for research and ability to locate primary source material enriched this project. I am also grateful to Zoriana Siokalo for devising and managing educational programming in support of the exhibition; Carole Q. Hurst and Bettina A. Murdoch for providing their expertise in fund-raising; Elizabeth Flynn for her enthusiastic handling of public relations; and Amy Lent for her marketing expertise.

I am enormously grateful to Bruce Katsiff, the Michener's director, for his commitment to every aspect of the project. Without his able leadership and encouragement, this exhibition and catalogue would not have been possible.

Constance Kimmerle, Curator of Collections
James A. Michener Art Museum

Bucks County Intermediate Unit #22

CIGNA Museum and Art Collection

The Corcoran Gallery of Art

Louis E. and Carol A. Della Penna

Marguerite and Gerry Lenfest

Lee and Barbara Maimon

National Academy of Design

Collection of Pearl S. Buck International

Philadelphia Museum of Art

Malcolm and Eleanor Polis

Reading Public Museum

Edward W. and Norma Redfield

Edward Redfield Richardson

Patricia A. Ross

Robert Bruce Ross

Speed Art Museum

Terra Foundation for the Arts, Daniel J. Terra Collection

Lisa and Joe Walker

Bob and Amy Welch

Widener University Art Collection

Woodmere Art Museum

Private collections

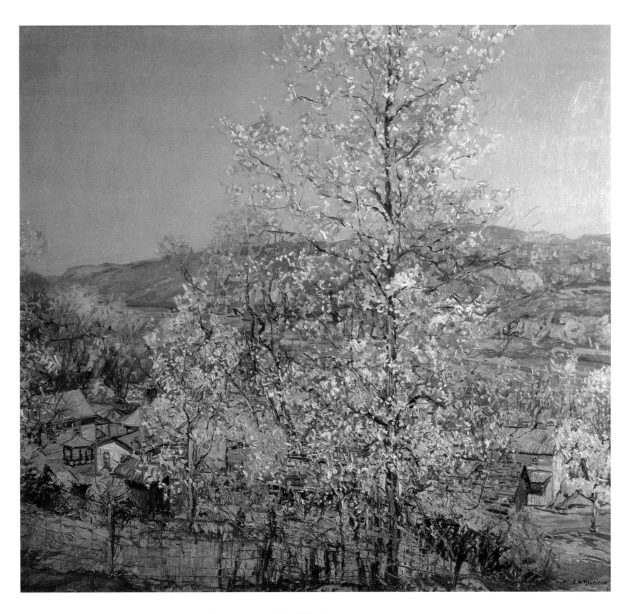

Fig. 1 Edward W. Redfield, SPRING VEIL, ca. 1928, oil on canvas, 50 × 56 inches.
Collection of Malcolm and Eleanor Polis.

In describing his reaction to one of Edward W. Redfield's "brave blossom pictures" "full of lush air and running water and breeze," artist Albert Sterner informed Redfield that the work, "painted as you always paint, from the shoulder," impressed him with its "just values and fine seeing."[1] During the first decade of the twentieth century, Edward Redfield developed a reputation for his vigorous and swiftly painted landscapes that conveyed the rawness and energy of a young nation emerging as a world power. His self-reliant character, disciplined deliberate methods, emphatic brushwork, and large, robust canvases connected with the ideals of many Americans, who viewed both the man and his work as embodying a regenerative force.

With its acquisition of new territory at the close of the Spanish-American War in 1898, America had effectively become a world power, viewing its progress as limitless. Historian Brook Adams was advancing the idea that a nation's art was a strong indicator of its vitality.[2] Decades later, a critic enthusiastically noted that it was "the strong-armed realist in Redfield" that had earned him the designation of "a true American type, who [had] evolved a breadth and vigor of brushwork suitable to American subjects."[3]

Pennsylvania Academy of the Fine Arts managing director John E. D. Trask suggested how Redfield's success was linked to the American culture's quest for a national form of expression in his preface to the 1909 catalogue accompanying Redfield's solo exhibition at the academy:

> With the storehouses of the world brought near to hand by travel's revolution, stimulated at home by a tense and nervous nation which for self-preservation turns more and more to the happy out-of-doors, the American landscape painter has seen a fairer vision and wrung from his own vibrant sensibilities a fuller note than has stirred the world before.

Fig. 2 Edward W. Redfield, THE TROUT BROOK (detail, cat. 36), ca. 1916, oil on canvas, 50 × 56 inches. In Trust to the James A. Michener Art Museum from Marguerite and Gerry Lenfest.

Among the men whose work may be considered typical of our time no one is more characteristically American than Mr. Redfield. His great successes have been made through the presentation of the aspects of the landscape under climatic and atmospheric conditions peculiarly our own. The national characteristics, vitality and decision, are his in the practice of his art, and in his tireless effort to acquire able craftsmanship he has in his painting developed great frankness and honesty.[4]

Capturing the vital energy of a specific place was a concern at the turn of the twentieth century for American landscape artists, who were seeking an alternative to their nineteenth-century predecessors' representation of the sublime aspects of the American virgin wilderness. By 1890 artists were beginning to focus on specific qualities of regions rather than on the opportunities and challenges of the frontier. As early as 1882, American critic Mariana Griswold van Rensselaer concluded that the best art contained "things which are most local, most characteristic and most unhackneyed."[5]

In his speech at the World's Columbian Exposition, held in Chicago in 1893, historian Frederick Jackson Turner suggested that the character of the nation had been shaped by its western frontier and not by Europe. The strong display of American impressionist paintings at the exposition bolstered Americans' confidence in native art and marked a turning point away from French academic art. Moved by his experience of seeing impressionist paintings at the 1893 Chicago exposition, American novelist Hamlin Garland called for American artists to focus on not only the distinctive features of American life but also the facts of the immediate present and the texture of a life they had experienced.

During the early twentieth century, Edward W. Redfield's paintings were phenomenally popular with those critics and cultural nationalists who identified the progress of American art as hinging on the artist's direct involvement with the distinctive features of the American scene. His art found substantial support from such critics as J. Nilsen Laurvik[6] and Christian Brinton,[7] who urged American landscape painters to free themselves from European traditions to achieve a democratic indigenous expression.

Striking a chord with critics urging artists to create a distinctly American art, the vigor and directness of Redfield's paintings also spoke powerfully to ordinary people, who wanted art to exude clarity and be rooted in authentic experience. A staunch advocate of tapping into the artistic impulse in every human being, Edward Redfield felt strongly that any art that requires explaining is not good art:[8]

> If my canvasses don't explain at a glance what they are meant to be, they are bad—utterly worthless. I absolutely miss my point. Why anyone of ordinary intelligence can understand my work without explanation.[9]

In an era when traditional rhythms of life and work were being disrupted by forces of industrialization and mechanization, Redfield's paintings provided welcome images of the rhythms of nature, its vital shaping forces, and its resurgent life. His bold, vibrant pictures, firmly anchored in an immediate, tangible local reality, embodied a regenerate spirit, while also satisfying his patrons' taste for fine craftsmanship, specificity, and clarity. As Charles Wheeler noted in his 1925 monograph on Redfield, "Reddy's rendition of hazy effects of atmosphere is free from doubtful or muddled passages and is filled with clearly seen poetic feeling."[10] Perhaps Homer Saint-Gaudens, director of the Carnegie Institute, summed up one of the most appealing qualities of Redfield's work when he described how his clear images embodied stability, immediacy, and directness:

> Bless you for your canvas. It adds strength and stability to an uncertain world. It is a tough life trying to get the right of it and argue out things on their merits so when I have one foot firmly planted on a base as substantial as yours, I am more happy.[11]

By 1910 Edward Redfield was recognized as one of the foremost landscape painters in the United States. His success was solidly grounded in his ability to paint distinctive aspects of the American landscape in clear and immediate terms that dissolved the boundaries between man and nature. Following Herbert Spencer, Walt Whitman, and Thomas Eakins, Redfield understood that people interpret the movements and forms of nature in terms of their individual experience. Realizing that art is fundamentally an expressive activity rooted in man's sensibility and feeling, Redfield knew that the power of landscape painting lay in its ability to bring individuals so close to nature that they would feel the currents of its life as strongly as they feel those of their own bodies. Perhaps this quality explains the resurgence of interest in his art today. In a culture increasingly driven by electronic communications, Redfield's clear, vibrant images provide a welcome counterbalance to the ephemeral, disembodied, virtual experiences that surround us today.

NOTES:

1. Albert Sterner to Edward W. Redfield, February 6, 1939, Edward Willis Redfield Papers, Archives of American Art, Smithsonian Institution, hereafter cited as AAA, microfilm reel 1183.

2. Brook Adams, "American Studio Talk," *International Studio* 7 (June 1899): xiii–xiv. For more information on American landscapes functioning as a national form of expression at the turn of the twentieth century, see *Paris 1900: The "American School" at the Universal Exposition*, ed. Diane P. Fischer (New Brunswick, N.J.: Rutgers University Press, 1999).

3. Unidentified newspaper clipping, Edward Willis Redfield Papers, AAA, microfilm reel 1184.

4. John E. D. Trask, preface to *Catalogue of the Exhibition of Landscape Paintings by Edward W. Redfield*, (Philadelphia: Pennsylvania Academy of the Fine Arts, 1909), n.p. Published in conjunction with Exhibition of Landscape Paintings by Edward W. Redfield shown at the Pennsylvania Academy of the Fine Arts, April 17–May 16, 1909, Philadelphia.

5. Mariana Griswold van Rensselaer, "Fifty-Seventh Annual Exhibition of the National Academy of Design," *American Architect and Building News* 11, no. 329 (April 15, 1882): 176.

6. Laurvik was a Norwegian-American art critic, who was a member of Stieglitz's Photo-Secession.

7. Brinton was an internationally noted critic, collector, and curator, who promoted modernism as early as 1910.

8. Redfield quoted in F. Arline de Haas, "Edward Redfield Qualifies as a Lightning Painter Making Fourteen Canvases in Fifteen Days' Work," *(Philadelphia) Public Ledger*, August 17, 1924.

9. "A Talk with Edward Redfield, Boothbay, Maine, September 23," newspaper clipping in Edward Willis Redfield Papers, AAA, microfilm reel 1184.

10. Charles V. Wheeler, *Redfield* (Washington, D.C., 1925), n.p.

11. Homer Saint-Gaudens to Redfield, November 2, 1937, Edward Willis Redfield Papers, AAA, microfilm reel 1183.

Born in Bridgeville, Delaware, on December 18, 1869, Edward Willis Redfield moved with his family to Camden, New Jersey, as a young boy. The artist would later reminisce about visiting the first exhibition of his work at the Philadelphia Centennial Exposition:

> I was seven years old. They had all the children in the public schools, classes all over, make drawings from the flat as they called it. And they gave me a cow to draw and it happened to be the best in the toddler's class. And [it was] sent in and exhibited and I saw it there. Went with father. About a million others in glass cases. And he lifted me up and put me in the muzzle of an enormous cannon they had on exhibition at that time. And he just set me in the thing so that I was above the crowd.[1]

At the age of twelve during school vacations, Edward began assisting his father, Bradley Redfield, a prosperous Quaker nurseryman in the wholesale fruit and flower business. Rising at one thirty in the morning, he traveled from Camden, New Jersey, to Philadelphia, where he helped his father set up produce.[2] When Edward Redfield entered his teens, Redfield's father decided that his son should apprentice with the engraving firm Grosseur and West. He arranged an interview at the engraving plant. Edward would later reveal how a Wild West extravaganza coming to town disrupted his future career as an engraver:

> The very day I went for an interview at the engraving plant, Buffalo Bill came to town with his Wild West show…. By the time it was over I had had time to think, and I was sure I didn't want to be an engraver's apprentice.[3]

Bradley Redfield's produce business brought him to Frenchtown, New Jersey, a thriving peach-shipping center, which opened the way for Edward to spend summer vacations on the Hinkle farm, near Frenchtown.[4] During the summer of 1884, Edward and three other boys camped on Bull's Island near Raven's Rock and rowed back to Philadelphia on a flat-bottom boat they purchased.[5]

Redfield's early art education included attending a German turnverein class in Camden,[6] where he copied from lithographs and engravings[7] and, in his words, "got a lot of calisthenics and a little drawing."[8] During the time of Redfield's residence in Camden, poet Walt Whitman was living and working in the city. Whitman's compilation of prose sketches published in 1882 as *Specimen Days* contained images of nature that would later be echoed in Redfield's seasonal landscapes. Describing his experience of nature in different moments, seasons, and hours of the day, Whitman related in *Specimen Days* his fascination with

Fig. 3 Haeseler Studios (Philadelphia), EDWARD W. REDFIELD, ca. 1900, gelatin silver print on paper. Courtesy of Mr. and Mrs. Edward W. Redfield II.

nature's "play of colors and lights, different seasons, different hours of the day,"[9] "brown soil … between winter-close and opening spring … dead leaves, the incipient grass, and the latent life underneath," "naked trees, with clear interstices, giving prospects hidden in summer,"[10] and the visible and invisible processes of nature that reveal "creation's incessant unrest."[11] Redfield would later tell his grandson Robert Stephens that he remembered seeing Whitman standing out on street corners in Camden, spouting his poetry.[12]

From 1881 until 1884 Edward attended classes at the Franklin Institute and the Spring Garden Institute in Philadelphia, where learning to draw was largely a matter of drawing from plaster casts. Surviving from this period of Redfield's early formal training are several charcoal drawings of plaster casts (cats. 1–6).

Redfield's rugged, direct style and progressive aesthetic beliefs were largely molded at the Pennsylvania Academy of the Fine Arts, where he studied from 1887 until 1889.[13] To prepare the charcoal and oil work that was required of all applicants for entrance to the academy, he engaged the services of Henry Rolfe, a commercial artist, for lessons in drawing and painting. After several weeks of lessons, which included advice that a work should be made at "one go" and taken directly from the subject, Redfield produced his required charcoal drawing and oil painting.[14] He would later credit Rolfe with teaching him the "one-go shot," a method that characterized his work throughout his career.[15]

At the Pennsylvania Academy, Redfield studied with Thomas Anshutz, James Kelly, and Thomas Hovenden. Redfield developed a lifelong friendship with Robert Henri, who would become the leader of the realist school of American painters known as the Ashcan school. His fellow students also included the sculptors Charles Grafly and Alexander Stirling Calder as well as the painters Henry McCarter and Hugh Breckenridge.

Although Thomas Eakins had left the academy in February 1886, Anshutz and Kelly preserved Eakins's teaching methods that insisted on close observation of nature, prolonged study from the nude model, and study of anatomy through dissection. Eakins reformed the curriculum of the academy to include in its modeling class work from life rather than study of antique sculpture. For Eakins, art was a means of revealing the vital organizing principles that determined the general forms of nature. Anatomical study, aided by photography, enabled Eakins to see forms in their minute varieties, to closely follow any indications of movement, and to distinguish what was essential to the just expression of such subtle, evanescent effects. In his 1879 article on the art schools of Philadelphia, William Brownell cited two things that distinguished Philadelphia from the New York art schools: immediate drawing with the brush and no prolonged study of the antique. Eakins urged his students to use the brush rather than pencil or charcoal and to work quickly.[16] In an article published in *The Penn Monthly* on the schools of the Pennsylvania Academy in June of 1881, Fairman Rogers,

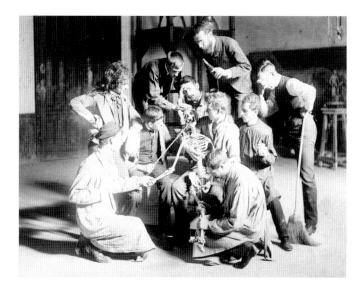

chairman of the academy's committee of instruction, noted that Eakins taught his students to "build up their figures from the inside, rather than fill them up after having lined in the outside."[17] Believing that the artist must first become acquainted with his subject and know what he was about, Eakins advised his students to closely observe the object of their study, being mindful of the feelings and sensual responses elicited:

> A half an hour of work that you thoroughly feel will do more good than a whole day spent in copying. Think of the weight. Get the portrait of the light, the kind of day it is, if its [sic] cold or warm, grey or sunny … and what time of the day it is. Think of these separately, and combine them in your work….[18]

Eakins urged his students to strain their brains more than their eyes, advising them, "you can copy a thing to a limit, then you must use intellect."[19] For Eakins, the big artist did not passively copy nature. The big artist moved parallel to nature, selecting and appropriating from all aspects of his individual experience prior to assembling his picture. Even as a young student Eakins recognized that the core of realism lay in the artist's willingness to establish a direct connection to the life of things around him and allow his subjective feelings, knowledge, and experience to be filtered into his picture:

> I cannot conceive that they should believe that an artist is a creator. I think Herbert Spencer[20] will set them right on painting. The big artist does not sit down monkey like and copy… he keeps a sharp eye on Nature & steals her tools. He learns what she does with light the big tool and then colour then form and appropriates them to his own use…. In a big picture you can see what o'clock it is afternoon or morning if its [sic] hot or cold winter or summer and what kind of people are there & what they are doing & why they are doing it…. If a man makes a hot day he makes it like a hot day he once saw or is seeing… or which he imagines from old memories or parts of memories & his knowledge & he combines & combines & combines never creates….[21]

As a teacher at the academy, Eakins oriented its course of study to focus on close observation and immediate experience as essential to the artist's

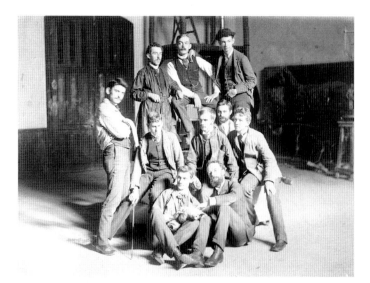

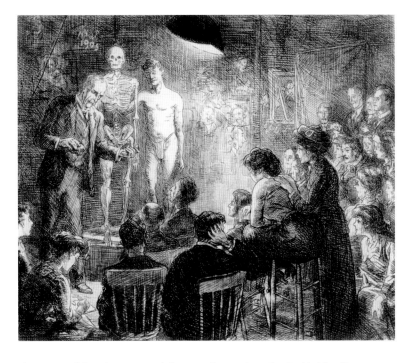

subtle expression of nature's evanescent effects. His student Thomas Anshutz would later state that "It was not until sometime after I had … come to Philadelphia to study … that I learned the difference between making a copy of lines and form which express some action and trying to express the action itself."[22]

Throughout his career, Redfield was fascinated by the natural forces that color the individual's reactions to nature and account for nature's mutable appearances. He understood that while one could teach others to draw or paint what they see before them, "there is a vast difference between people who copy and people who feel what they see."[23] Alert to the ever-changing phases of nature, he knew that reality is rooted in man's senses and that nature is a composite of shifting visions. His forthright, direct, and vigorous technique did not preempt his desire to interpret the movements and forms of nature in terms that dissolved the boundaries between man and nature.

Like Whitman and Eakins, Redfield understood that art is an expressive activity rooted in man's sensibility and feeling. In a 1948 interview he quipped that he never felt art could be taught since "real art comes from feeling."[24] Such a work as *The Riverbank, Lambertville, New Jersey* (cat. 23) powerfully reveals that in recording the specific details of a riverbank in Lambertville, Redfield did not lose sight of the quietist poetry that such an isolated river scene possessed. For Redfield, the landscape functioned as much as a vehicle to provide an intense emotional experience for its viewers as a depiction of nature's appearances. Like Eakins, he understood the important role that memories and feelings play in determining what one perceives and experiences, and he believed that he could tap into the artistic impulse in every human being. In an article published in *American Artist* in 1959, Henry Pitz described how Redfield's art revealed something hidden behind appearances that was responsible for them:

> One can walk the [Delaware] river shores and climb the hills and recognize the sites of many Redfield canvases of forty and fifty years ago, but this is merely an interesting fact. What is important is that those canvases sum up the look, feel, and flavor of a countryside. They prod us into a shared awareness of the working of the seasons upon a land and a people. That they have a pigmental delight and shifting, interchanging patterns of color and shape is a matter of course—not their only reason for being. They are pictures not only of particulars, but of essences.[25]

Redfield studied his subject closely before painting it. Although he often painted scenes as swiftly as possible in a four- to eight-hour period, he studied these scenes in advance, consistent with his training at the academy. After selecting a subject, he carefully observed it, sometimes going, according to one contemporary account, a dozen times to the spot before it seemed ripe to him.[26]

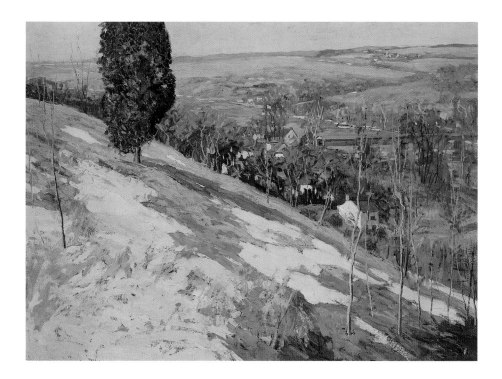

Fig. 8 Edward W. Redfield, HILLSIDE AT CENTER BRIDGE, 1904, oil on canvas, 36 x 50 inches. W. Moses Willner Fund, 1905.152. Reproduction, The Art Institute of Chicago.

In preparation for one work, he admitted to studying the glow of evening light—the condition lasting for "a half an hour, three-quarters ... until it gets dark" for "seven or eight months" in an attempt to "get the notes."[27] Fascinated by the forces that account for a scene's appearance and color man's reaction to it, he advised artists prior to painting to "find out what you want to paint, study it in advance, watching for the time-of-day lighting you want. See it, seize it, remember it—then get out and paint it."[28]

Prior to acquiring an automobile in 1912, Redfield painted most of his work within a mile of his home. At times he returned to the same subject and produced a fresh view by shifting his viewpoint and observing the scene under different conditions. He reminisced about painting scenes of the Carversville mill, working one day from one point of observation and producing another painting the next day from another angle.[29] In 1904 he painted *Hillside at Center Bridge* (fig. 8), capturing the vista of houses of Center Bridge from a hillside patchily covered with old snow. He returned to the same place several years later and produced a fresh scene by shifting his viewpoint and observing it through a line of barren trees *(A Pennsylvania Landscape*, ca. 1916; cat. 34). Redfield bought a plot of land in Point Pleasant from neighbor Michael Mullen near his home in Center Bridge and painted there many times from points within a radius of a few hundred yards. His emotional attachment to the property in Point Pleasant is revealed in a 1929 interview: "There is a real 'church': go there at sundown and watch the changing colors in earth and sky and water. It is a place to worship!"[30]

The simple character; emphasis on value, contrast, and structure; and concern for tactile form found in a group of charcoal sketches created by Redfield while a student at the Pennsylvania Academy suggest the influence of Eakins and Anshutz. Following Eakins's and Anshutz's concept of art as a sensible appearance, Redfield discloses the essential character of a thing in its simplest form (cats. 7–10).

European Experience (1889–1892)

During his final year of studies at the academy, Redfield's landscape painting *Wissahickon* was included in its 1888 annual exhibition. The following year, Bradley Redfield agreed to finance his son $50 a month to study in Europe.

Edward kept a journal (cat. 11) of his voyage to Great Britain and France in August 1889 with his Pennsylvania Academy schoolmates Frank Hays and Alexander Stirling Calder and painter C. A. Houston. The journal contains lively descriptions of boisterous prayer meetings on board and his companions' bouts with seasickness, as well as sketches and descriptions of some of the most colorful characters on board—"two old men who would forever glide into some obscure corner and discuss whether the earth was flat or round. " The young artist noted finding such interesting subjects for study as the Irishmen who were returning to their homeland "with haggard faces and eyes that sorrowfully looked forth from their hollow depths ... and with remnants of what had been fine clothes and forms" and children with "funny little legs and wild disheveled hair ... crowded together seemingly seeking consolation from one another."[31]

The journal also contains rich descriptions of the ever-changing conditions of nature and atmosphere on the open sea.[32] Redfield wrote that when he tired of the monotony of ship life, he stood for hours over the stern, watching "the great mass of foam as it arises from the propellers, one moment white then green and at another time blue always changeing [sic] and taking the most beautiful tints imaginable...." Upon reaching the coast of Ireland, he described the "beautiful moss covered banks and rich red, brown and yellow grasses that seemed to grow upon the surface of rocks that arose in graceful lines from the sea, which dashed itself against them as if to wear away an old grudge...."[33]

As soon as he arrived in Paris, Edward visited the Universal Exposition. He described the experience of proceeding down the main walk into the expo: "harmonious colours, beautiful buildings everywhere told of the good taste of their designers and builders, sausage stands, coffee booths, fakers, turks, arabs, and a sprinkling of the whole world were mixed in one big jumble, everyone good naturedly pushing and being pushed on...." Before reaching the art exhibition, he watched belly dancers going through a series of turns and wiggles "that made the bald headed men crazy with delight and caused the goodly old women to say it was shocking...." Upon reaching the picture galleries, Edward noted the enormity of the display of all the great masters and concluded that the finest picture in the exposition was Jules Bastien-Lepage's *Joan of Arc*.[34]

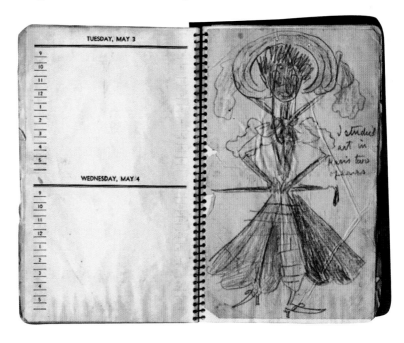

Fig. 9 Edward W. Redfield, I STUDIED ART IN PARIS TWO YEARS, graphite and colored pencil cartoon sketch from Edward W. Redfield journal, 1949. Courtesy of Dorothy Hayman Redfield Collection.

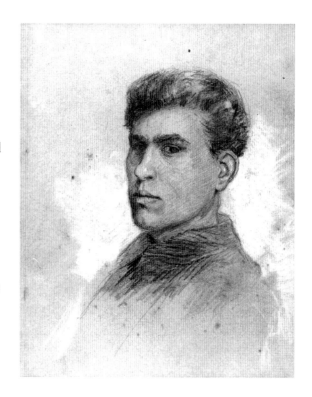

Edward attended classes at the Académie Julian with the intention of becoming a portrait painter. He studied with the academic painters Adolphe William Bouguereau and Tony Robert-Fleury[35] and traveled during the summer of 1890 with Robert Henri to the Mediterranean port of Saint-Nazaire, where he painted directly from nature in a high-keyed palette. Redfield's small canvas *Dune Walk, France* (cat. 12) was likely painted at this time.

While in Paris, Redfield became familiar with the work of the French impressionists and the vigorous snowscapes of Norwegian impressionist Fritz Thaulow (1847–1906; cat. 13). He would later comment on his major interests while in Paris: "I generally went to the Luxembourg—was interested in Monet, Thaulow, Pissarro—mostly."[36]

Redfield's self-portrait sketch (fig. 10; cat. 14), completed as a student in Paris in 1890, demonstrates his ability to achieve a finely discerned, carefully conceived likeness. The subject's thoughtful expression and intense gaze suggest the young artist's ability to produce a subtle study of himself that underscores the linkage of drawing to seeing and feeling.

Redfield's enthusiasm for portrait painting lessened as he found himself more interested in painting outdoor scenes, especially snow scenes and marine scenes. He quipped: "With landscape, if I make it good enough, there are many who will appreciate it. Portrait painting must please the subject as a general thing—or no pay! It's a hired man's job."[37] While staying at the Hotel Deligant (fig. 11) in 1891 in the village of Brolles, near Fontainebleau, with a group of American art students that included Henri, Charles Grafly, and E. Thompson Seton, Redfield painted his first snow scene directly from nature.[38]

Redfield's stay at the inn proved fruitful: he met the innkeeper's daughter Elise Deligant, who would later become his wife, and his first snow scene, *Road—Forest of Fontainebleau,* was accepted by the Paris Salon. With everything going his way, Redfield decided to ship the painting back to the annual exhibition at the Pennsylvania Academy, where it was bought by Mrs. Robert Lincoln. Lincoln later arranged an 1892 show for Redfield at the Doll and Richards Gallery in Boston.[39] Before returning to the United States, Redfield traveled with Henri and William Gedney Bunce to paint in Venice during the summer of 1891.[40]

On his return to the United States in August 1892, Redfield spent some time in North Hector, New York, painting lake scenes.[41] The following year he traveled back to London to marry the innkeeper's daughter he had met in Brolles. The newly married couple returned to the United States to live with Redfield's parents in Glenside, Pennsylvania. While residing in Glenside, Redfield painted a number of small canvases of local scenes in a loose impastoed style that display an interest in capturing the transient effects of light and weather (cat. 16).

Edward joined Robert Henri and a group of artists (Walter Elmer Schofield, John Sloan, Everett Shinn, William Glackens, George Luks, James Preston, Edward Davis, Charles Grafly,

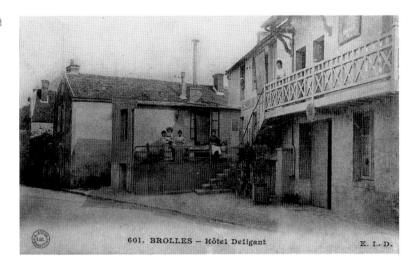

Fig. II Hotel Deligant, Brolles, France, n.d. Edward W. Redfield met his wife, Elise Devin Deligant, while staying at the hotel in 1891. Elise was the daughter of the innkeeper. Courtesy of Dorothy Hayman Redfield Collection.

601. BROLLES — Hôtel Deligant E. I. D.

Alexander Stirling Calder, and Hugh Breckenridge) in Henri's Philadelphia studio for weekly aesthetic discussions that centered on such progressive art topics as the need for American artists to find a means of expressing the spirit of the everyday life around them. They explored the relation of their work to that of such writers as Ralph Waldo Emerson, Émile Zola, Honoré de Balzac, Henrik Ibsen, Leo Tolstoy, Henry David Thoreau, Charles Gilman Norris, Hamlin Garland, Stephen Crane, and especially Walt Whitman.[42] Many of the views espoused by such critics as Frank Mather, Guy Pène du Bois, and Christian Brinton, which centered on art as a medium of communication and a response to everyday life, were ideas explored in Henri's weekly discussions.

Country Life

In 1898, two years after his father had lost his fortune during the economic depression of the nineties, Redfield and his wife bought an island farm in Center Bridge, Pennsylvania, consisting of 127 acres beside the Delaware River and canal. In the next few years, he sold most of the land, except for one-and-a-half acres on the towpath facing the canal.[43] Redfield would later reveal why he came to the Bucks County countryside:

> ... not for the beauty of the countryside, but because this was a place where an independent, self-sufficient man could make a living from the land, bring up a family and still have the freedom to paint as he saw fit.[44]

The story of the couple's relocation to Center Bridge was the subject of a 1907 article by Walter Dyer appearing in *Country Life in America* magazine. Entitled "Two Who Dared—How a Well Known Artist and his Wife Cut Loose from the City and Started Life Anew in the Country with No Capital—the Building of a Studio Home," the article described how the "gospel of the simple life" drove the couple to buy a farm situated mostly on an island where they worked hard and confronted the obstacles of nature:

Residence of E. W. Redfield, Centre Bridge, Pa.

Fig. 12 Postcard with illustration of residence of E. W. Redfield, Center Bridge, Pennsylvania. Published by C. R. Middleton, Druggist, New Hope, Pennsylvania, n.d. Courtesy of Mr. and Mrs. Edward W. Redfield II.

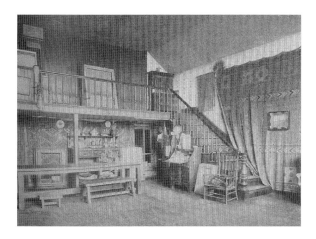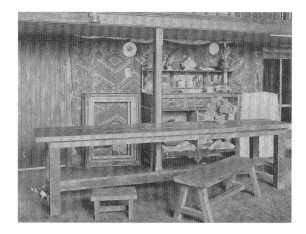

Figs. 13–14 Interior of the Redfields' living room and dining room, which also served as the artist's studio. Furnishings include driftwood furniture crafted by Edward W. Redfield. Reproductions of photographic illustrations from Walter Dyer's article "Two Who Dared—How a Well Known Artist and his Wife Cut Loose from the City and Started Life Anew in the Country…." *Country Life in America,* December 1907, p. 195. Courtesy of Olin Library, Cornell University.

At first they camped out, going indoors only to escape the rain, until Mr. Redfield had put the place in order. With his father's help he repaired the foundations, which were in fairly good condition, replastered the walls, repaired the roof and windows and woodwork, and made a dry and comfortable house of it, if not an elegant one. Meanwhile he was cultivating a little vegetable garden near the house.

The house was furnished chiefly from the friendly river that flowed at the foot of the garden. From the driftwood he secured enough tough and seasoned timber to make tables and chairs. Some of which he still uses, for he is a craftsman as well as a painter. He also built a boat and a pontoon bridge reaching to the island using dozens of derelict casks and kegs….

"There were times [Redfield noted] when we didn't have two cents for a postage stamp, if you call that poor. For six months we had little to eat except potatoes and beans that I raised, the eggs our twelve chickens laid, and the bass I caught in the river."[45]

Dyer concluded his article describing the simple life of the country as an ideal environment for the full and free expression of individuality:

The country called them and they went forth not knowing what the outcome would be. They have blazed the trail for those who follow. They have taught us one more lesson in the gospel of the simple life. They have brought a little nearer to realization the artist's millennium—"And only the Master shall praise us, and only the Master shall blame; And no one … shall work for fame; But each for the joy of working, and each in his separate star, Shall draw the Things as he sees It for the God of Things as They Are."[46]

The Redfields' retreat to the country mirrored the experience of many city dwellers, who sought a more simple life in the country during the time of the economic depression that rocked the American economy from 1893 to 1897. As unemployment in the nation's cities reached 35 percent, arts and crafts revivalists embraced the simple life and moral work ethic of the subsistence farmer and craftsman as a path to a better life.

The shift from entrepreneurial ("free labor") to industrial (managerial) capitalism that occurred at the turn of the century exerted a tremendous influence on the daily life of many Americans. With the introduction of standard time and the invention of the time clock, rhythms of life and work were no longer controlled by the seasons and the soil. The shift of an economy committed to the well-being of the farmer and skilled artisan to one of wage labor precipitated shifting attitudes toward work. As punctuality, loss of self-autonomy, and impersonality began to color the contents of urban working life, modern culture was viewed by adherents of the arts and crafts philosophy as alienating people from the natural world.[47]

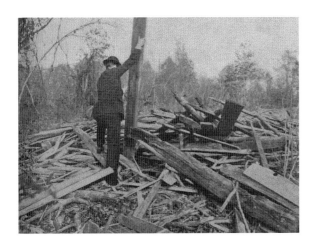
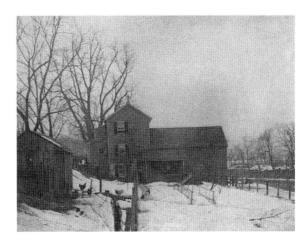

Figs. 15–16 Edward W. Redfield selecting timber from a pile of driftwood from the Delaware River. The artist used the timber to build a boat, pontoon bridge, and furniture for his home. The Redfield home in winter. Reproductions of photographic illustrations from Walter Dyer's article "Two Who Dared," *Country Life in America,* December 1907, p. 195. Courtesy of Olin Library, Cornell University.

As Walter Dyer noted, Redfield's experience of living in the country not only tested his character but sharpened his survival instincts and self-reliance:

> When spring came again, Mr. Redfield found that it was a submarine villa that he had acquired. One night the river rose hurriedly and with vigor, and the Redfields left for the nearest neighbor's in a boat, after transferring to the second story as much of their belongings as they could. This has happened nearly every year since, until it has come to be a regularly expected thing....
>
> It all sounds humble enough but in seven years Edward Redfield has become an independent man. He owes no man a penny. He is no man's slave. He can look every man in the eye and bid the world defiance. He lives where he wishes; his work is what he chooses.[48]

The trials of living in the country not only deepened the artist's respect for nature, they also deepened his knowledge of how forces shaping nature also shaped men's lives. Years later, when asked to describe his teachers on an application for membership in the Salmagundi Club, Redfield noted that nature had been his greatest instructor.[49] While assembling his canvases for the 1929 solo exhibition at the Art Club of Philadelphia, the artist reminisced about events that had influenced his artistic development even more than his schooling and recalled the experience of having "miniature icebergs crashing against the walls" of his house as the ice began to break on the river during the annual spring flood season.[50]

In his 1906 article devoted to the winter land-scapes of Redfield, art critic B. J. O. Flower suggested that Redfield's move from "the crowded, nerve-racking, brain distracting metropolitan centers to a quiet nook on the picturesque banks of the beautiful Delaware"[51] had enabled him to live a more focused, productive life. Flower described the compelling manner in which Redfield captured nature's quiet latent power buried under the snow and ice and hidden in the "skeleton trees, the somber river

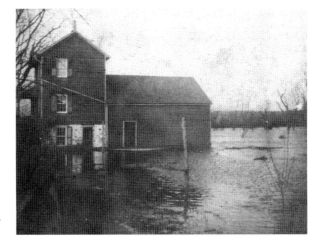

Fig. 17 The Redfield home during a spring flood, ca. 1902, Center Bridge, Pennsylvania. Photograph courtesy of Thomas Folk.

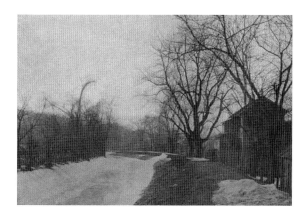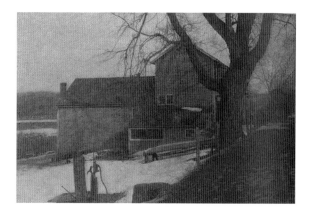

Figs. 18–19 The Redfield home on the canal and towpath and view of water pump in the yard, where "an Academy medal winner works a pump—600 strokes a day." Reproductions of photographic illustrations from Walter Dyer's article "Two Who Dared," *Country Life in America,* December 1907, p. 196. Courtesy of Olin Library, Cornell University.

and … idle boats."[52] Noting that the artist painted in the winter when the temperature is zero and the wind is blowing forty miles an hour, Flower portrayed Redfield as a man who confronted life with directness and intensity.[53] Flower's association of Redfield's artistic success with his willingness to embrace the robust simplicities of nature was a popular sentiment in America at the turn of the century when many individuals feared that the city was a breeding ground for decadence while rural life offered opportunities for intense experience and bodily testing.[54]

In an article devoted to the subject of nationalism in art, Guy Pène du Bois, noted figure painter and editor of the journal *Arts and Decoration,* compared the Pennsylvania school of landscape painters to the Boston figure painters. In much the same fashion as Dyer and Flower, he described the Pennsylvania painters and their leader Edward Redfield as vigorous men of the soil battling the turbulent power of nature. In contrast to the aristocratic Boston group (headed by Edmund Tarbell, Joseph DeCamp, William M. Paxton, and Frank W. Benson), whose figures were never found "outside the province of the lady" and whose complacency resulted from the "removal of struggle" from their lives, the Pennsylvania group came from "a line of settlers pushed to rudimentary thought by rudimentary living." The difference in character, Pène du Bois reasoned, came from a difference in environment—"one is of the city, the other of the country."[55] Maxfield Parrish's paintings of *The Artist, Sex, Male* (fig. 21), likely a snide reference to the Boston school of painters, and *The Farmer, Philosopher* (fig. 22), which appeared on the covers of *Collier's* magazine in May 1, 1909, and November 2, 1912, reflect the public perception of the aristocratic urban artist as effeminate and unfocused as opposed to the man of the soil, whose sensibility was developed by intimate encounters with nature.

Exploring the Conditions of Nature

> When I first began to work, most artists used models in studios. What I wanted to do was to go outdoors and capture the look of a scene, whether it was a brook or a bridge, as it looked on a certain day.
> —Edward W. Redfield[56]

It was not long after the couple settled in their first house at Center Bridge that their first child died from being struck by a swinging barn door. Redfield took his wife back to France to visit her parents and maintain some distance from the tragedy. After a brief stay in Brolles, they moved to Alfort on the Seine, a village near Paris, where Redfield painted landscapes of the Seine and Parisian street scenes. The deep perspective, meditative mood, and interest in capturing the transient qualities of weather found in such works as *Evening on the Seine* (ca. 1899; cat. 17) and *France* (ca. 1898–99;

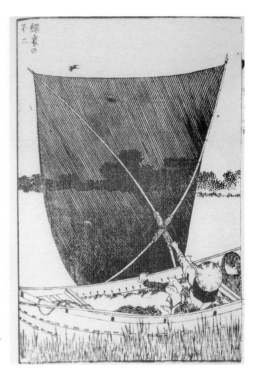

cat. 18) suggest Robert Henri's expressive painterly Parisian cityscapes of the late 1890s (*La Neige*, 1899; fig. 23).

Henri visited the Redfields in Alfort and described how Redfield's work evolved over the year:

> You know Reddy was first at Brolles (Forest of Fontainebleau)—since he has come to live at Charenton (or rather Alfort, across the river from Charenton). It's practically Paris—being the East outskirt of the city on the river. Beautiful place within half an hour of the Louvre by boat and on the edge of the country in the other direction. Reddy did good things down in Brolles in spite of the season being the green period for forest and the place not being just the right kind of subject for the painter of creeks and snow. But now, since he is at Charenton he has done work that is far ahead of all that he has ever done before. River scenes looking towards Paris—He has found the thing he likes to paint and plenty of it. He has left all his old successes way behind with this new work.[57]

The Bridge at Joinville (cat. 19), painted while the artist lived at Alfort, was one of two entries in the Paris Universal Exposition in 1900 that earned Redfield a bronze medal.[58] Its deep perspective, loose, heavy impastoed brushwork, and tonalist style no doubt appealed to a jury supportive of landscapes revealing an assertive personality and reflecting distinctive American traits.[59]

Before Redfield's return to the United States, the Pennsylvania Academy held a one-man show of Redfield's landscapes (March and April 1899). Most of the works were scenes in Glenside or Center Bridge[60] and suggest his deepening interest in the transient effects of light and weather, conditions of nature, and phases of a season. Among the twenty-seven works exhibited were *The Brook in Twilight, The Last Ray, After the Thaw, Early Winter Morning, Evening Star, Autumn Afternoon, After Sundown, Twilight, Grey Day*, and *The First Snow*.[61] The titles are clues to the importance Redfield placed on the conditions of the scenes. He would later comment that the most appropriate titles for his works were those giving the date on which they were painted instead of more specific titles describing the place:

> And their records they should have been dated you might say. And that should have been their titles. April the 23rd, with the year. Now in that way you have your titles in the same time. But you have to find these titles you know, "The Laurel Brook," and what have you.[62]

Upon returning to Center Bridge, Redfield painted a number of large atmospheric winter scenes in a muted palette. In one such scene, *Waiting for Spring* (1901; cat. 20), an idle tethered boat, enveloped in a gray leaden atmosphere, expresses the somber mood of the quiet, latent time in late winter when the earth is swollen with snow water.

According to Redfield's biographer, Charles Wheeler, after settling in Center Bridge, the artist made up his mind to work out for himself "the technique of painting a landscape at one unit effort" that would achieve "freshness and spontaneity of color effect … of … one day or a part of a day." Redfield estimated that it would take him ten years to achieve this goal.[63]

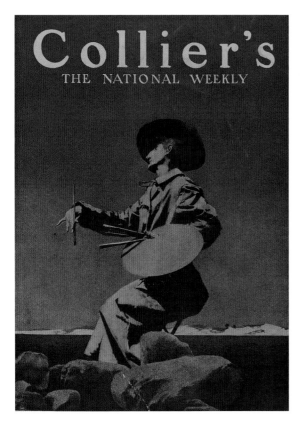

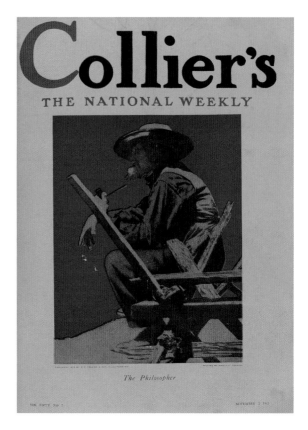

Fig. 21 Maxfield Parrish (1870–1966), THE ARTIST, SEX, MALE, cover illustration for *Collier's The National Weekly Magazine*, May 1, 1909. Courtesy of New York Public Library.

Fig. 22 Maxfield Parrish (1870–1966), THE FARMER, PHILOSOPHER, cover illustration for *Collier's The National Weekly Magazine*, November 2, 1912. Courtesy of New York Public Library.

From 1900 until 1910 Redfield painted a number of large snow scenes outdoors at "one go." By 1910 his keen ability to capture the ever-changing phases of winter had earned him a reputation as the leading painter of American snow scenes. *Hillside at Center Bridge* (1904; fig. 8), painted from a slope overlooking Center Bridge, captures the transient effects of light and weather on specific aspects of the scene. Dead grasses push through the melting snow as the distant river curves through the landscape. Its enlarged foreground emphatically suggests the artist's firsthand, close observation and immediate experience of the scene. A more remote river scene, *The Riverbank, Lambertville, New Jersey* (ca. 1908–10; cat. 23), depicts the somber austere aspects of the river landscape in the dead of winter. A line of bare tree trunks, overladen with clinging vines, stretches across the banks of the icy Delaware. In *The Island* (1908; fig. 24) winter's grasp on the flow of water between two grassy banks in a field of snow is vividly suggested. The line of scraggly grasses, growing along the banks of the canal, creates a screening effect that functions to montage the foreground and distant views. In *Winter Snowscene, Coppernose Hill* (ca. 1910; cat. 24),

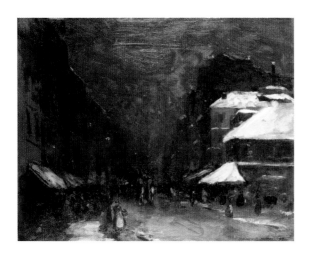

Fig. 23 Robert Henri (1865–1929), LA NEIGE, 1899, oil on canvas, 25¾ x 32 inches. Musée d'Orsay, Paris. Photo: Gerard Blot. Musée d'Orsay, Paris. Photo credit: Réunion des Musées Nationaux.

Redfield captures the exhilarating effects of a spectacular scene, painted from a hillside overlooking the river valley on a cold sunlit day. His swift technique is evident in the shorthand of juicy brushstrokes that cover the canvas and form an overall surface patterning. Single thin creamy streaks of paint capture the bright, crisp, glittering effects of sunlight as it strikes the branches of trees and grass in the foreground.

The dramatic simplicity of these early winter scenes suggests Redfield's use of a number of compositional strategies found in Japanese prints of simple everyday scenes: a perpectival structure overlaying big foregrounds with distant views, sharp horizons, barren spindly trees, and panoramic stretches of snow broken by intervals of protruding vegetation. Japanese printmaker Hokusai created novel effects in *Fuji behind a Net* (from the series of One Hundred Views of Mount Fuji, 1834–37; fig. 20) by inserting a screen to splice a large foreground over the background. Edward Redfield understood how such a device could be used to enhance the drama and meaning of an ordinary scene.[64]

In 1903 Redfield and his wife began spending summers in Boothbay Harbor, Maine. Redfield would later reveal that Dr. Samuel W. Woodward, a patron of his work, suggested that he go to Maine to paint and offered him $1,000 to finance his first summer:

> In Maine I got a house for $6 a month; made a lot of the furniture for it myself; borrowed some and bought the rest second-hand. That fall I still owed Dr. Woodward $600.00. Then two things happened; Dr. Woodward's funds were all caught in the big bank smash, and I won a $1,000 prize at Carnegie Institute. Immediately I sent him the $600 balance, and it was the only cash he had.[65]

The Maine landscape provided Redfield with an opportunity to explore the forms of nature unique to the Maine seacoast, the power of the sea, and the work of people in relation to it in such works as *Boothbay, Maine* (1902; cat. 25); *Boothbay Harbor at Night* (ca. 1904; cat. 26);

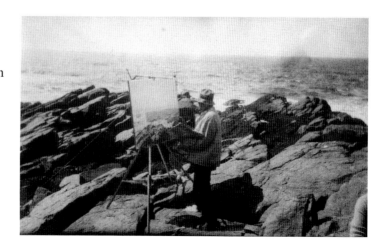

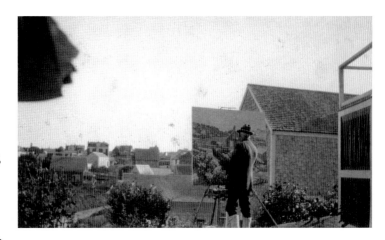

and *Boothbay Harbor* (1925; cat. 27). *Boothbay Harbor at Night* (cat. 26), which depicts three sailboats with night-lights shining on the water, received the Society of American Artists' Shaw Fund Prize in 1904.

After painting water for a few summers in Boothbay, Redfield noted that he still found it difficult to paint:

> I've been trying to get the movement of it; the feel of the wind playing over the harbor, the color; the life. I've only been going up there painting water for a few years now. Maybe after seven or eight years of painting water I'll be able to get it right.[66]

Describing his Boothbay paintings, Arline de Haas, critic for the Philadelphia *Public Ledger*, seemed to think the artist got it right:

> Here is the deep blue of the bay, the points of land jutting out into the water, the town on the distant shore, and the fishermen's huts on the edge of the shallow beach; whitecaps lashed by the frenzied winds into leaping dashing wavelets, rocking the boats tied in their land moorings. They are fresh and vigorous, these canvases, brushed with the tang of salt air, wind swept spaces violently active....
>
> Fourteen canvases out of fifteen days' work, and there would have been fifteen, Redfield explained, "only one day the wind was so strong that it was impossible to moor the easel and keep the canvas in place." Few artists work so passionately and so devotedly. But Redfield knows landscape. There is no hesitancy about his work; no deliberation. He is certain of the placement of things; of his medium. He knows what he wants to paint, and he paints it.[67]

When Robert Henri and his wife spent the summer of 1903 in Maine with the Redfields, Henri noted how the "action painter" impressed the Monhegan Islanders, "slinging the paint over big canvases, astounding the natives and astounding the local artists with his rapidity as well as his results...."[68]

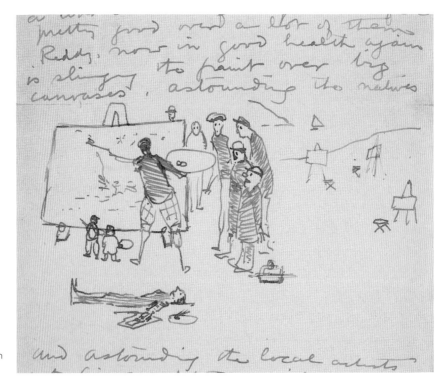

Accolades and Awards

During the first decade of the twentieth century, Redfield became one of the most popular and widely exhibited landscape painters in America. As early as 1903, he was elected a member of the Society of American Artists. A year later he was elected an Associate of the National Academy of Design, and he became an Academician in 1906.

On the occasion of Redfield's election to the academy as an associate member, Thomas Eakins painted Redfield's portrait (cat. 28). Renowned for his

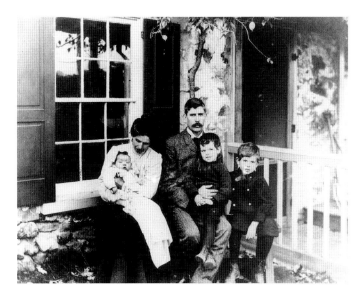

ability to imbue his male subjects with a vigorous temperament, Eakins created a portrait that suggested the subject's clear vision and deliberate manner. As Redfield's floodlit form emerges from the dark background, his gaze is clearly focused and connected to the world around him. In highlighting Redfield's head and hands, Eakins suggests the mental vigilance and physical labor that account for the artist's achievements. The flexed posture of the subject's clasped hands suggests the decisive, direct manner in which Redfield engaged the world.

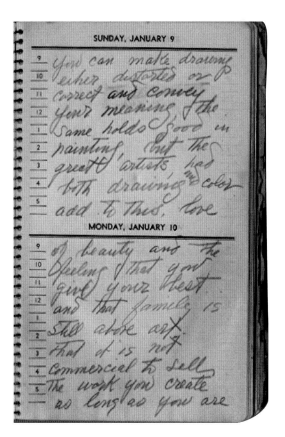

Redfield's first gold medal was awarded in 1896 by the Art Club of Philadelphia. Other honors and awards followed. He received a bronze medal in 1900 from the Universal Exposition in Paris; a bronze medal from the Pan-American Exposition, Buffalo (1901); the Temple Gold Medal[69] from the Pennsylvania Academy (1903); Shaw Fund Prize from the Society of American Artists (1904); Second Hallgarten Prize from the National Academy of Design (1904); and a silver medal from the Louisiana Purchase Exposition in Saint Louis (1904), where he served as a member of the advisory committee. From 1905 until 1910, he received the Jennie Sesnan Gold Medal (1905)[70] and the Gold Medal of Honor from the Pennsylvania Academy (1907); a Gold Medal of the

Fig. 28 Edward W. Redfield with wife, Elise; baby daughter, Louise; eldest son, Laurent; and younger son, Horace, ca. 1906. Courtesy of Mr. and Mrs. Edward W. Redfield II.

Fig. 29 "You can make drawings either distorted or correct and convey your meaning, & the same holds good in painting, but the great artists had both drawing and color add to this, love of beauty and the feeling that you give your best and that family is still above art, that it is not commercial to sell the work you create as long as you are not guilty of making that your object in painting them—" Edward W. Redfield, journal, 1949. Courtesy of Dorothy Hayman Redfield Collection.

Second Class from the Carnegie Institute (1905); the Webb Prize from the Society of American Artists (1906); awards from the Carnegie International Exhibitions in 1907 and 1908; a third prize (William A. Clarke Award) from the Corcoran Biennial (1907); a first prize (William A. Clarke Award) from the Corcoran Biennial (1908); a third class medal from the Paris Salon (1909); a second prize Harris Medal from the Art Institute of Chicago (1909); and a gold medal from the Buenos Aires International Exposition (1910).

By the turn of the century, the American art establishment had developed into a system where winning a medal in a major exhibition often precipitated offers from other museums and galleries. Museum directors, eager to find talented artists for their annual exhibitions, selected artists for these shows by direct invitation as well as by juried selection.[71] Redfield developed lifelong friendships with such directors as the Corcoran's C. Powell Minnigerode, Pennsylvania Academy of the Fine Arts' John E. D. Trask,[72] and the Carnegie's Homer Saint-Gaudens, who invited him to participate or chair the jury selecting and awarding prizes for their annual shows. As early as 1903 Robert Henri noted the value of Redfield's service on "juries galore" in promoting his work.[73] Redfield served as a juror for exhibitions at the Art Institute of Chicago (Watercolor Annual 1901, American Annual 1907, American Annual 1919); Corcoran (Biennials in 1907, 1908, 1914 [chairman], 1923 [chairman], 1932); National Academy of Design (Annual Exhibition 1909, Winter Exhibition 1909); and Pennsylvania Academy of the Fine Arts (Annual Exhibitions in 1895, 1898, 1901 [chairman], 1904, 1906, 1907 [chairman], 1912, and 1916); and for such major exhibitions as the Panama-Pacific International Exposition in 1915, the Carnegie International Exposition in 1919, and the Philadelphia Sesquicentennial International Exposition in 1926.

As Redfield collected a cache of awards and served on juries, major American institutions began collecting his work. By 1909, his paintings could be found in the collections of the Art Institute of Chicago, Carnegie Institute, Art Club of Philadelphia, Pennsylvania Academy of the Fine Arts, Boston Art Club, New Orleans Art Association, Saint Botolph Club (Boston), Brooklyn Museum, Telfair Academy of Fine Art (Savannah), Corcoran Gallery, Detroit Museum of Art,[74] the John Herron Art Institute (Indianapolis), and the Samuel T. Shaw Collection (owner of the Grand

from top to bottom:

Fig. 30 Medals awarded to Edward W. Redfield. Courtesy of Edward Redfield Richardson.
1900 bronze medal, Universal Exposition, French Republic, inscribed "E. W. Redfield."
1903 Joseph E. Temple Gold Medal, Pennsylvania Academy of the Fine Arts,
inscribed "Edward W. Redfield 1903." Awarded to the best painting in the annual exhibition.
1907 bronze medal, Corcoran Gallery of Art.

Fig. 31 Medals awarded to Edward W. Redfield. Courtesy of Mr. and Mrs. Edward W. Redfield II.
1913 gold medal from Twenty-second Annual Exhibition of the Washington Society of Artists,
inscribed "Edward W. Redfield."
1904 silver medal, Louisiana Purchase Exposition, Saint Louis.

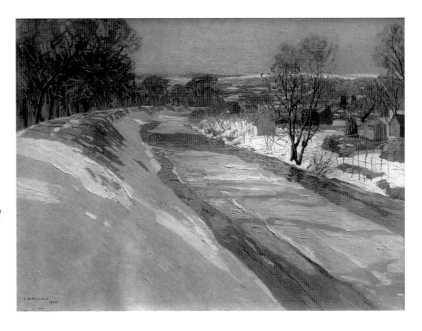

Union Hotel, New York City). When the French government bought one of his winter scenes (*February* [also known as *Canal in Winter*], 1907; fig. 32) for the Luxembourg Museum in 1909, critic Frank Jewett Mather noted the significance of this purchase for American landscape artists. It was in fact the first American landscape bought by the French government for the Luxembourg Museum. Writing in *Scribner's* magazine, Mather declared the purchase of Mr. Redfield's *February* as marking the end of the probationary period of the American landscape and the beginning of France's acceptance of American themes:

> It seems to me that the time has come when we too shall contribute from our landscape something specific and valuable to the world, and this implies for ourselves a more keen and affectionate enjoyment of a land that has received the classic consecration of art.[75]

It was not just Redfield's depiction of a Pennsylvania towpath that Mather viewed as emphatically American, it was his "crisp, direct naturalism" "saved from banality by thoughtful selection and elimination" that perfectly captured "the quality of a youthful art."[76]

The following year critic Nilsen Laurvik dubbed Redfield "the standard bearer" for the progressive painters "who are glorifying American landscape painting with a veracity and force that is astonishing the eyes of the Old World." He characterized Redfield's vigorous and intensely local work as strongly reflecting the "times in which we live."[77] A supporter of artists who were freeing themselves from foreign traditions to achieve a national expression that was a full and free expression of their own personality, Laurvik viewed Redfield as a rejuvenating force in American culture. Disturbed by the formulaic results of dreamy painters who viewed nature through a temperament, he praised Redfield's strong work ethic, disciplined methods, and clear vision:

> His color is fresh, alive and truthful, laid on with a crisp, trenchant touch that bespeaks a robust, masculine vigor. In his manner and method of painting his work is a reflection of the methods of the impressionists which he has adapted to his own uses. And while his art is intensely local in its subject matter his manner of treatment is thoroughly advanced and modern, expressed with an almost amazing virtuosity—which is, however, the final result of long, persistent effort to acquire a complete control of his medium. He … works almost exclusively out of doors, in the presence of his subject, and he usually completes a canvas at one sitting. His unremitting industry, coupled with an unusual capacity for work during the winter months, is productive of a number of canvases that are certain to enliven and lend interest to all the annual exhibitions, which are not complete without a Redfield.[78]

In 1909 Redfield was given a show at the Pennsylvania Academy, where he exhibited forty-six paintings. In his review of the exhibition for the Philadelphia *Public Ledger*, Reginald Cleveland Coxe described the work as evidencing "earnest study, vigorous and a rather original handling,"

as well as "an exquisitely delicate sense of color and composition." He pointed to several paintings possessing a fine sense of atmosphere but noted the lack of life in the work:

> There must be life in a landscape, shown by figures, or the movement of the wind must be felt in the trees or clouds; something alive….

> One can find the light and color of the impressionists, but none of their mannerisms. He has yet to feel the life in nature, the winds and clouds, the moods that make her so fascinating….[79]

Redfield resigned from the National Academy of Design in 1909, purportedly because two letters insufficiently addressed to him were returned to the academy undelivered. Newspaper accounts of Redfield's resignation suggested that Redfield was also troubled by the academy's conservative values. One account quoted the artist as remarking a few days before his resignation that the limitations forced upon artists by the rules of the academy hindered the development of individual expression.[80] As the first member to resign from the academy, Redfield's action created quite a stir:

> The fact that Mr. Redfield, who is considered by many European and American authorities to be the foremost landscape painter in the United States, is one of the select few who hold the position of Academician, makes the matter the more sensational from the viewpoint of those in artistic circles.[81]

Broadening the Range

Beginning that same year, Redfield spent several months in New York City, where he painted such large, moody, atmospheric cityscapes at twilight as *Lower New York* (cat. 31) and *Brooklyn Bridge at Night* (cat. 30). Redfield's friend George Trask[82] revealed that upon hearing about the painting of the Brooklyn Bridge at Schaus Gallery, Trask visited and found the painting to be a "wonder."[83] These spectacular twilight scenes embody the magic critic Mariana Griswold van Rensselaer associated with nocturnal views of New York in her 1892 article in *Century* magazine:

> The abrupt, extraordinary contrasts of its sky-line are … subdued to a gigantic mystery, its myriad, many-colored lights spangle like those of some supernally large casino; and from the east or south we see one element of rare and solemn beauty—the sweep of the great bridge, defined by starry sparks, as though a bit of the arch of heaven had descended to brood over the surface of the waves.[84]

Although Redfield portrays Brooklyn in *Brooklyn Bridge at Night* as an inviting, peaceful environment, he also fills the scene with references to its bustling activity as boats stream along the river, headlights of cars imply movement across the bridge, and lights in the buildings suggest a vibrant environment. What might have been portrayed by other artists as a seedy environment becomes for Redfield a romantic, dynamic scene as lines and shapes are softened under the glow of diminishing light. The scene's enticing quality contrasts with some of the more harsh views of city life painted contemporaneously by members of The Eight, a group of progressive American painters led unofficially by Robert Henri, who rejected the genteel style and subject matter promoted by the National Academy of Design.

Redfield continued to broaden the range of his subject matter. As early as 1911 he was creating works that portrayed the seasonal experience of spring with a richness and variety that could not be found in his earlier spring pictures. Critic Helen Henderson described his "recent spring pictures" as exhibiting a new depth and tender atmosphere:

> They are full of subtleties of colour, of intricacies of method, very different from the old direct way and vastly richer in imagination. His later pictures have a depth, a profundity, which carries the mind beyond the surface of the canvas, deep into the atmosphere of the picture.[85]

Cherry Blossoms (ca. 1912; cat. 32), an award-winning entry in the Carnegie International Exhibition in 1913, captures the delicate color haze, warm sunlight, moist atmosphere, and hint of lingering cold that are part of an

early spring day. Redfield would continue to experiment with portraying the various atmospheric aspects and climatic effects of the spring season, and by the late teens and twenties his spring pictures rivaled his winter scenes as scintillating seasonal pictures with extraordinary depth and atmosphere.

In 1915 Redfield was given his own room to display his canvases at the Panama-Pacific International Exposition in San Francisco (an honor shared with such other living artists as William Merritt Chase, John Singer Sargent, Frank Duveneck, J. Alden Weir, Edmund Tarbell, and Childe Hassam). In his critical review of the Redfield Gallery, Eugen Neuhaus singled out Redfield's simple and direct style, describing the artist as "the painter par excellence" as a realistic painter of the outdoors:

> The joy of putting paint on canvas to suggest a relatively small number of things which make up the great outdoor country, like skies, distance, and foregrounds, is his chosen task. He is the most direct painter we have. With a heavily loaded brush, without any regard for anything but immediate effect, he expresses his landscapes candidly and convincingly. He is plain-spoken, truthful, free from any trickery—as wholesome as his subjects. His *a la prima* methods embody, to the professional man, the highest principle of technical perfection, without falling into a certain physical coarseness so much in evidence in most of our modern work.... the impression one gains from his works is that they are honest transcriptions of nature by a strong, virile personality.[86]

In a letter to Redfield in April 1916, painter Birge Harrison complimented the artist for his remarkable development of poetic vision:

> I simply cannot resist the impulse to congratulate you on your work. You are growing!... Your technique of course has always been of the first order, but in the group which you showed us yesterday there was a remarkable development of the poetic vision, a wonderful brooding sense of beauty which made me forget the marvelous technique without which it would have been impossible.[87]

Following his showing at the Panama-Pacific Exposition, an article in *Arts and Decoration* magazine described how Redfield's work had become a prime source for copying and forgery:

> Mr. Edward W. Redfield is the original Redfield, the instigator, the incentive of official American landscape painting, the object of which the majority of landscape painting, mirrorwise, is the reflection. He is the original Redfield—the other Redfield's [sic] bear different signatures—and inspecting them carefully one may unearth these signatures and know surely that they are not from the hand of the original Redfield. The original is physically short of six feet in height. But the symbol of him, reached perhaps by politics, rises four feet or more, more or enough to tower above the statesmen of the politicians of our art, and from the pinnacle thus made, to domineer over all official situations. This may be why Mr. Redfield has won all the prizes—it cannot be that any have escaped his efficient scrutiny—offered regularly at the regular exhibitions. He has been the recipient of a considerable amount of praise, at the same time that whispered suspicions and no end of scandal, art scandal be it understood, have hovered about him as persistently as atmosphere....
>
> Everyone knows Mr. Redfield, the artist, as a painter of unusual placidity—the first American to delineate landscape with a No. 12 brush—a broad painter, sometimes described as a rugged one. His pictures and the influence of his pictures are to be encountered everywhere, where landscapes are to be seen.[88]

In 1929 Redfield was given the opportunity to exhibit forty paintings in a solo exhibition at the

Fig. 33 pp. 35, 36 Photographs of Edward W. Redfield's solo exhibition at the Art Club of Philadelphia, December 5–25, 1929. W. Coulbourn Brown, Philadelphia, photographer. Courtesy of Mr. and Mrs. Edward W. Redfield II.

Art Club of Philadelphia, an exhibition that in 1930 moved from Philadelphia to the Grand Central Art Galleries in New York. Charles Wheeler's article in the *American Magazine of Art* described how Redfield managed the installation in the Art Club's limited space:

> At the Philadelphia Art Club the hanging and arrangement were excellent; each picture was framed differently and appropriately; the whole group was brought together in a unified, decorative scheme.
>
> Here the dimensions of the single exhibition room were so limited that the wall spaces presented one long surface opposite the entrance doors, a shorter surface at each end of the room and two still smaller areas at either side of the doors. In this case the artist arranged his pictures in groups of center-pieces important in size flanked by double rows of smaller pieces in such a manner that a variety of effect of color spots and of darker and lighter mass spots made harmonious units without disturbing the grand balance of the whole wall or the room itself.[89]

Helen Henderson's review of the New York show described the artist's long successful career and hinted that he may have reached his prime in past years:

> He has enjoyed all the honors in many parts of the world. He is represented in all the local museums as well as the Luxembourg of Paris. His pictures have been extensively bought by private collectors. His career is one of uninterrupted success. We have spoken for years of his prodigious energy, the amazing vitality of his canvases, their truth to nature. Sometimes in the past he seemed to search more deeply into the mysteries of the subject to seek to grasp more of the intellectual content of art and from time to time has produced such a canvas as "The Grey Veil" (not here shown), which was an immense advance over the usual output and showed the artist on the heights, still climbing, still seeking to see further and know more.[90]

It is interesting to consider how a man who was something of a solitary figure gained such notoriety and support from his public. With the exception of the summer of 1902, when Redfield offered sketching and landscape classes at Center Bridge, he never accepted art students.[91] As F. Newlin Price, director of Ferargil Galleries in New York, noted, Redfield had no "love for the heart of the town, the pageantry of the city streets, the receptions and teas, and social whirl."[92] Redfield himself stated that he didn't have time "to work the social game" since he was too preoccupied trying to "learn something from nature."[93]

On the occasion of a dinner held for Redfield by the Art Club of Philadelphia, it was noted by the press that "the man in whose honor fifty diners had sat down, made the briefest speech of all … consisting merely of the heartfelt words, 'I thank you for this occasion.'"[94] In a letter to C. Powell Minnigerode, director of the Corcoran Gallery of Art, Redfield described why he would not attend an evening affair at the Pennsylvania Academy:

Fig. 34 Edward W. Redfield painting outdoors, n.d. Courtesy of Collection of Mr. and Mrs. Edward W. Redfield II.

I shall expect you up for the Academy Show and here, either before or after that affair. I will not do the evening stunt though I would be willing to await you at the club. I confess I'm not overly brilliant but most times I can forget it, it's only at these functions that the appalling truth reaches out, grasps my hands, ties my feet and salutes me as the champion all around idiot—so I'm off—for life![95]

Redfield noted that he received very little publicity through the New York press since he would not pose for photos with his paintings and offered them little "except a normal life and paintings that are too readily understood by the ordinary observer: no puzzle pictures and no bananas."[96] He described how the artist seeking publicity often became trapped in a meaningless game:

Fame to many means great publicity and those that seek it write appreciative letters to critics give them sketches or paintings and think more about themselves than their work—too often it results in self love, that blinds them to their faults and frank friends, who dare to break in on their great self appreciation are no longer welcome in their studios. So that the gatherings finally become mutual admiration societies, producing nothing worth while but, too often teach others that art is easy, just paint—it all seems to and is the student imitating the teacher and a clique is created that with art jargon and a constant reminder of the Armory show that to them makes them masters of Befuddledom![97]

All in a Day's Work

[Redfield] is in truth, just what he seems to be, direct, keen, a fine companion and thorough workman, a man of the hills and the mountain streams.

—F. Newlin Price, 1922[98]

Redfield's phenomenal popularity from 1900 until 1920 cannot be fully understood without considering how his life and work were viewed as embodying essential characteristics of a national spirit that accounted for the progress of America. His strong work ethic, persona as a common man of the soil battling nature, simple subject matter, swift and direct method of painting, and ability to produce images providing authentic, intense experiences for his viewers were in fact a potent combination of qualities held in high regard by the American art-loving public. Even after 1912 when his snow scenes were no longer viewed as progressive in such prestigious exhibitions as the Corcoran Biennials, his vigorous paintings and strong work ethic connected with the ideals of many Americans, who viewed both the man and his art as embodying a regenerative force.

In 1925 Redfield's biographer, Charles Wheeler, described the artist's careful study of his subject and his swift, rigorous working method in heroic terms:

His preparation for a painting … consists … of a careful study of the setting of his scene and the selection of the time-of-day lighting to be reproduced. Preferably this preliminary work takes place during the day before his actual effort to paint; starting early in the morning at the hour the easel will be placed, say soon after 8 o'clock. He eats no luncheon and works steadily seven or eight hours. Gradually he has been able, in this

manner, to use larger and larger canvases producing his best, most convincing pictures upon a surface fifty-six inches wide and fifty inches high. This is a remarkable achievement from a purely physical view, to be able to cover twenty square feet of surface with paint applied in short brushstrokes. Aside from the quality of the work it is doubtful if there is another living man who can equal this speed of application.[99]

As Redfield himself noted, making a painting in "one go" was demanding work:

> All those big canvases 50–56's[100] were made outside in about seven hours. And of course a great many were made in cold weather, and your paint becomes hard in the tubes. You have to reduce with a great deal of oil in order to make it soft enough to manipulate. It's quite a job to cover a canvas that size with small brushes. And mix the many mixes that you make. And you are drawing the same time that you are painting.[101]

After he retired from painting, Redfield reminisced about painting less than a mile from his home before he acquired a car in 1912:

> You see when I started … we didn't have automobiles. And my equipment weighed about fifty pounds. And if you work in winter, we used to wear these heavy knitted stockings over felt boots, Russian. And then with the gum on top of that. And you had heavy underclothes. In those days corduroy pants probably, and then a shirt and a sweater, and coat. And on top of that a sheepskin coat, lined you know. And then you had what they called pulse warmers. Made specially with the fingers cut out. So that it covers all that section of the wrist. That is the worst section to have exposed when you are painting, cause it thins your blood and chills you all over. You keep that warm. And on the palette hand I'd have a heavy glove.

> And those big canvases the 50–56s they'd have a cross bar in them. And I'd put them on the head. And if there is no wind blowing I'd work without holding them. If it's windy you'd have to hold them with one hand. The box slung over the shoulder with the easel. And then you are going through snow. You are working the road. And so your mile was about as far as you'd want to travel. And do a day's work afterwards. Most of the work was made within a half mile to three-quarters. And loaded in that way you had to go very slowly. And the object being not to get too heated up…. So that when you start work you are comfortable, but not overheated.[102]

Near the end of his life, Redfield stated that his love of nature had been the prime force shaping his life.[103] Fascinated by the evanescent nature of experience, he sought to capture the effects of sunlight and atmosphere that revealed the unique essence of a scene as it emerged from single moments and aspects of phenomena. In a review of an exhibition of his paintings held in 1914 at the Memorial Art Gallery in Rochester, New York, Redfield's keen eye and rigorous technique were noted:

> Most sensitively alert to the ever-changing phases of his subjects, his keen eye records the differences with unerring fidelity—here, deftly suggesting the soggy, wet, melting snow—there, the dry, powdery surface as it appears in zero weather—again, he successfully gives the effect of a heavy snowfall with thick, gray atmosphere threatening still another storm, while often he pictures the bright, crisp scintillating effect of sunlight as it flits across the snow-covered fields…. When he has selected a subject for presentation he studies it most analytically and carefully observes under which atmospheric conditions it appears to best advantage, often going a dozen times to the spot before it seems ripe to him.[104]

Understanding that reality is rooted in man's senses and that nature is a composite of shifting visions, Redfield concluded that nature needed to be adjusted at times:

> If you think nature can be copied, just try it. For one thing you'll find the light and shadows change completely in the five to seven hours it takes to make a painting. To paint a scene correctly, it may be necessary to shift a tree or leave a tree out, something the camera can't do.[105]

Discussing the creation of one of his paintings of the Carversville mill painted from atop the quarry, Redfield noted:

> I enlarged that bridge there so it was more prominent in the thing, and then I extended the road around that path where the building is. There is a road there. And in that I had a couple of children with a sled and a Christmas tree. Sort of holiday spirit thing you know.[106]

In describing his working method, the artist emphatically stated that it was not his objective to copy what was before him:

> I always liked nature. I was satisfied to get something that resembled it. Now that doesn't mean photographic accuracy by any means, because that leaves nothing to the imagination at all. It's a statement. And that's all there is to it.[107]

He also explained the important role that memory played while composing his works:

> I never sat down, I'd just walk back and forth. Big canvas you can't see around it when you are painting. So you carry what you see back and forth and paint. And it's not like painting a still life of an apple or something that you can see and just copy. You have to learn the subject so that you carry your mind from one point to another.[108]

In creating his landscapes, Redfield experimented with such devices as enlarged foregrounds, close-up views, and montaged foregrounds and backgrounds that emphatically suggested his unique vantage point, his close observation of the scene, and his desire to enhance the immediacy of the scene.

Breaking of Winter (1914; fig. 36), a high-keyed outdoor scene, portrays the thawing season when snow clings to the damp ground and the warmth of the sun releases winter's hold on the landscape. Spindly trees, set close to the viewer, are wind bent, and their crisp leaves appear to flutter. Formally and symbolically this work is about the artist's intimate encounter with life forms that survive the challenges of winter.

In *Woods and Stream in Winter, Upper Delaware* (1916; cat. 35), swift strokes of paint depicting the scraggly branches of trees and vegetation create a vibrant surface pattern while an enlarged foreground enhances the immediacy of the scene. *The Trout Brook* (ca. 1916; cat. 36) is another winter scene with an activated surface pattern that draws attention away from the facts of the scene. As the brook tumbles over stones in its path, the water and forest vegetation gleam from the bright sun that etches blue shadows on the snow. Winter is infused with a sense of life that suggests the fleeting effects of natural phenomena.

During the late teens and early twenties Redfield produced a series of works depicting close-up views of winter brooks and streams that approach abstraction. *Winter Wonderland* (ca. 1917; cat. 37) is one such work, with an all-over surface pattern that prompts the viewer to lose sight of the specific facts of the scene.[109]

The Redfields moved to Pittsburgh in 1919 where they lived while their son Laurent attended Carnegie Technical School and Redfield served as a juror for the Carnegie International Exhibition.

Fig. 35 "I expect to pull out for Maine in a few days as blossoms are about over here and I want to follow them north." Excerpt from Redfield letter to John Suster, May 7, 1927. Courtesy of Collection of Dorothy Hayman Redfield.

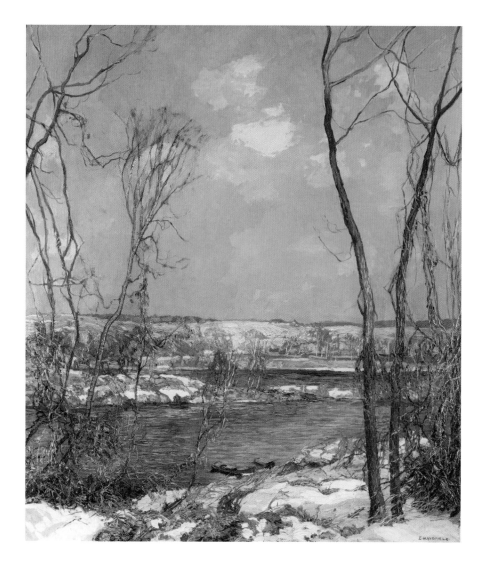

Shortly after serving on the jury, Redfield described how the climate in Pittsburgh was very difficult for painting:

> The moisture in the air and the general smoky conditions are discouraging for oil.... I have been able to produce a few landscape paintings even in the vicinity of Pittsburgh that have been praised rather highly. But on the whole it is rather difficult to mix the paints properly. It seems strange that this peculiar climate should be chosen for the exhibition of something seldom produced here.[110]

During his stay in Pittsburgh Redfield painted *Overlooking Soho, Pittsburgh* (ca. 1918; cat. 39). The industrial haze enveloping the atmosphere of this town suggests the adverse impact of rolling mills in the Soho district. He painted a number of works with such social commentary while in Pittsburgh but never developed the theme after he returned to Center Bridge.

Redfield continued painting large winter landscapes through the twenties and thirties. In *Late Afternoon* (ca. 1925–30; cat. 41), he depicts an expansive scene overlooking the Delaware River from atop Mike Mullen's Hill at the end of day when the landscape's colors and forms shift as long blue shadows stretch across the landscape and the setting sun casts an orange hue on select surfaces.

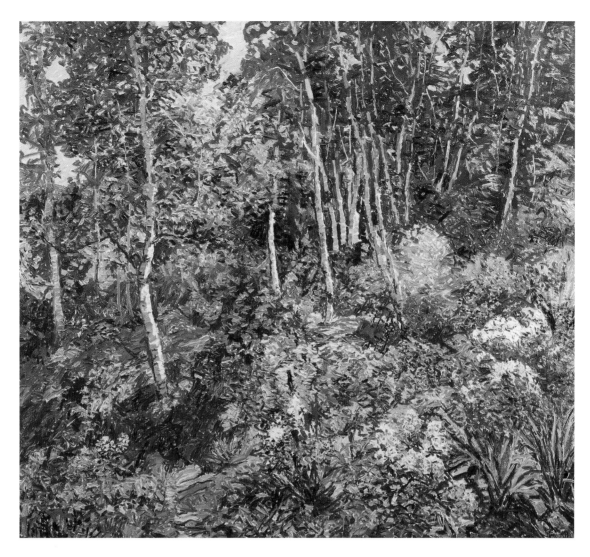

Fig. 37 Edward W. Redfield, SPRING, 1932, oil on canvas, 50 × 56 inches. Private collection.

Redfield's portrayal of the glassy stillness of water in his imposing scene of *The Mill in Winter* (1922; cat. 42) reveals a fascination with how the phenomenal appearances of nature take shape by virtue of their relations to the shapes and colors of their surroundings.

In *The Upper Delaware* (cat. 43), painted circa 1918, Redfield portrays a mighty force that he loved and respected throughout his life. He was drawn to the beauty and spirit of the Delaware River, and he underscores these qualities in his depiction of the slowly drifting chunks of ice that the river carries as it curves through the landscape and disappears into the distant landscape.

Some of Redfield's most popular works during the 1920s and '30s were winter scenes such as *Washington's Birthday* (ca. 1938; cat. 44), *Sleigh Ride to the Grist Mill* (n.d.; cat. 45), and *Fleecydale Road* (n.d.; cat. 46), which contain intimate touches of village life.

In 1923 a fire destroyed the bridge connecting Center Bridge, Pennsylvania, with Stockton, New Jersey. The fire started when lightning struck the bridge during a violent storm. Redfield stood with Bucks County artist William L. Lathrop and watched the spectacle. As the bridge burned, Lathrop remarked to Redfield that it would make a dramatic picture. Although Redfield made notes on an envelope during the fire, [111] he departed from his practice of capturing a landscape *en plein air* and waited to paint the scene in his studio. The following two days he produced two dramatic paintings

of the fire. The larger canvas, *The Burning of Center Bridge* (cat. 48), depicts spectators helplessly watching the bridge burn as plumes of smoke fill the sky and the foliage of the surrounding trees gleams and flutters.

In an interview with Robert Lippincott, Redfield admitted that he began spending less time painting winter scenes as he got older due to the demanding nature of painting in the harsh weather.[112] During the teens and twenties he produced such landscapes as *October* (n.d.; cat. 49) and *October Breeze* (1927; cat. 51), where he experimented with depicting the play of color and fresh atmosphere of the autumnal season.

Although Redfield was experimenting with the effects of spring as early as 1911, he began to give more special attention to the variety of effects produced by this season in the late teens. *Early Spring* (1920; cat. 54) suggests the slight chill in the atmosphere and moisture in the land that herald the delicate color haze of a landscape emerging from winter. In placing a line of large trees in the foreground over the middle and distant views of the landscape, the artist focuses attention on the surface rather than the distance, and the scene's shifting patterns of color and shape are accentuated. The strong value contrasts and gleaming surfaces of *Dr. Bell's House* (ca. 1920; cat. 55) depict springtime as an arena of motion and change. In *Spring Veil* (ca. 1928; cat. 56), a vibrant blossoming tree is set against budding vegetation, subtle tones of lavender scattered throughout the landscape, the distant river, and blue sky. The blooming tree becomes, in effect, a veil, transforming the visual particulars of the scene beyond into a picture suggestive of the vital forces coursing through nature, infusing disparate elements of the image with a spirit of resurgent life. In his 1932 work *Spring* (fig. 37), Redfield covers the canvas with spontaneous dabs of paint that produce a sense of vibrating forms diffusing into patterns of color. The overall surface movement/pattern is counterbalanced by the vertical tree trunks scattered across the middle ground and background.

Edward W. Redfield was an avid gardener. In 1941 he was awarded first prize by the Bucks County Council for Preservation of Natural Beauty in their canal garden contest. His desire to preserve the natural beauty of the country landscape had earlier compelled him to purchase a plot of land in Point Pleasant when he heard that it was to be subdivided and built with bungalows.[113]

The natural aesthetic guiding Redfield's gardening and landscape painting is reflected in his circa 1933 painting *Wisteria* (cat. 57). In this scene, which captures the harmonious relation between the

Redfield home and grounds, Redfield's wife, Elise, looks out on the lush flowering bushes as she sits under the wisteria, surrounded by plantings and shadowy foliage. The aesthetic behind the design of such a landscape could be found in many contemporary journals that were filled with articles advising homeowners to keep a sharp eye on nature when designing their grounds:

> Observe the pathways in nature,—the brooks, the lake shores, the margins of the forest, the edge of the swamp.... Note the gentle curves and variety in planting. Consider what would be the effect if all the curves were to be straightened and all the informalities taken out. Then consider whether you may not have derived a lesson for your own place, in holding to the free and graceful spirit of the wild.[114]

When C. Valentine Kirby visited Redfield's home in 1947 he described the house as belonging to "mother nature in its setting of grand old trees, shrubbery and garden tract."[115] The house he described, the last Center Bridge home, purchased by the Redfields in 1931, was the subject of several Redfield paintings. In both winter and spring scenes of the home, Redfield captured a sense of how vegetation in the landscape blended with the home, making it appear to have a harmonious relationship with its landscape environment (cats. 58, 59).

When not painting, Redfield produced Windsor furniture in his studio, obtaining many of his design ideas from illustrations in the books of Wallace Nutting.[116] According to one critic, Redfield turned "the legs of a Windsor seat with as much facility as he can turn a wave in a marine."[117] The artist's interest in making things also extended to hooked rugs (cats. 60, 61), tole trays (cats. 62, 63), boxes (cats. 64, 65), and painted chests (cat. 66 and fig. 43), some of which were included in exhibitions of his paintings as early as 1929. Dorothy Hayman recalled how her father-in-law went to extraordinary measures to obtain the precise colored material that he wanted for his rugs:

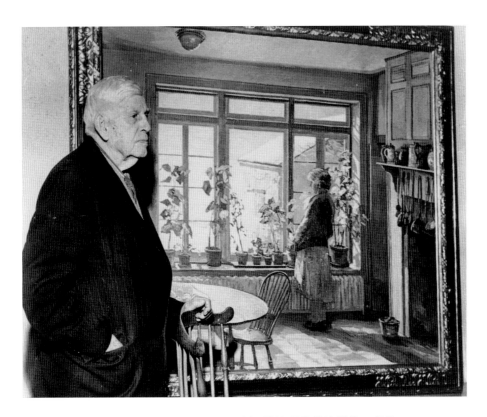

Fig. 39 Edward W. Redfield standing beside his painting SOUTH WINDOW (1941), ca. 1960.
Courtesy of Mr. and Mrs. Edward W. Redfield.

> He frequently would dye the material to get the color he wanted. If you went to see him in an outfit of the color he needed in a rug, you might have to go home in a barrel. Once his daughter-in-law Martha Coombs saw him with the sleeve out of a beautiful and expensive jacket she had given him. She asked what had happened and he said "oh, I needed the color for a rug.[118]

Just as in his landscape painting, Redfield fashioned his rugs and furniture and even restored his home from the material of things around him. Using weathered timber from the Delaware River and clothing snatched from his family, his creations reflected the direct connection he made with the life around him. His pragmatic and self-reliant character fit comfortably within the craft ideal that provided Americans in the early twentieth century with a sense of autonomy and individual identity in a rapidly developing modern commercial society.

Redfield's genius resides in his ability to direct the minds of his viewers to a realization of how the forces shaping nature also shape people's lives. In depicting his immediate experience of a certain place, on a certain day, at a certain hour, his paintings suggest how man's experiences of nature and the artist's images of nature function both as a source and as a product of feelings and moods.

Judging by the response of several students to works displayed in an exhibition of Redfield's paintings in Doylestown in 1951, Redfield's work powerfully connected with young people. Seventh-grader Sally Gott wrote:

> My favorite picture was "Sunlight and Shadows." I think it shows one of the plain and beautiful works of nature. It seems so real and true to life that when I first looked at it, I almost thought I could walk right into it. Another thing I liked about it was the deep blue of the winter sky. For some reason when I look, at it, it makes me feel much nearer to the good things in life.[119]

Ninth-grader Don Reese also liked *Sunlight and Shadows* (n.d.; cat. 67) because it made him feel "as if I were actually inside the painting, like the peace and stillness of the untracked snow. It gives me the awed feeling that I get when standing in a snowbound forest of being completely alone and away from the outside world."[120]

Fig. 41 Edward W. Redfield seated in his studio, surrounded by furniture and paintings that he created, ca. 1950. Studio window in his Center Bridge, Pennsylvania, home with view of Center Bridge over the Delaware River. Courtesy of Mr. and Mrs. Edward W. Redfield II.

Redfield was acutely aware of how a viewer's attraction for a particular sight might be grounded in old memories revived by a scene. He noted that Bucks County was full of subjects that people found intensely interesting:

> I don't know of a better place for anybody to come to.... Lots of people have found it intensely interesting.... They had these old mills, these old stone mills with their brooks. I preferred them of course with snow on, because of the contrast. Give you a chance to sleigh and get some color in and all that sort of thing. Whether it was there or not you would put them in.[121]

As a close observer of nature, Redfield learned to disclose the unique essence of a scene as it emerged from single moments and combined aspects of phenomena. He judged his art as successful to the extent that it provided an authentic intense experience for its viewers and revealed at a glance what it was meant to be. When Elise Redfield died in 1947, Edward burned a huge inventory of his paintings that he judged substandard. In 1948 he painted *Linekin Bay* (fig. 40), the last landscape he would paint directly from nature.[122] As his eyesight failed and he realized that he could no longer keep up with the demanding conditions of painting direct from nature he decided to give up painting:[123]

> I was outside one day. My insteps were burning. It was very windy, and I had trouble keeping my easel up. So I quit. The main reason, though, was that I realized that I wasn't as good as I had been, and I didn't want to be putting my name on an "old man's stuff" just to keep going.[124]

He quipped about how his intense interest in nature continued even after he no longer painted:

> Almost everything in nature is of interest to me. I sit here and look out the window. I never get lonesome. To me it's a continuous show. The effect of light, and of course that's what makes everything.... I very often arrange the things still ... as if I was painting. Just the same thing except that I don't paint. I don't want to paint a lot of stuff that is not up to snuff. You have to meet a certain standard or else you wouldn't send it out. Of course, I did burn I guess about seven hundred canvases.[125]

Redfield died at the age of ninety-six on October 19, 1965.

NOTES:
Redfield's Art and Life

1. Edward W. Redfield, audiotaped interview by Robert H. Lippincott for the *Bucks County Realtor Magazine*, March 4, 1963. Private collection. J. M. W. Fletcher has published a transcription of most of this interview in *Edward Willis Redfield: An American Impressionist, 1869–1965: The Redfield Letters, Seven Decades of Correspondence*, vol. 2 (Lahaska, Pa.: JMWF Publishing, 2002), 469–81.

2. Martha Candler Cheney, "The Making of an Artist: Some Recollections of Edward W. Redfield, N.A.," *Bucks County Traveler* (May 1953): 22; Edward W. Redfield, "What America Means to Me," typescript, private collection, 1.

3. Redfield, "What America Means to Me," 1.

4. "$500 For a Painting by This Neighbor—Edward Willis Redfield Was the First Artist to Discover the Valley—Yet He's Neighborly," *Delaware Valley News*, Milford and Frenchtown, N.J., April 27, 1934.

5. F. Newlin Price, "Redfield, Painter of Days," *International Studio* 75, no. 303 (August 1922): 402.

6. There was a growing interest in the closing years of the nineteenth century in the beneficial effects of turnverein (gymnast clubs), games, and manual work as promoting the free expression of natural impulses and senses and as beneficial in warding off the harmful effects of modern sedentary life. The aim of the turnverein movement was to promote healthy minds in healthy bodies.

7. Henry C. Pitz, "Edward Redfield: Painter of a Place and Time," *American Artist* (April 1959): 32.

8. Ibid., 32.

9. Walt Whitman, "Colors—A Contrast," *Specimen Days* from *Specimen Days and Collect* (1883, repr. Mineola, N.Y.: Dover Publications, 1995), 93.

10. Whitman, "The Common Earth, The Soil," *Specimen Days* from *Specimen Days and Collect*, 100.

11. Whitman, "The Great Unrest of Which We Are Part," *Specimen Days* from *Specimen Days and Collect*, 196.

12. In a telephone conversation with this author, on December 12, 2003, Robert Stephens confirmed Redfield's awareness of Whitman while living in Camden. In his monograph *Edward Willis Redfield, 1869–1965: An American Impressionist, His Paintings and the Man behind the Palette* (Lahaska, Pa.: JMWF Publishing, 1996), J. M. W. Fletcher cites Redfield's remembrance of Whitman to his grandson (p. 51).

13. Pennsylvania Academy of the Fine Arts student records indicate these dates. Redfield stated that he studied at the academy for a period of five to six years and that he began studying there at the age of fifteen (audiotaped interview with Robert H. Lippincott; Redfield quoted in Dorothy Grafly, "Redfield: Subject of One Man Show at the Art Club: Subtle Studies of Snow, Vigor in Nature," *(Philadelphia) Public Ledger*, December 8, 1929.

14. Charles V. Wheeler, *Redfield* (Washington, D.C., 1925), n.p.

15. Dorothy Grafly, "Redfield: Subject of One Man Show at the Art Club...."

16. Willliam Charles Brownell, "The Art Schools of Philadelphia," *Scribner's Monthly* 18 (September 1879), cited in *Art in Theory, 1815–1900*, ed. Charles Harrison and Paul Wood with Jason Gaiger (London: Blackwell Publishers, 1998), 648–49.

17. Fairman Rogers, "The Schools of the Pennsylvania Academy of the Fine Arts," *Penn Monthly* 12 (June 1881): 455.

18. Thomas Eakins quoted in Charles Bregler, "Thomas Eakins as a Teacher," Part 1, *The Arts* 17, no. 6 (March 1931): 385.

19. Ibid., 383.

20. Nineteenth-century British philosopher Herbert Spencer (1820–1903) applied the theory of evolution to philosophy. His *Principles of Psychology*, published in 1855, treated the mind as a function of an evolved organism, molded by external forces of the physical environment: through a process of tentative and experimental adjustment, an individual's response to his environment became woven into human thought and habitual action if it proved useful for

thought and experience. Spencer advised the artist to discover the rules by which natural effects are produced. He urged the artist to construct his image of a person or scene from a series of experiences that suggest its natural rhythms and essential condition of being.

21. Eakins to Benjamin Eakins, March 6, 1868, quoted in *Art in Theory, 1815–1900*, ed. Charles Harrison and Paul Wood with Jason Gaiger, 420–21.

22. Thomas Anshutz quoted in "American Portrait Painters of Today—Thomas Anshutz," *Vogue* (June 17, 1909), in Sandra Denny, "Thomas Anshutz: His Life, Art and Teachings" (master's thesis, University of Delaware, 1969), 20.

23. Redfield, "What America Means to Me," 2.

24. Redfield quoted in "Center Bridge Artist Found Fame in Solving Problems," *Trenton (N.J.) Evening Times*, November 16, 1948.

25. Pitz, "Edward Redfield: Painter of a Place and Time," 29.

26. *An Exhibition of Paintings by Edward W. Redfield and a Collection of Works by European Masters* (Rochester, N.Y.: Memorial Art Gallery, 1914), n.p. An exhibition catalogue published in conjunction with An Exhibition of Paintings by Edward W. Redfield and a Collection of Works by European Masters held at the Memorial Art Gallery, Rochester, May 9–June 7, 1914.

27. Redfield, interview, March 4, 1963.

28. Quoted in C. F. A. Ward, "Artists in the County, Edward Redfield," *Bucks County Traveler* (June 1955): 21.

29. Redfield, interview, March 4, 1963.

30. "Folks Worth Knowing in the Delaware Valley," *Lambertville (N.J.) Record*, October 24, 1929.

31. Edward Willis Redfield journal, 1889, n.p. Private collection.

32. Redfield's descriptions of the sea and his later pictorial descriptions of nature are similar to those found in nature writer and art critic John C. Van Dyke's *Nature for Its Own Sake: First Studies in Natural Appearances* (New York: Charles Scribner's Sons, 1898). In the section "The Open Sea," Van Dyke marvels that there is "not an hour when the wind does not shift the form of the waves, not an hour when the light and color of the water are not changing, not an hour from dawn to dawn when the uneasy, faceted surface is not throwing back reflections of the sky in a thousand variegated hues" (113).

33. Redfield journal, 1889, n.p.

34. Ibid.

35. As Thomas C. Folk has noted in *The Pennsylvania Impressionists* (Madison, N.J.: Fairleigh Dickinson University Press; London: Associated University Presses, 1997, p. 42), under these painters' tutelage, Redfield would have been studying the model for some eight hours rather than the three required at the Pennsylvania Academy.

36. Redfield quoted in Wheeler, *Redfield*, n.p.

37. Ibid., n.p.

38. Thomas Folk, *Edward Redfield: First Master of the Twentieth Century Landscape* (Allentown, Pa.: Allentown Art Museum, 1987), 26. An exhibition catalogue published in conjunction with Edward Redfield: First Master of the Twentieth Century Landscape, Allentown Art Museum in Allentown, Pa.

39. Ibid., 27; Peter Hastings Falk, ed., *The Annual Exhibition Record of the Pennsylvania Academy of the Fine Arts*, vol. 2 (Madison, Conn.: Sound View Press, 1989), 398. Letter from Elise D. Lincoln to J. D. Woodward, February 29, 1892, mentions Lincoln's purchase of #199 in the catalogue, cited in J. M. W. Fletcher, *The Redfield Letters*, vol. 1, 20. Another letter from John Andrews Meyers (secretary, Pennsylvania Academy of the Fine Arts) to Redfield (February 25, 1915) lists works sold by the Pennsylvania Academy of the Fine Arts from 1892 to 1915. *Road—Forest of Fontainebleau* is listed as sold in 1892 (Fletcher, *The Redfield Letters*, vol. 1, 164).

40. Folk, *Edward Redfield: First Master of the Twentieth Century Landscape*, 27.

41. Redfield to Henri, August 10, 1892, quoted in Folk, *Edward Redfield: First Master of the Twentieth Century Landscape*, 28.

42. The Gist of Drawings: Works on Paper by John Sloan, http://www.tfaoi.com/aa/2aa/2aa315.htm. Excerpt from William B. Scott and Peter M. Rutkoff, *New York Modern: The Arts and the City* (Baltimore: Johns Hopkins University Press, 1999). The Gist of Drawings: Works on Paper by John Sloan was an exhibition held at the Museum of Art, Fort Lauderdale, Fla., October 6–December 3, 2000.

43. J. M. W. Fletcher, *Edward Willis Redfield, 1869–1965*, 6.

44. Redfield quoted in Chris Carr, "Bucks County's Living Legend, Edward Redfield," *Panorama* 5, no. 10 (October 1963): 11.

45. Walter A. Dyer, "Two Who Dared—How a Well Known Artist and his Wife Cut Loose from the City and Started Life Anew in the Country with No Capital—the Building of a Studio Home," *Country Life in America* 13 (December 1907): 195–96.

46. Ibid., 197.

47. Melissa Dabakis in her recent work *Visualizing Labor in American Sculpture: Monuments, Manliness, and the Work Ethic, 1880–1935* (Cambridge: Cambridge University Press, 1999) describes the shifting attitudes toward work that are reflected in American sculpture during the period. Her discussion of Walt Whitman's celebration of the working man and artisanal toil in his *Song of the Exposition* and *Leaves of Grass* is especially relevant here.

48. Dyer, "Two Who Dared," 195–96.

49. "General Biographical Information," application form for reinstatement of membership in the Salmagundi Club, May 12, 1947, private collection.

50. Grafly, "Redfield: Subject of One Man Show at the Art Club…," *(Philadelphia) Public Ledger*, December 8, 1929.

51. B. J. O. Flower, "Edward W. Redfield: An Artist of Winter-Locked Nature," *Arena* 36, no. 1 (July 1906): 22.

52. Ibid., 25.

53. Ibid., 23.

54. In an August 1898 article appearing in the *Atlantic Monthly* entitled "Landscape as a Means of Culture," Harvard professor N. S. Shaler similarly advised individuals that they could develop their sensibility to natural beauty by acquiring a contemplative way of approaching the landscape, a process demanding solitude and a turning away from the spirit of the modern age. Noting that few persons in the late nineteenth century developed this capacity due to the crowding of people in impersonal urban environments, Shaler advised individuals to make themselves thoroughly familiar with a scene, seeing it from the same point of view and under the same conditions of hour and sky, day after day, until its essence emerged and the forces that have brought the scene to its existing form could be felt. In this way, Shaler theorized that landscape painting functioned as a means of culture as it brought individuals closer to their native environment, sharpened their sensibilities, and enhanced their understanding of how the forces shaping nature also shape the events of their own lives (Shaler, "Landscape as a Means of Culture," *Atlantic Monthly* 82 [August 1898]). For an in-depth discussion of turn-of-the-twentieth-century American antimodernism, see T. J. Jackson Lears, *No Place of Grace: Antimodernism and the Transformation of American Culture, 1880–1920*, rev. ed. (1981; repr., Chicago: University of Chicago Press, 1994).

55. Guy Pène du Bois, "The Boston Group of Painters: An Essay on Nationalism in Art," *Arts and Decoration* 5, no. 12 (October 1915): 457, 459.

56. Edward W. Redfield, quoted in Barbara Pollock, "A Visit with Edward W. Redfield," *(Philadelphia) Sunday Bulletin Magazine*, August 4, 1963.

57. Henri to John Sloan, November 4, 1899, quoted in *Revolutionaries of Realism: The Letters of John Sloan and Robert Henri*, ed. Bennard B. Perlman (Princeton, N.J.: Princeton University Press, 1997), 37.

58. Diane P. Fischer, ed., *Paris 1900: The "American School" at the Universal Exposition* (New Brunswick, N.J.: Rutgers University Press, 1999), 202. Published in conjunction with the exhibition Paris 1900: The "American School" at the Universal Exposition shown at the Montclair Art Museum, September 18, 1999–January 16, 2000, Montclair, N.J. The other entry was *The Road to Edge Hill*, n.d., unlocated.

59. For a discussion of tonalism as the preferred form for landscapes in the 1900 Paris Exposition and as an American invention, see Fischer, *Paris 1900*, p. 74.

60. Folk, *Edward Redfield: First Master of the Twentieth Century Landscape*, 32.

61. *Exhibition of Paintings by E. W. Redfield* (Philadelphia: Pennsylvania Academy of the Fine Arts, 1899). Published in conjunction with Exhibition of Paintings by E. W. Redfield (March 22–April 5, 1899), shown at the Pennsylvania Academy of the Fine Arts, Philadelphia.

62. Redfield, interview, March 3, 1963.

63. Wheeler, *Redfield*, n.p.

64. For a more in-depth discussion of the novel effects that can be created by a play of the near and far, see Kirk Varnedoe, *A Fine Disregard: What Makes Modern Art Modern*, rev. ed. (1990; repr., New York: Abrams, 1994), 68–77.

65. Redfield, "What America Means to Me," 4.

66. F. Arline de Haas, "Edward Redfield Qualifies as a Lightning Painter Making Fourteen Canvases in Fifteen Days' Work," *(Philadelphia) Public Ledger*, August 17, 1924.

67. Ibid.

68. Henri to John Sloan, Monhegan Island, September 5, 1903, quoted in Perlman, *Revolutionaries of Realism: The Letters of John Sloan and Robert Henri*, 74.

69. The Temple Gold Medal was awarded to the best painting in the exhibition and was the academy's most prestigious gold medal.

70. The Jennie Sesnan Medal was awarded to the best landscape in the annual exhibition.

71. Kathleen Foster describes the machinery of the American art establishment and how it supported the work of Daniel Garber in *Daniel Garber, 1880–1958* (Philadelphia: Pennsylvania Academy of the Fine Arts, 1980), 26, a catalogue accompanying an exhibition of the work of Daniel Garber at the Pennsylvania Academy, June 27–August 24, 1980.

72. Trask also served as United States commissioner for the International Fine Arts Exposition in Buenos Aires in 1910, as director of fine arts for the Panama-Pacific International Exposition in San Francisco in 1915, and as art director for the Philadelphia Sesquicentennial Exposition when he died in 1926.

73. Henri to Sloan, October 12, 1903, quoted in *Revolutionaries of Realism*, 75.

74. The Detroit Museum of Art became the Detroit Institute of Arts in 1919.

75. Frank Jewett Mather Jr., "The Field of Art: The Luxembourg and American Painting," *Scribner's* 47 (March 1910): 382.

76. Ibid., 381.

77. J. Nilsen Laurvik, "Edward W. Redfield—Landscape Painter," *International Studio* 41, no. 162 (August 1910): xxix, xxxii.

78. Ibid., xxxvi.

79. Reginald Cleveland Coxe, "Exhibition of Redfield's Paintings," *(Philadelphia) Public Ledger*, April 18, 1909.

80. "E. W. Redfield Quits National Academy," *American*, undated newsclipping, Edward Willis Redfield Papers, AAA, microfilm reel 1184.

Fig. 42 Edward W. Redfield painting among flowers at Monhegan, Maine, 1928.
Courtesy of Edward Redfield Richardson.

81. "Mr. Redfield Quit National Academy," *Herald*, unidentified newsclipping, Edward Willis Redfield Papers, AAA, microfilm reel 1184.

82. George F. D. Trask was president of S. F. Hayward and Company in New York City.

83. Trask to Redfield, May 9, 1910, Edward Willis Redfield Papers, AAA, microfilm reel 1182.

84. "Picturesque New York," *Century* 45, no. 23 (December 1892), 16, quoted in "The City: The Urban Scene," H. Barbara Weinberg, Doreen Bolger, David Park Curry, *American Impressionism and Realism: The Painting of Modern Life, 1885 to 1915* (New York: Metropolitan Museum of Art, 1994), 168. Catalogue accompanying an exhibition at the Metropolitan Museum of Art, May 10–July 24, 1994.

85. Helen W. Henderson, *The Pennsylvania Academy of the Fine Arts ...* (Boston: L. C. Page and Company, 1911), 142. Redfield exhibited *The Hemlocks*, *The Gray Veil*, and *Snake Island Pool* in the 1911 annual. Henderson describes the influence of the work of Edward Redfield upon the landscape of the present day as one of the strongest in the movement of contemporary art. While describing his breadth of handling as expressive of the modern tendency, she singled out the lack of charm in his surface depiction of stubborn facts as a weakness yet noted that Redfield's recent springtime pictures showed a departure in subject and an increase in his power of expression.

86. Eugen Neuhaus, *The Galleries of the Exposition: A Critical Review of the Paintings, Statuary, and the Graphic Arts in the Palace of Fine Arts at the Panama-Pacific International Exposition* (San Francisco: Paul Elder and Company, 1915), 65–66.

87. Birge Harrison to Edward Redfield, April 2, 1916, Edward Willis Redfield Papers, AAA, microfilm reel 1183.

88. "Who's Who in American Art—E. W. Redfield," *Arts and Decoration* 6, no. 3 (January 1916): 135.

89. Charles V. Wheeler, "Redfield's One-Man Show," *American Magazine of Art* 21, no. 3 (March 1930): 140.

90. Helen W. Henderson, "Redfield in New York," January 11, 1930, unidentified clipping in Edward Willis Redfield Papers, AAA, microfilm reel 1184. This article is a review of Redfield's solo exhibition at Grand Central Art Galleries, New York, January 7–31, 1930.

91. Pitz, "Edward Redfield: Painter of a Place and Time," 84. Ellen Northrup, "Artist in Stained Glass," *The Bucks County Traveler* 8, no. 5 (April 1957): 42, cited in Folk, *Edward Redfield: First Master of the Twentieth Century Landscape*, 34.

92. Price, "Redfield, Painter of Days," 406.

93. Redfield, interview, March 4, 1963.

94. Unidentified newsclipping, Edward Willis Redfield Papers, AAA, microfilm reel 1184, 370.

95. Redfield to C. Powell Minnigerode, January 24, 1922, quoted in Fletcher, *Edward Willis Redfield, 1869–1965*, 15.

96. Publicity manager of Grand Central Art Galleries quoting Redfield in letter to Erwin S. Barrie, December 27, 1929, Edward Willis Redfield Papers, AAA, microfilm reel 1183.

97. Edward W. Redfield journal, 1949. Private collection.

98. Price, "Redfield, Painter of Days," 406–7.

99. Wheeler, *Redfield*, n.p.

100. Redfield's designation of a "50–56" canvas refers to its size: fifty inches high and fifty-six inches wide.

101. Redfield, interview, March 4, 1963.

102. Ibid.

103. Redfield, "What America Means to Me," 1.

104. *An Exhibition of Paintings by Edward W. Redfield* (Rochester, N.Y.: The Memorial Art Gallery, 1914), n.p.

105. Redfield quoted in "Center Bridge Artist Found Fame."

106. Redfield, interview, March 4, 1963.

107. Ibid.

108. Ibid.

109. John Caldwell cited the abstract quality of *Winter Wonderland* in "55 Years of Redfield at Rutgers Gallery,"

The New York Times, April 12, 1981, Sunday New Jersey section, cited in Folk, *Edward Redfield: First Master of the Twentieth Century Landscape*, 45. Folk discusses the abstract nature of Redfield's winter brook series of paintings in his exhibition catalogue *Edward Redfield: First Master of the Twentieth Century Landscape*, 45–47.

110. "Pittsburgh: Poor Place for Painting," undated newspaper clipping, Edward Willis Redfield Papers, AAA, microfilm reel 1184.

111. Dorothy Hayman Redfield, typed notes for interview on "The Louise Collins Show," WBUX radio broadcast in honor of Redfield Week (May 1–10, 1987) and an exhibition at Heritage Towers, Doylestown, Pa., 3–4. Private collection.

112. Redfield, interview, March 4, 1963.

113. "Folks Worth Knowing."

114. "Making of a Country Home: Being a Series of Practical Papers on the Possibilities of Home-Making by Persons of Moderate Means—II. The Grading of the Land. The Boundaries," *Country Life in America* 2 (May 1902), 7–9, quoted in Lisa N. Peters, "Cultivated Wildness and Remote Accessibility: American Impressionist Views of the Home and Its Grounds," in *Visions of Home: American Impressionist Images of Suburban Leisure and Country Comfort* (Carlisle, Pa.: Trout Gallery, Dickinson College, 1997), 19.

115. C. Valentine Kirby, *A Little Journey to the Home of Edward W. Redfield*, Bucks County Series, Unit 3 (Doylestown, Pa.: Public Schools of Bucks County, 1947), n.p.

116. Redfield quoted in "Folks Worth Knowing."

117. Grafly, "Redfield: Subject of One Man Show at the Art Club.… "

118. Dorothy Redfield, typed notes for interview on "Louise Collins Show," 2.

119. Sally Gott to Redfield, November 14, 1951, Edward Willis Redfield Papers, AAA, microfilm reel 1183.

120. Don Reese Jr. to Redfield, December 6, 1951, Edward Willis Redfield Papers, AAA, microfilm reel 1183.

121. Redfield, interview, March 4, 1963.

122. A photograph of *Linekin Bay* in the possession of a member of the Redfield family is inscribed by Redfield on the back: "The last painting I made from nature."

123. Redfield did continue to produce paintings, but "painted only for pleasure" (Redfield, "Three Score and Five," typescript, private collection, n.p.).

124. "President Carter and His Family May Soon Have a Daily Reminder of What New Hope Looked Like a Couple of Generations Ago," *New Hope (Pa.) Gazette*, April 28, 1977, 5.

125. Redfield, interview, March 4, 1963.

Fig. 43 Blanket chest painted by Edward W. Redfield and given to his daughter-in-law Dorothy Hayman Redfield on her twenty-fourth birthday. Courtesy of Laurent and Mercedes Ross.

Catalogue[1]

1 UNTITLED (plaster frieze with dove), ca. 1884
Charcoal on paper, 18 x 13½ inches
Signed lower right: "Ed ___Redfield / ___W A Porter"
(loss in signature area)
Collection of Mr. and Mrs. Edward W. Redfield II

Redfield listed Porter as one of his early teachers in his application
for reinstatement to the Salmagundi Club (May 12, 1947).

2 UNTITLED (plaster cast of hand), ca. 1885
Charcoal on paper, 8 x 12¼ inches
Collection of Mr. and Mrs. Edward W. Redfield II

3 UNTITLED (plaster cast of hand with compass
on base), ca. 1885
Charcoal on paper, 13 x 16 inches
Signed, lower right: "Edward W. Redfield"
Collection of Edward Redfield Richardson

4 UNTITLED (plaster cast of leaf on plaque), 1885
Charcoal on paper, 13 x 12¼ inches
Signed lower right: "Jan 1885—Redfield"
(loss in signature area) and inscribed lower left: "< cast >"
Collection of Mr. and Mrs. Edward W. Redfield II

5 UNTITLED (plaster cast of leaf on plaque), ca. 1885
Charcoal on paper, 13 x 12½ inches
Collection of Edward Redfield Richardson

6 UNTITLED (plaster cast of three-lobed
figure on plaque), ca. 1885
Charcoal on paper, 15 x 15 inches
Signed lower right: "E W Redfield"
Collection of Edward Redfield Richardson

7 UNTITLED (male torso), ca. 1888
Charcoal on paper
7½ x 18¾ inches
Collection of Mr. and Mrs. Edward W. Redfield II

8 UNTITLED (elderly man), ca. 1888
Charcoal on paper
9½ x 18½ inches
Collection of Mr. and Mrs. Edward W. Redfield II

9 UNTITLED (female torso), ca. 1888
Charcoal on paper
9 x 9 inches
Collection of Edward Redfield Richardson

10 UNTITLED (female nude), ca. 1888
Charcoal on paper
24 x 18 inches
Collection of Edward Redfield Richardson

55

MISS O'BRIEN THE EARTH IS FLAT

11 Sketches, Edward W. Redfield journal, 1889
Ink on paper
Collection of Mr. and Mrs. Edward W. Redfield II

LIVERPOOL LANDING CUSTOM HOUSE

*next morning we took an extra good wash, thinking that our appearance probably had something to do with it. they were very anxious for us to

UNTITLED (English landscape)

12 DUNE WALK, FRANCE, ca. 1890
Oil on canvas
12½ x 15¾ inches
Signed lower left: "Redfield / France"
Private collection

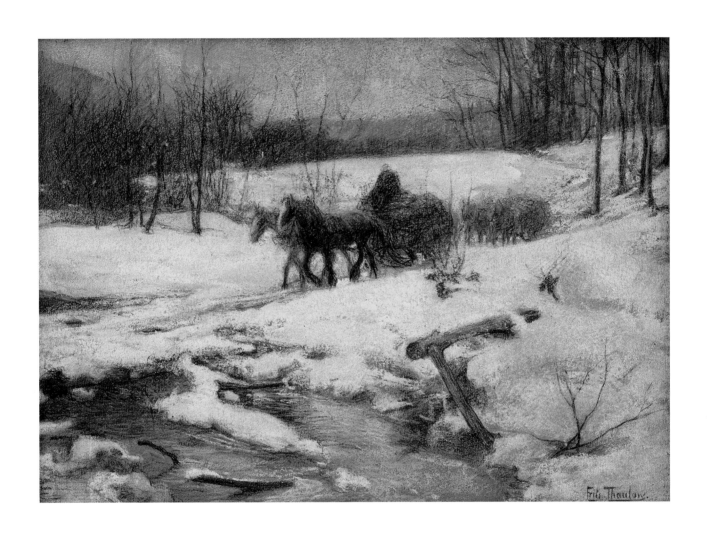

13 Fritz Thaulow (1847–1906)
HORSE DRAWN CARTS IN WINTER, n.d.
Pastel on paper
8 x 12 inches
Signed lower right: "Fritz Thaulow"
Private collection

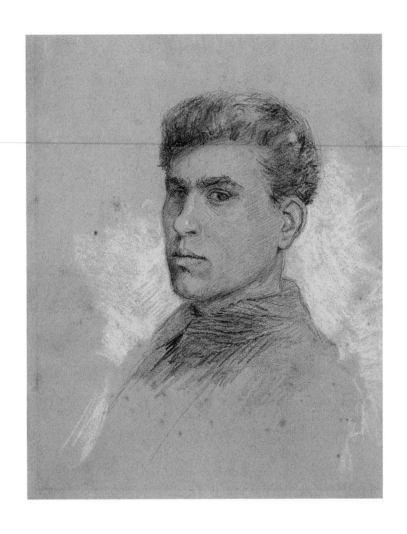

14 SELF-PORTRAIT, 1890
Pencil and white chalk on wove paper
10½ x 7¾ inches
Collection of Patricia A. Ross

15 UNTITLED (winter landscape), ca. 1897
Oil on canvas
19⅞ x 28⅞ inches
Signed lower left: "E W Redfield"
Private Collection in Trust to the James A. Michener Art Museum

16 UNTITLED (meadow creek), 1898
Oil on canvas on board
22¼ x 32 inches
Signed lower left: "E W Redfield / 98"
Collection of Malcolm and Eleanor Polis

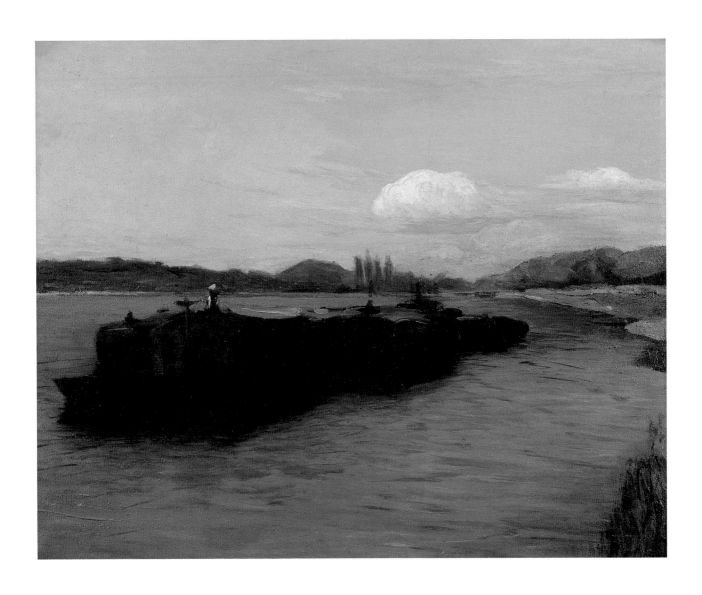

17 EVENING ON THE SEINE
(also known as *Early Evening: Seine*), ca. 1899
Oil on canvas
32 x 40 inches
Signed lower right: "E W Redfield"
Private collection

Exhibited: Sixty-Ninth Annual Exhibition (1900), Pennsylvania Academy of the Fine Arts (no. 423),
where it was illustrated in the catalogue and titled *Early Evening: Seine*.

18 FRANCE, ca. 1898–99
Oil on canvas
31¼ x 40³⁄₁₆ inches
Signed lower left: "E W Redfield / France"[date illegible]
Terra Foundation for the Arts, Daniel J. Terra Collection, 1999.126;
Photography Courtesy of Terra Foundation for the Arts, Chicago

19 THE BRIDGE AT JOINVILLE, 1898
Oil on canvas
20 x 25 ¾ inches
Signed lower left: "E W Redfield"
Collection of Malcolm and Eleanor Polis

Exhibited: Redfield was awarded a bronze medal at the 1900 Universal Exposition in Paris, where he
exhibited *The Bridge at Joinville* (1888) (no. 57, Fr. 253) and *The Road to Edge Hill* (no. 54, Fr. 254).

20 WAITING FOR SPRING, 1901
Oil on canvas
26 x 36 inches
Signed lower left: "E W Redfield."
Collection of Malcolm and Eleanor Polis

Exhibited: Pennsylvania Academy of the Fine Arts Annual Exhibition in 1902 (no. 51), where it was
subsequently purchased by Dr. George Woodward, son-in-law of Henry Howard Houston, director of
the Pennsylvania Railroad. Woodward was a successful real-estate developer in Philadelphia.

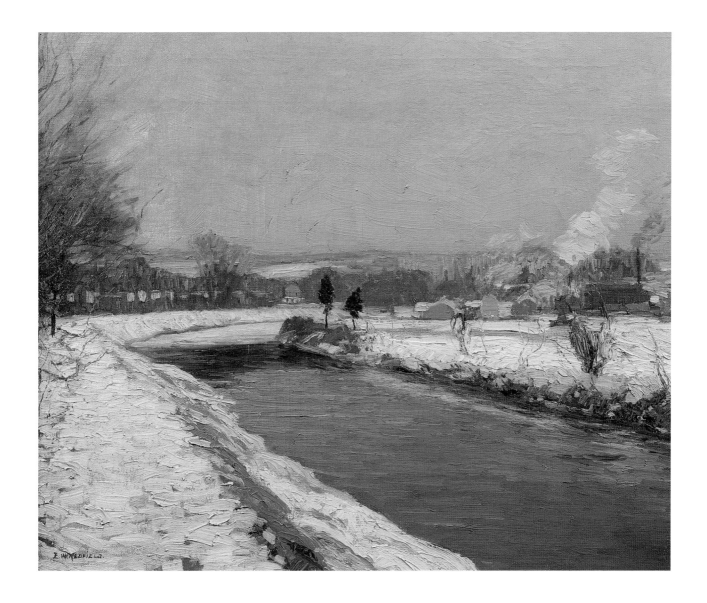

21 THE CANAL, STOCKTON, ca. 1903
Oil on canvas
26 x 32 inches
Signed lower left: "E. W. REDFiELD."
Collection of Malcolm and Eleanor Polis

Exhibited: Boston Art Club's Sixty-Ninth Exhibition, Oil Paintings and Sculpture (January 1–30, 1904) (no. 63).

A review of the Boston Art Club exhibition, appearing in *The Boston Evening Transcript*, January 2, 1904, singled out *Canal at Stockton:*

> Over on the south side of the large gallery he has another still more striking work, "Canal at Stockton" (63), which is one of the most vivid examples of actuality, and one of the most brilliant pieces of outdoor painting in the exhibition. It is a wee bit too real, too positive, too aggressive, too clever but few painters go further in the direction of description....

A review of the show in *The Boston Globe,* January 2, 1904, also mentions *Canal at Stockton:*

> The "Canal at Stockton" by Edward W. Redfield is handled in a masterly manner. The blue shadow on the snow bank, the trees against the sky, the color of the canal and the luminous snow on the right with the intense sky, make a wonderful color harmony....

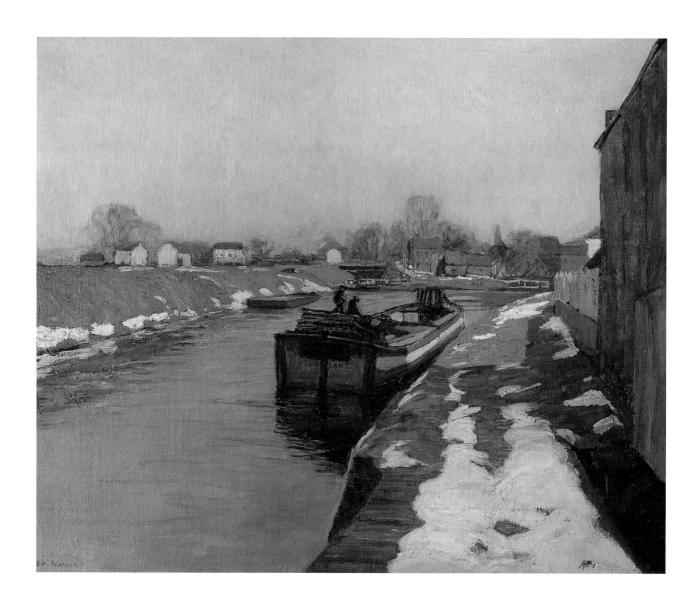

22 CANAL AT LAMBERTVILLE
(also known as *The Canal*), ca. 1905–06
Oil on canvas
32¼ x 39½ inches
Signed lower left: "E W. REDFIELD."
Collection of Pearl S. Buck International

Exhibited: National Academy of Design's 1906 Winter Exhibition (no. 58) as well as Redfield's solo exhibition at the Pennsylvania Academy of the Fine Arts (April 17–May 19, 1909), where it was titled *The Canal* and illustrated in the catalogue (no. 33). In a review of Redfield's 1909 solo exhibition at the Pennsylvania Academy, Reginald Cleveland Coxe mentions *The Canal*:

> The "Evening Sunlight," or the "Canal" rather (33), shows a glow of atmosphere into which one might walk and sit down: you feel it as truly in the distance, as it comes forward to where the picture meets the frame. One cannot tell why a Millet moon will go back thousands of miles beyond the figure in the foreground, but it does, and Millet himself could not explain how he did it. The same is true of this enveloping atmosphere.

Redfield also exhibited *The Canal* in the 1907 Annual Exhibition of the Art Institute of Chicago (no. 298), the 1909 solo exhibition at the City Museum of Saint Louis, as well as in his 1909 solo exhibition at the Detroit Museum of Art, where the scene was described in the museum's *Bulletin* as "one of the most restful of pictures, alike in subject and color":

> It displays a quiet canal scene, with a canal-boat making its slow journey along the towpath, heralding the approach of spring and another season of traffic, though the winter snows have not entirely yielded, nor has [sic] the trees and the plant life of the fields as yet felt the warming influence of the returning sun.

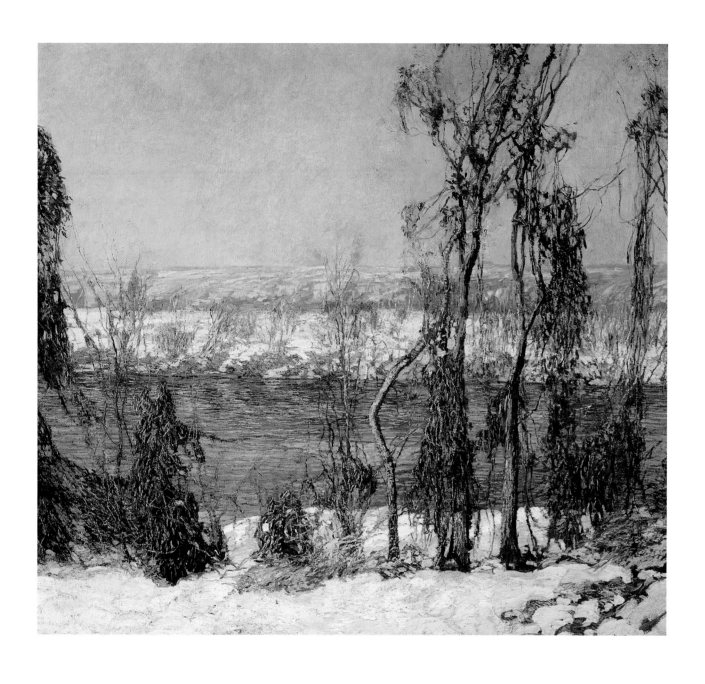

23 THE RIVERBANK, LAMBERTVILLE, NEW JERSEY, ca. 1908–10
Oil on canvas
50 x 56 ½ inches
Signed lower right: "E. W. Redfield."
Anonymous gift 1984.13
Collection of the Speed Art Museum, Louisville, Kentucky

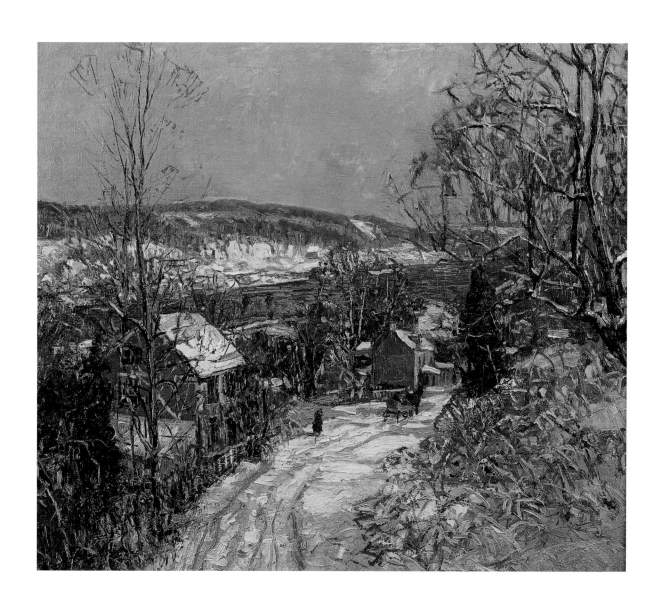

24 WINTER SNOWSCENE, COPPERNOSE HILL, ca. 1910
Oil on canvas
26 x 32 inches
Signed lower right: "E W REDFiELD."
Private collection

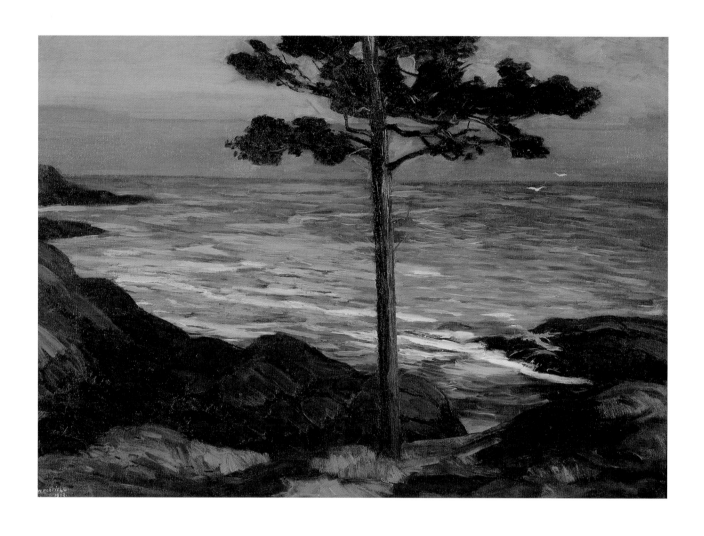

25 BOOTHBAY, MAINE, 1902
Oil on canvas
36 x 50 inches
Signed lower left: "E. W. REDFiELD. / 1902."
Courtesy of the Reading Public Museum, Reading, Pennsylvania

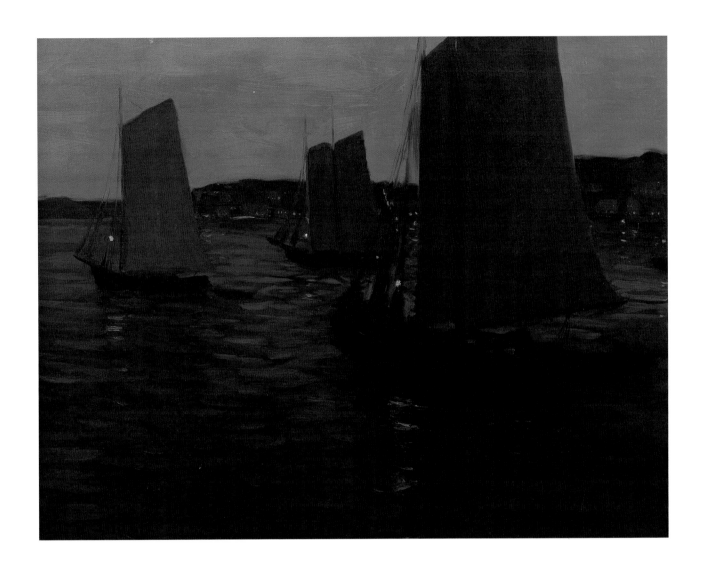

26 BOOTHBAY HARBOR AT NIGHT, ca. 1904
Oil on canvas
29 ¼ x 38 ½ inches
Signed lower left: "E. W. Redfield."
Private collection

Exhibited: *Boothbay Harbor at Night* was awarded a Shaw Fund Prize in the 1904 Society of American Artists exhibition.

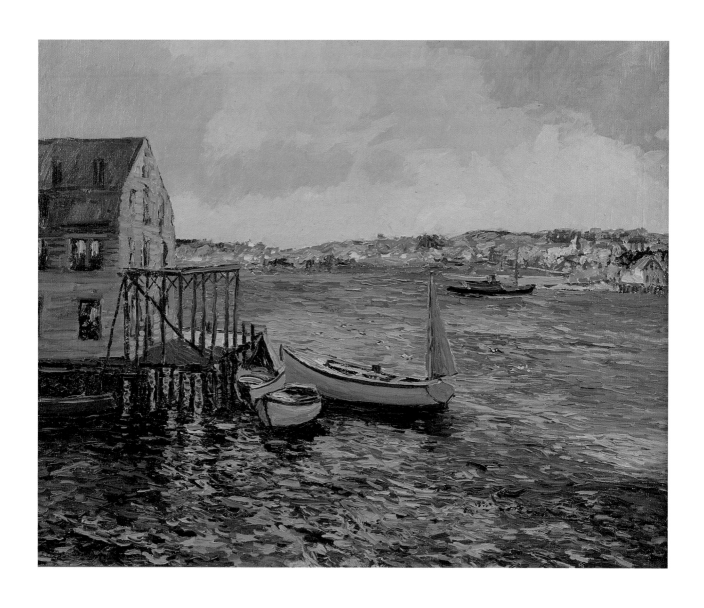

27 BOOTHBAY HARBOR, 1925
Oil on canvas
26 x 32 inches
Signed and dated lower left: "E W REDFIELD / 1925."
Private collection

28 Thomas Eakins (1844–1916)
EDWARD W. REDFIELD, 1905
Oil on canvas
30 x 26 inches
National Academy of Design, New York (400-P)

Painted as an Associate of the National Academy of Design diploma presentation piece for Redfield's election as an associate member to the National Academy of Design. Upon election to the academy, associate members were required to donate a portrait of themselves. Presented to the academy, October 16, 1905.

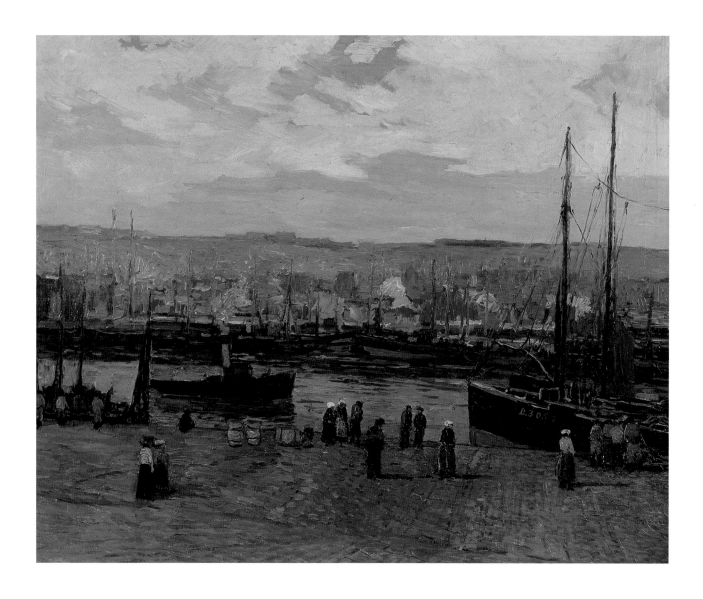

29 BOULOGNE HARBOR
(also known as *The Harbor of Boulogne*), 1908
Oil on canvas
32 ¼ x 40 inches
Signed lower right: "E. W. REDFiELD."
Anonymous

Exhibited: National Academy of Design Annual Exhibition (1909) under the title *The Harbor of Boulogne* and illustrated in the catalogue (no. 217).

It appears that the canvas was altered in size by the artist sometime after 1959, when it was illustrated in Henry C. Pitz's article "Edward Redfield: Painter of a Place and Time" in *American Artist* (April 1959). The illustration of *The Harbor of Boulogne* in the Pitz article indicates that the work was signed and dated (lower left, in the area later cut down), and its caption states that it measured 38 x 50 inches.

30 BROOKLYN BRIDGE AT NIGHT, 1909
Oil on canvas
36 x 50 inches
Signed lower left: "E. W. REDFIELD. /1909."
Courtesy of CIGNA Museum and Art Collection

31 LOWER NEW YORK
(also known as *Lower Manhattan*), ca. 1910
Oil on canvas
38 x 51 inches
Signed lower left: "E W REDFIELD"
Courtesy of CIGNA Museum and Art Collection

32 CHERRY BLOSSOMS, ca. 1912
Oil on canvas
32 x 40 inches
Signed lower right: "E W. REDFiELD"
Collection of Marguerite and Gerry Lenfest

Exhibited: Redfield received an award in the Carnegie International Exhibition in 1913 for *Cherry Blossoms*.
Exhibition records list it as a "position one" painting, a designation reserved for major works.

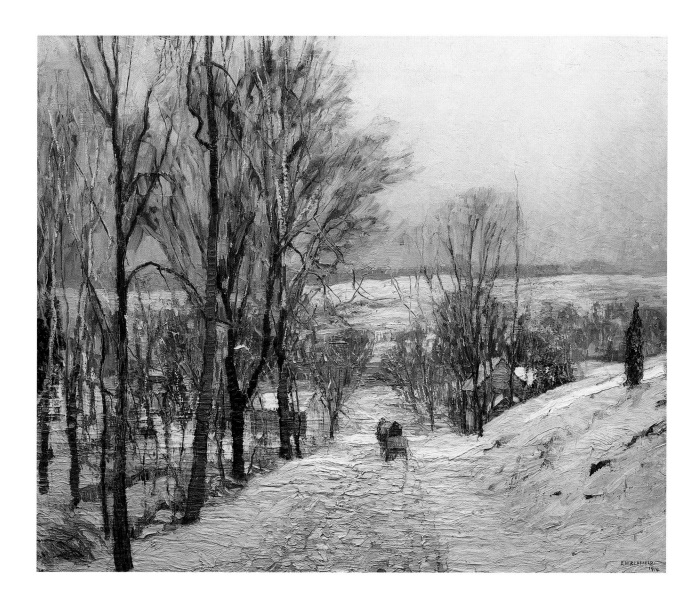

33 THE GREEN SLEIGH, 1914
Oil on canvas
28½ x 34½ inches
Signed and dated lower right: "E. W. REDFIELD. / 1914"
Collection of Bob and Amy Welch

Exhibited: Redfield's 1916 solo exhibition at the Corcoran Gallery of Art (March 14–April 9, 1916). During the exhibition, the painting was sold to William J. Flather for $750. In a letter (March 23, 1916) to C. Powell Minnegerode, director of the Corcoran, Redfield declared:

> I was glad to hear that Mr. Flather had purchased *The Green Sleigh*, this picture has nearly sold twice before and has always been a favorite with the general public.

Another painting by the same name was included in Redfield's solo exhibition at the Memorial Art Gallery in Rochester, New York (May 9–June 7, 1914), and illustrated in the catalogue. Redfield exhibited a painting titled *The Green Sleigh* in the Panama-Pacific International Exposition in San Francisco in 1915 (no. 3926). It is unclear if the work featured here is the painting that was exhibited in the Panama-Pacific Exposition.

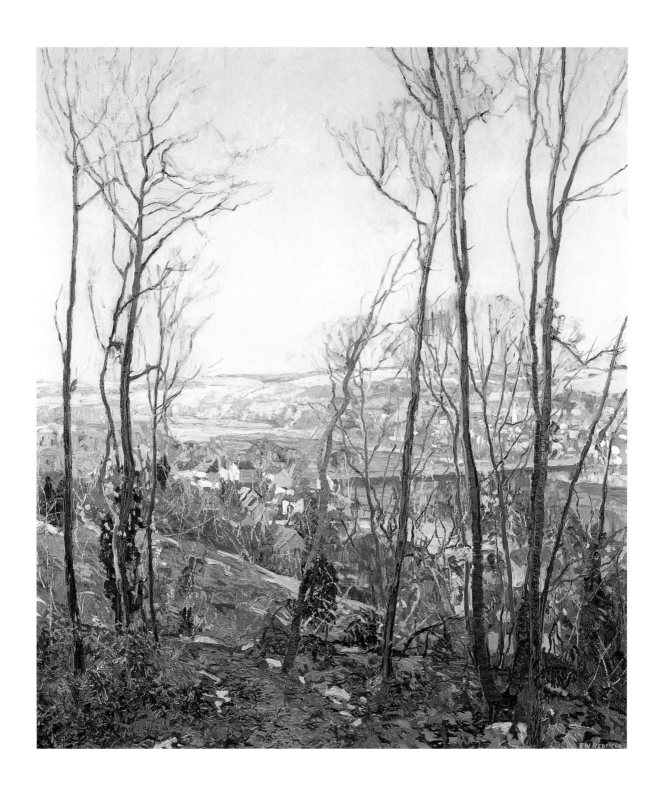

34 A PENNSYLVANIA LANDSCAPE, ca. 1916
Oil on canvas
56 x 50 inches
Signed lower right: "E W REDFIELD."
Courtesy of CIGNA Museum and Art Collection

Exhibited: 111th Annual Exhibition, Pennsylvania Academy of the Fine Arts, Philadelphia (1916), where
it was illustrated in the catalogue (no. 302).

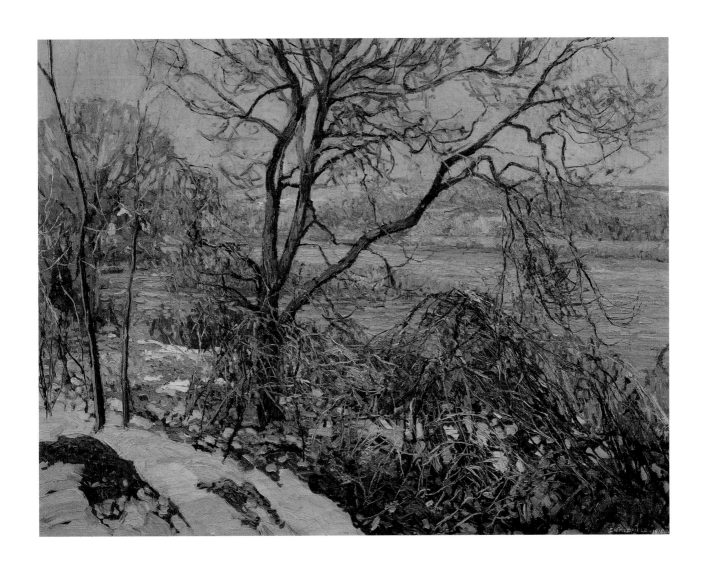

35 WOODS AND STREAM IN WINTER, UPPER DELAWARE, 1916
Oil on canvas
38 x 50 inches
Signed lower right: "E. W. REDFiELD. 1916."
Widener University Art Collection,
Gift of A. Carson Simpson and Mrs. Peggy Simpson Carpenter, 1953

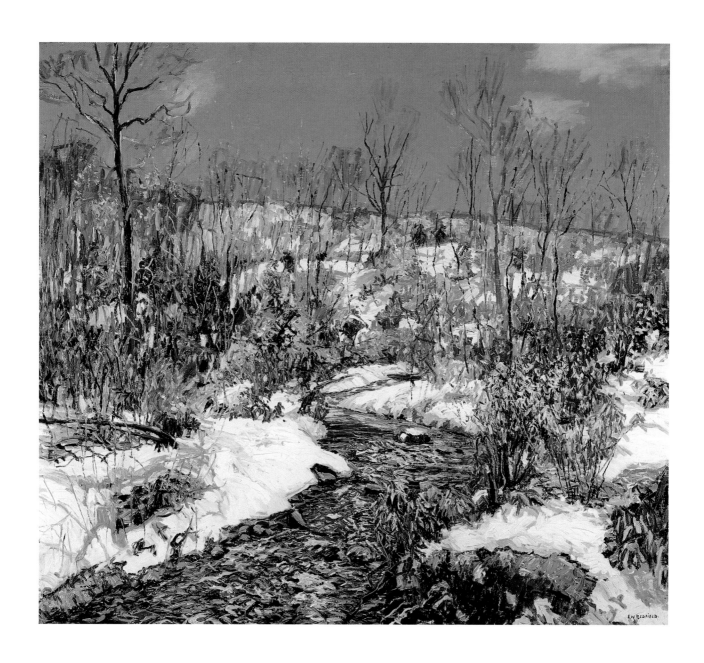

36 THE TROUT BROOK, ca. 1916
Oil on canvas
50 x 56 inches
Signed lower right: "E. W. REDFiELD." Stretcher is inscribed
"#224 *The Trout Brook* / 50 x 56 Ma (?) 1916" in pencil.
In Trust to the James A. Michener Art Museum from Marguerite and Gerry Lenfest

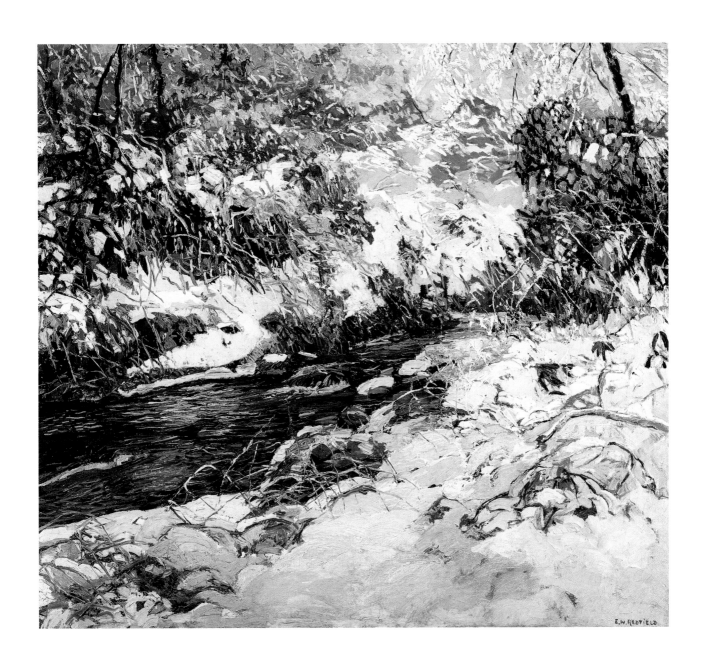

37 WINTER WONDERLAND, ca. 1917
Oil on canvas
50 x 56 inches
Signed lower right: "E. W. REDFiELD."
Collection of Lisa and Joe Walker

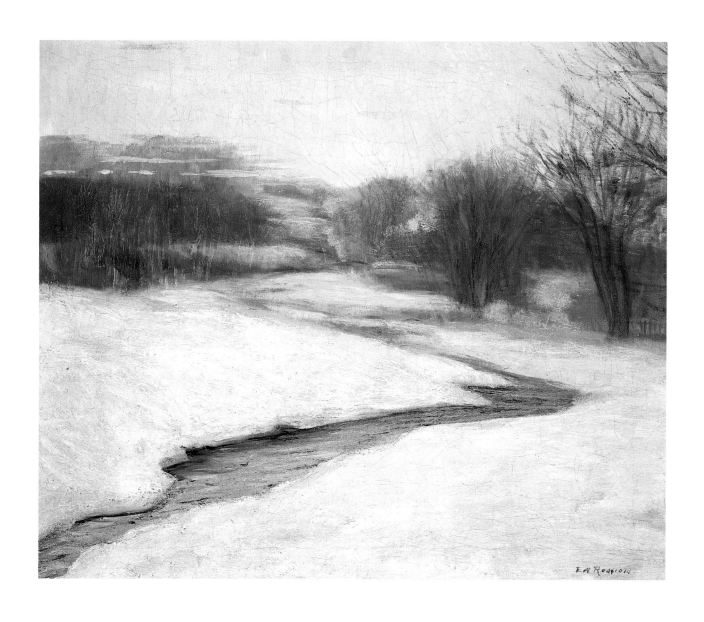

38 UNTITLED (stream in a snowy field), n.d.
Oil on canvas
22¼ x 26 inches
Signed lower right: "E. W. Redfield."
In trust to the James A. Michener Art Museum from Marguerite and Gerry Lenfest

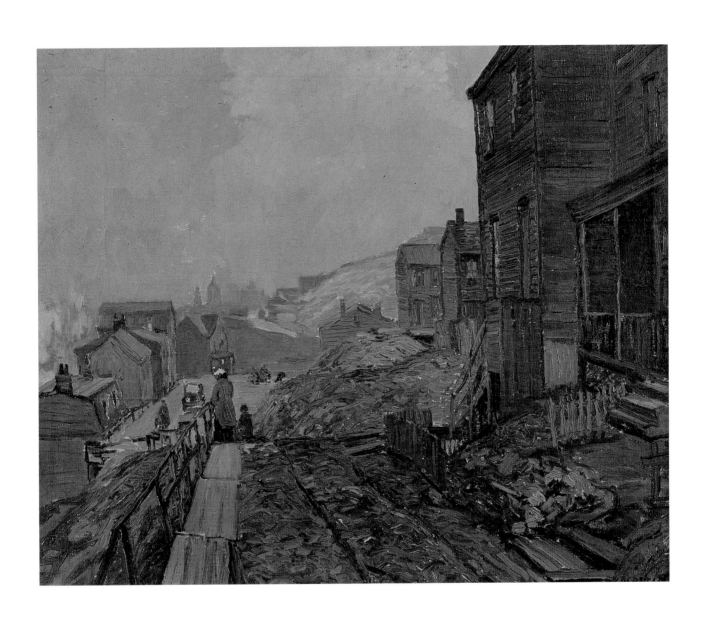

39 OVERLOOKING SOHO, PITTSBURGH, ca. 1918
Oil on canvas
26 x 32 inches
Signed lower right: "E W. REDFiELD."
Private collection

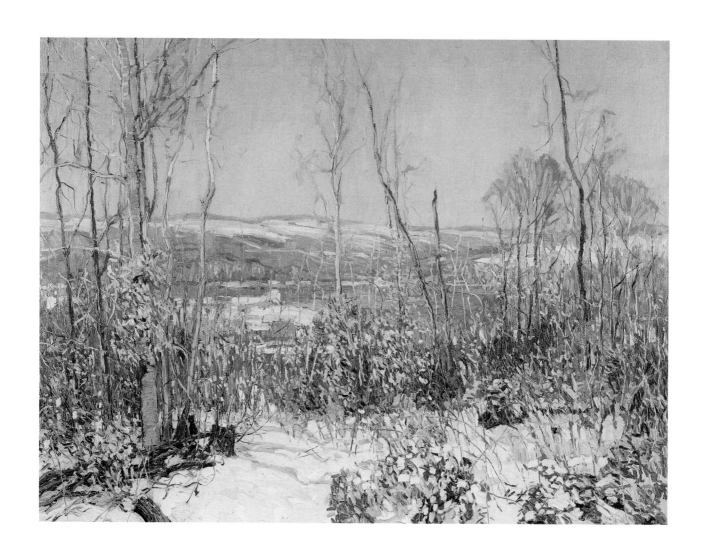

40 OVERLOOKING THE DELAWARE, ca. 1919
Oil on canvas
38 x 50 ¼ inches
Signed lower left: "E. W. REDFiELD."
Philadelphia Museum of Art: Gift of Mr. and Mrs. J. Stogdell Stokes, 1931

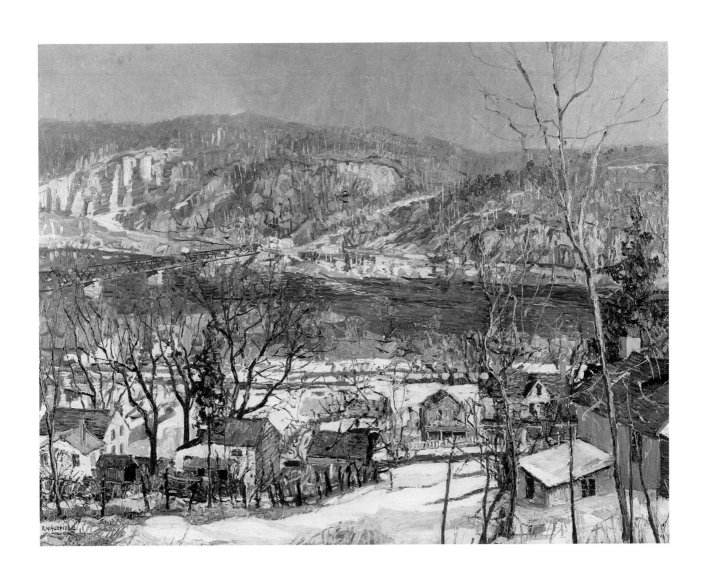

41 LATE AFTERNOON, ca. 1925–30
Oil on canvas
38 x 50 inches
Signed lower left: "E. W. REDFiELD."
Woodmere Art Museum, Purchase, 1959

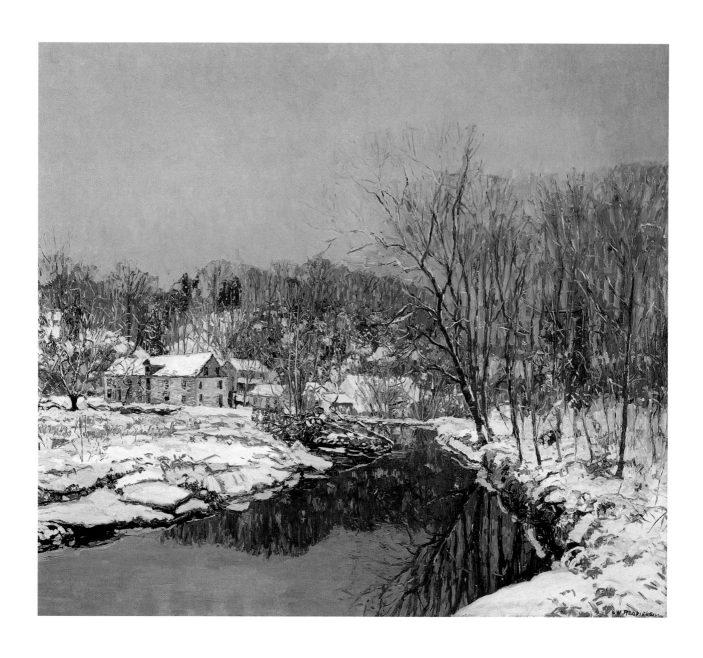

42 THE MILL IN WINTER, 1922
Oil on canvas
50¼ x 56½ inches
Signed lower right: "E W REDFIELD."
Collection of the Corcoran Gallery of Art, Washington,
D.C. Museum Purchase, Gallery Fund

Exhibited: Winter Exhibition of the National Academy of Design in 1922 (no. 337) as well as the Corcoran
Gallery of Art Biennial in 1923 (no. 131), where it was illustrated in the catalogue.

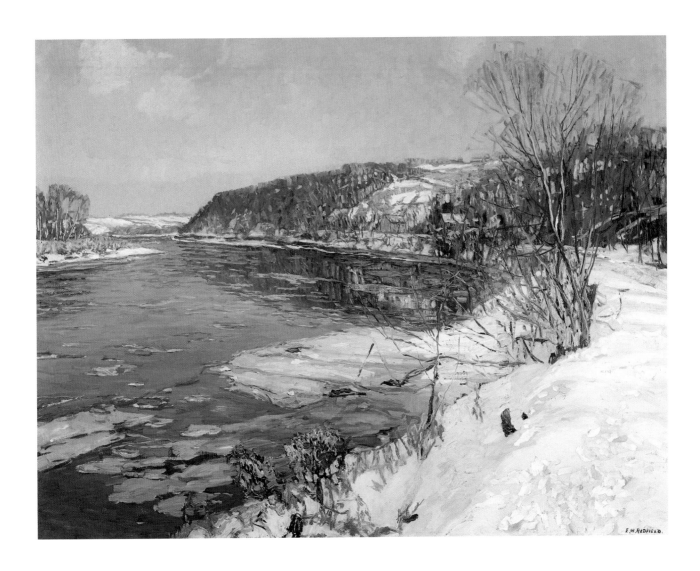

43 THE UPPER DELAWARE, ca. 1918
Oil on canvas
38 x 50 inches
Signed lower right: "E. W. REDFIELD."
In trust to the James A. Michener Art Museum from Marguerite and Gerry Lenfest

Exhibited: During the period 1918–29, exhibited at the Twelfth Annual Exhibition of Selected Paintings by American Artists, Albright Art Gallery, The Buffalo Fine Arts Academy, Buffalo, New York (July–September 1918) (no. 24); the 1924 Annual Exhibition of the Pennsylvania Academy of the Fine Arts (no. 99), where it was illustrated in the catalogue; Eighteenth Annual Exhibition of Selected Paintings by American Artists at the Albright Art Gallery (1924); Redfield's solo exhibition at the Milwaukee Art Institute (no. 24) (November 1–30, 1924); his solo exhibition at Macbeth Gallery, New York (March 3–23, 1925); his solo exhibition at the Grand Rapids Art Gallery (March 1–31, 1929) (no. 24); and his solo exhibition at the City Library Gallery, Des Moines Association of Fine Arts (February 3–28, 1929) (no. 24), where it was featured on the cover of the catalogue. The painting was also featured on the cover of the *American Magazine of Art* in January 1925.

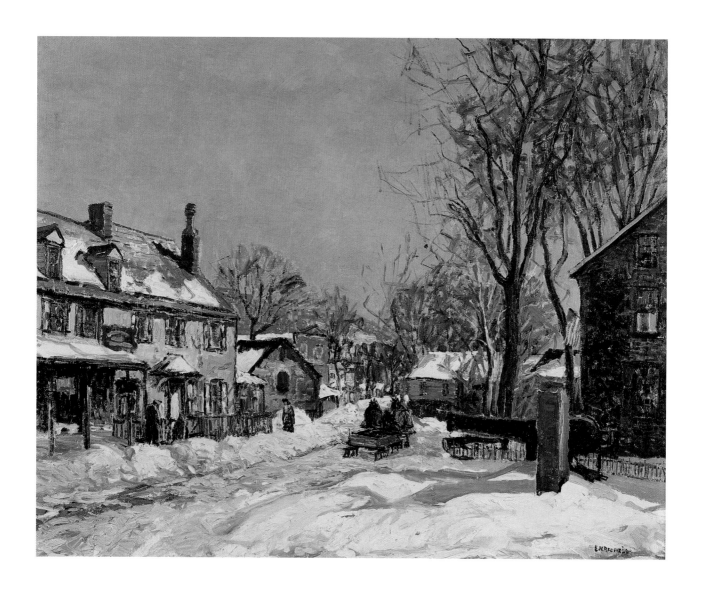

44 WASHINGTON'S BIRTHDAY, ca. 1938
Oil on canvas
32 x 40 inches
Signed lower right: "E. W. REDFIELD."
Private collection

Exhibited: 1938 Annual Exhibition of the Pennsylvania Academy of the Fine Arts (no. 258).

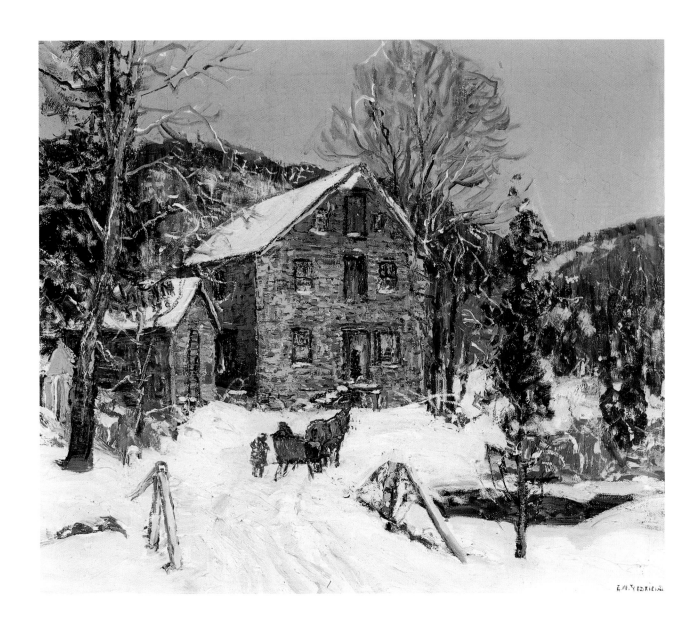

45 SLEIGH RIDE TO THE GRIST MILL, n.d.
Oil on canvas
21 x 25 inches
Signed lower right: "E. W. REDFiELD."

In Trust to the James A. Michener Art Museum from Marguerite and Gerry Lenfest

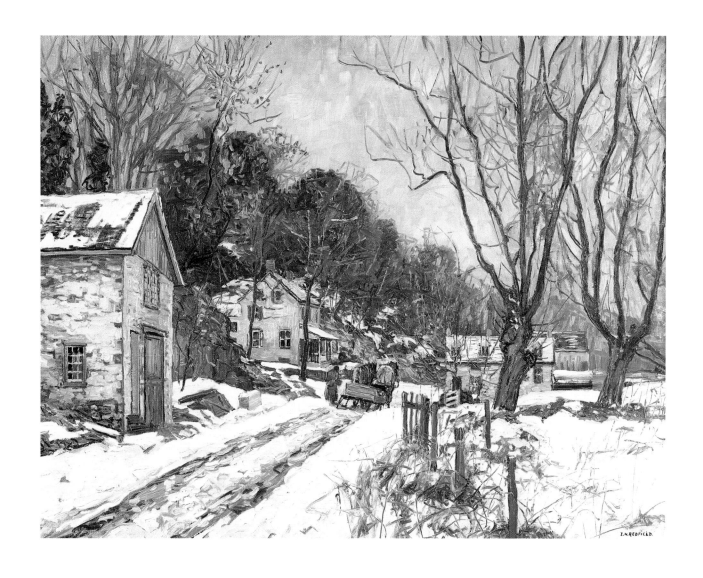

46 FLEECYDALE ROAD, n.d.
Oil on canvas
37 ½ x 49 ½ inches
Signed lower right: "E. W. REDFiELD."
James A. Michener Art Museum. Gift of the Laurent Redfield Family

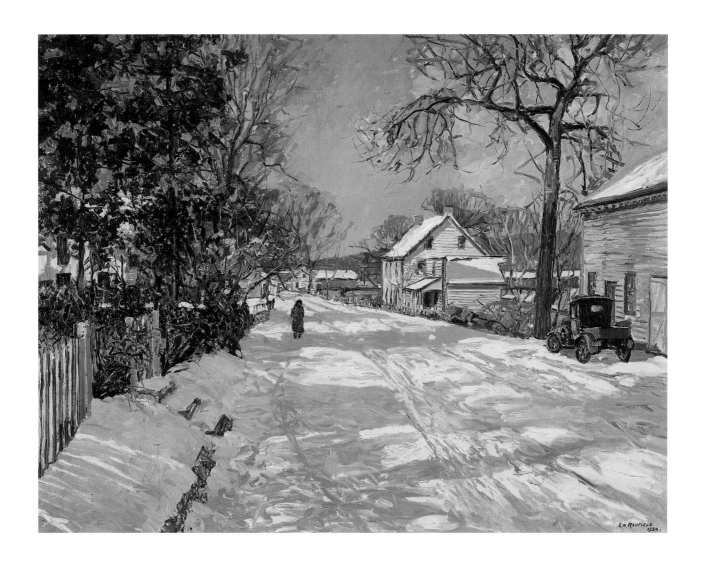

47 LUMBERVILLE IN WINTER, 1930
Oil on canvas
38 ½ x 50 ½ inches
Signed lower right: "E. W. REDFiELD. / 1930."
In Trust to the James A. Michener Art Museum from Marguerite and Gerry Lenfest,
with assistance from First Union Bank

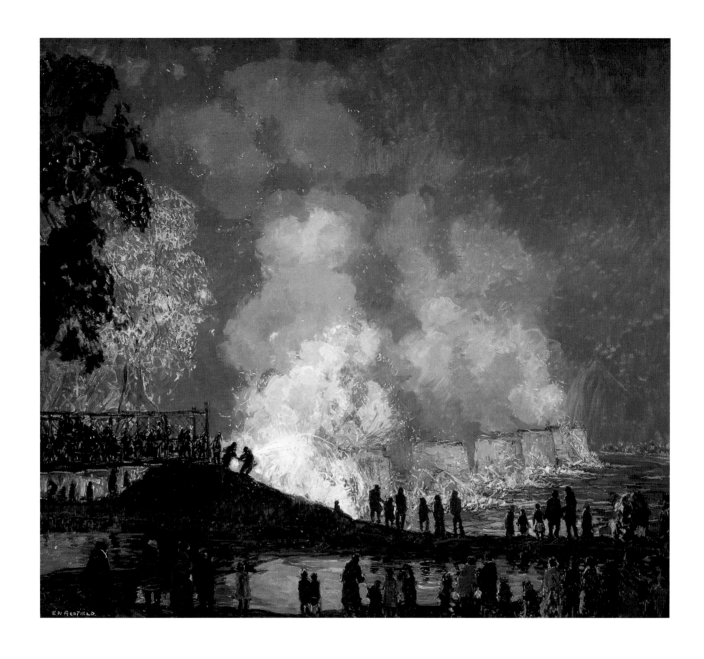

48 THE BURNING OF CENTER BRIDGE, 1923
Oil on canvas
50¼ x 56¼ inches
Signed lower left: E W REDFiELD.
James A. Michener Art Museum. Acquired with Funds Secured by State Senator Joe Conti,
and with Gifts from Joseph and Anne Gardocki and the Laurent Redfield Family

Exhibited: Redfield's solo exhibition at the Art Club of Philadelphia in 1929 (no. 20).

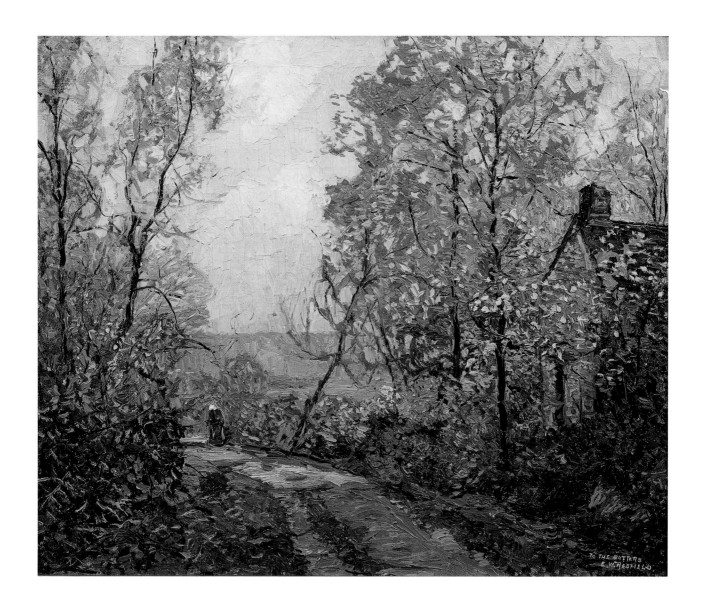

49 OCTOBER (also known as *Autumn),* n.d.
Oil on canvas
26 x 32 inches
Signed lower right: "TO THE SOTTERS / E. W. REDFIELD. / E W REDFIELD"
In Trust to the James A. Michener Art Museum from Marguerite and Gerry Lenfest

George Sotter studied with Redfield during the summer of 1902. Before Sotter moved to Bucks County in 1919, Redfield advised him on how to find a house and make a living as a painter:

> Regarding the place near Doylestown, it might be somewhat lonesome, also the road might not be very good in winter. The place itself is good—The house tight and I should judge in good shape, but I would not buy hurriedly there are other places to look at, there are quite a few places coming on the market along the Neshaminy towards Rushland—my but it's a fine country to paint and live in! I have sold upwards of $1000 worth of paintings since Jan 1st so things are moving. The only thing that is required is to get the pictures. I think you will have relatively little trouble making a straight living from painting once you get time to paint as you work hard and should make good. When you see the right place to live, "buy" but do not buy one too large—house and an acre or two is all that's required—the rest is work and takes too much time! Tell me anything that wants doing! (Redfield to George Sotter, May 21, 1919. Private collection)

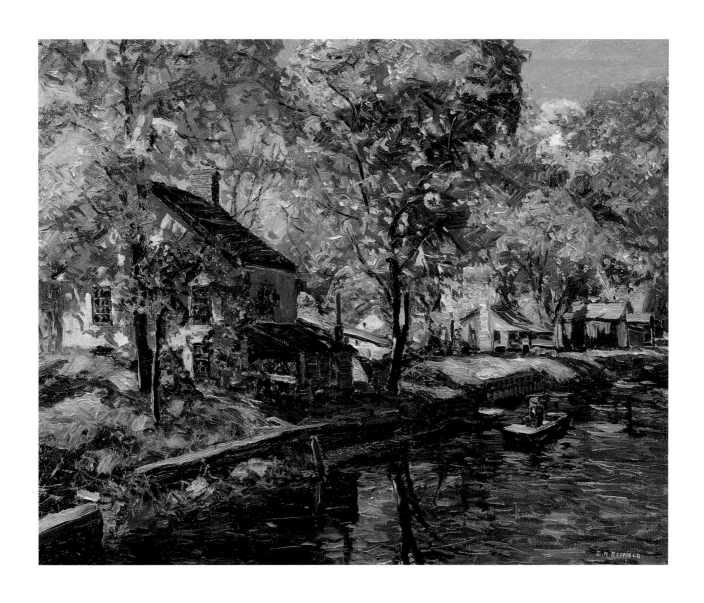

50 CANAL IN AUTUMN, n.d.
Oil on canvas
26 x 32 inches
Signed lower right: "E. W REDFiELD."
Collection of Louis E. and Carol A. Della Penna

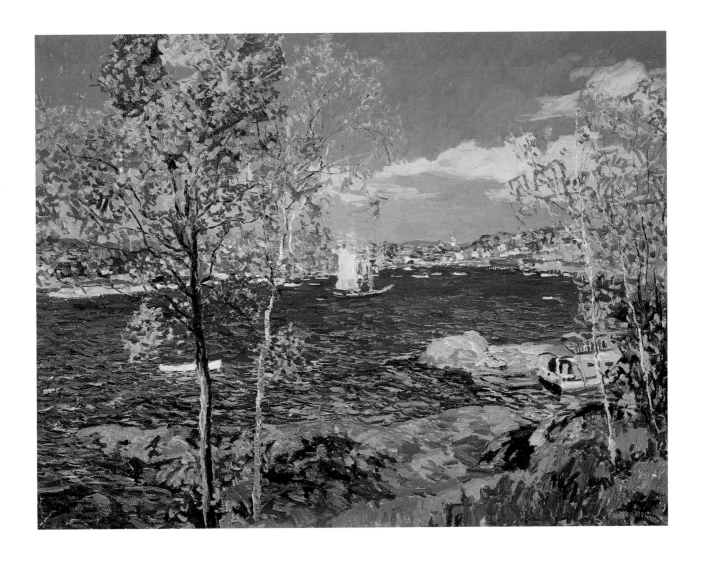

51 OCTOBER BREEZE, 1927
Oil on canvas
38 x 50 inches
Signed lower right: "E. W. REDFiELD."
Collection of Edward Redfield Richardson

Exhibited: Art Institute of Chicago Annual Exhibition, 1928 (no. 131), as well as Redfield's solo exhibition at the Art Club of Philadelphia in 1929 (no. 13), which traveled to the Grand Central Art Galleries in New York in 1930 (no. 12).

This work was painted along the shore of Boothbay Harbor, Maine, close to the Redfield summer home on Atlantic Avenue.

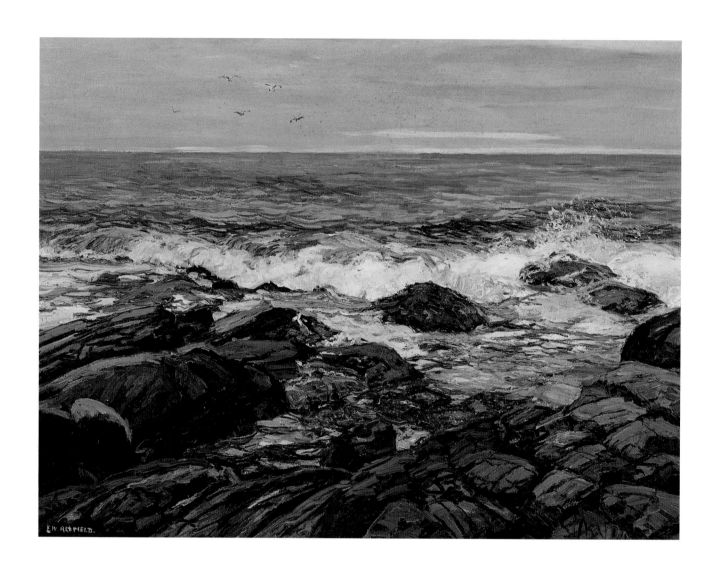

52 SOLITUDE, 1927
Oil on canvas
38 x 50 inches
Signed lower left: "E. W. REDFiELD."
Collection of R. Bruce Ross

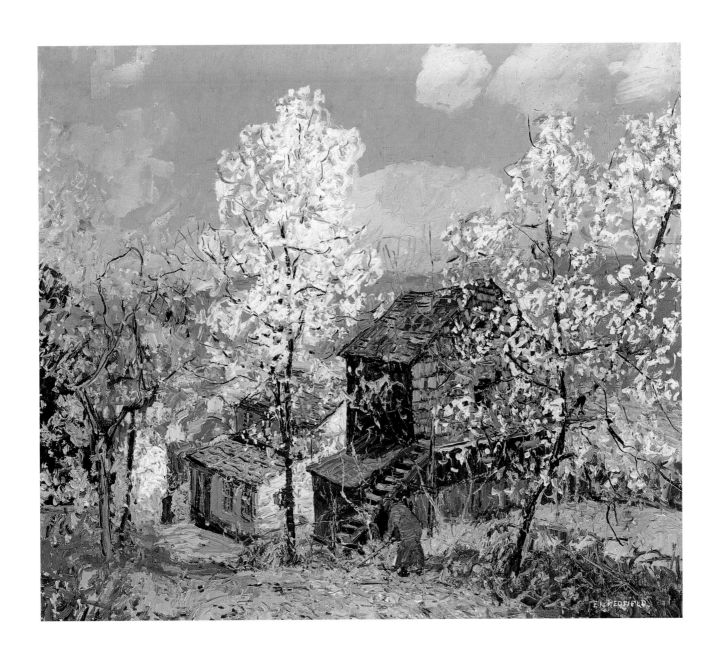

53 MAY AT POINT PLEASANT, ca. 1920
Oil on canvas
28½ x 30 inches
Signed lower right: "E W REDFiELD."
Collection of Lee and Barbara Maimon

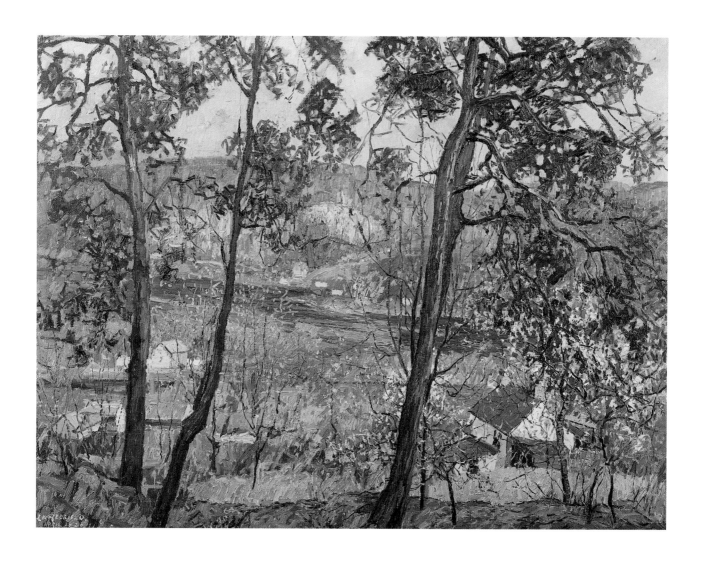

54 EARLY SPRING, April 29, 1920
Oil on canvas
38 x 50 inches
Signed and dated lower left: "E W REDFiELD. / APRIL 29. 20"
Inscribed on stretcher: "Early Spring" "Pt. Pleasant Mike Mullens"
In Trust to the James A. Michener Art Museum from Marguerite and Gerry Lenfest,
with assistance from First Union Bank

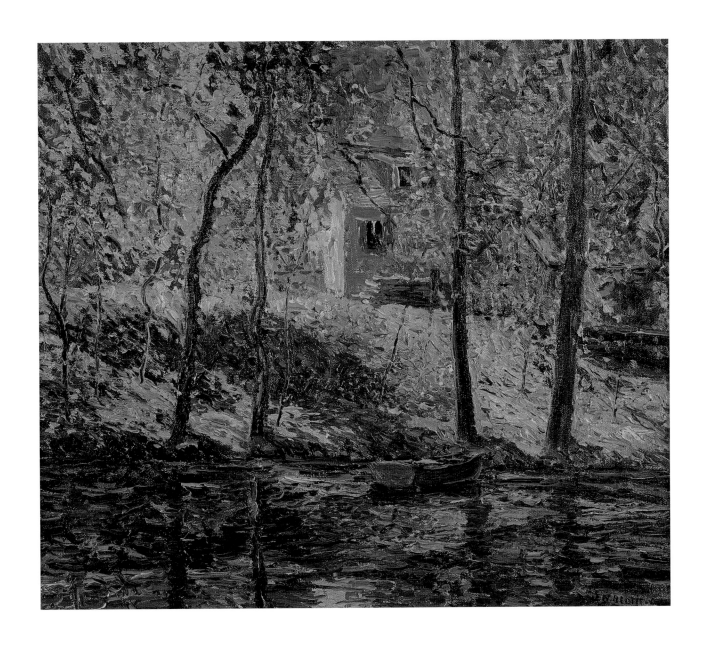

55 DR. BELL'S HOUSE, ca. 1920
Oil on canvas
18½ x 21¾ inches
Signed lower right: "E W. REDFiELD."
Anonymous

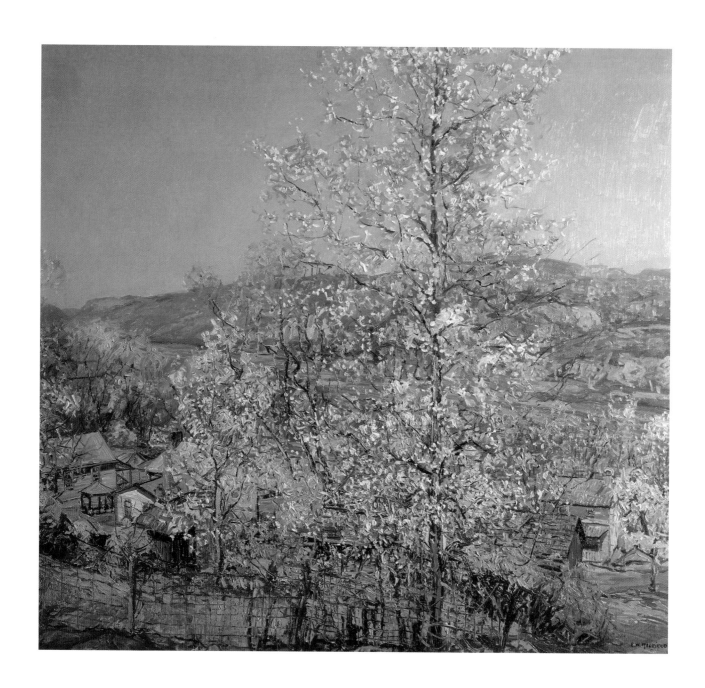

56 SPRING VEIL, ca. 1928
Oil on canvas
50 x 56 inches
Signed lower right: "E. W. REDFiELD."
Collection of Malcolm and Eleanor Polis

Exhibited: Corcoran Gallery of Art Biennial, November 30, 1930–January 11, 1931, no. 126.

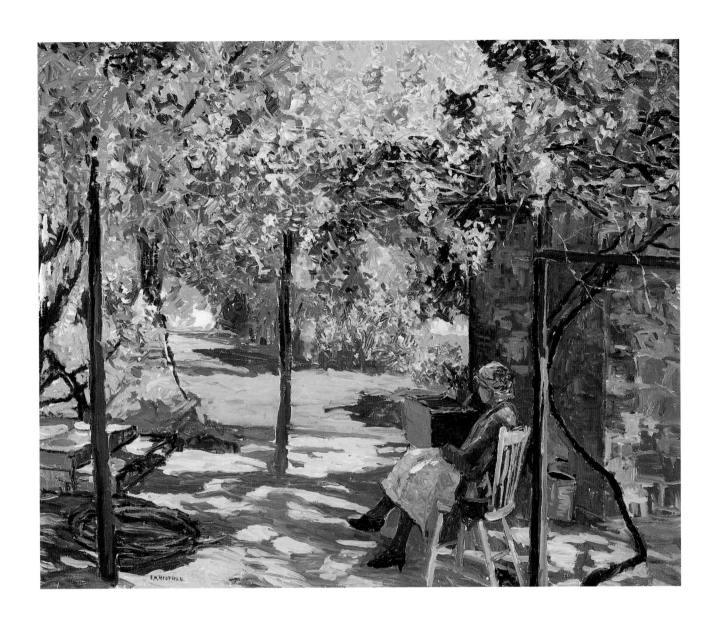

57 WISTERIA, ca. 1933
Oil on canvas
26 x 32 inches
Signed lower left: "E. W. REDFiELD."
Collection of Edward Redfield Richardson

Redfield's wife, Elise, sits under the wisteria arbor, which connected to the main house
and the springhouse of the Redfields' last home in Center Bridge, Pennsylvania.

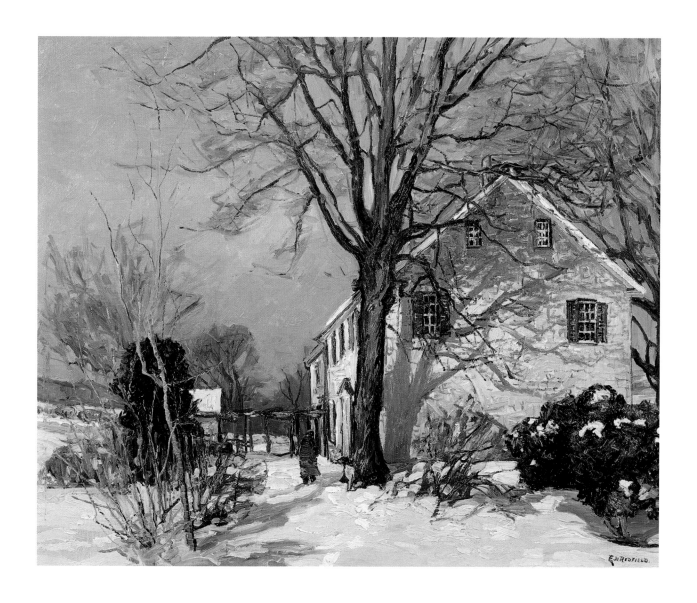

58 THE HOMESTEAD, n.d.
Oil on canvas
32 x 40 inches
Signed lower right: " E.W. REDFiELD."
Collection of Marguerite and Gerry Lenfest

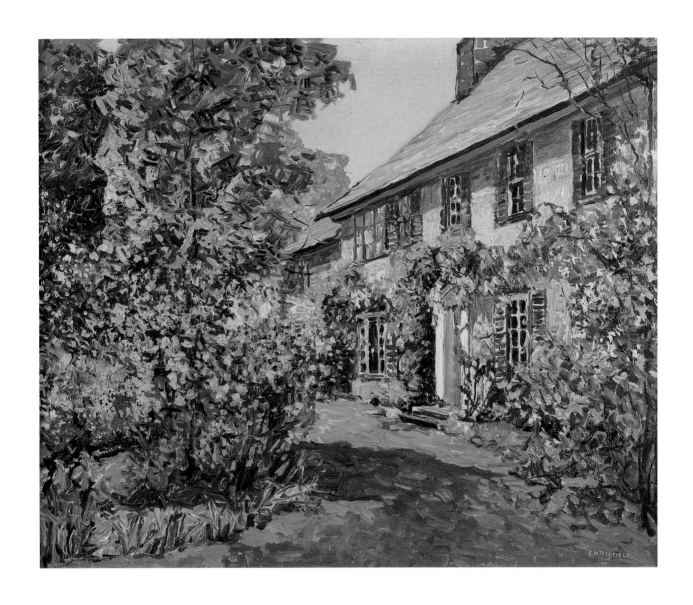

59 OUR HOME, n.d.
Oil on canvas
26 x 32 inches
Signed lower right: "E. W. REDFiELD."
Collection of Patricia A. Ross

60 WEDDING SCENE IN NORMANDY, ca. 1928
Hooked rug
37 x 54 inches
Collection of Patricia A. Ross

Exhibited: Redfield's solo exhibition at the Art Club of Philadelphia in 1929 (no. 33).

61 BOOTHBAY HARBOR, n.d.
Hooked rug
39 x 45 inches
Collection of R. Bruce Ross

62 PAINTED TOLE TRAY (crowd of figures with sleigh), n.d.
Oil on pressed metal
21 ½ x 29 inches
Collection of Patricia A. Ross

63 PAINTED TOLE TRAY WITH SCALLOPED EDGE (sleigh scene with figures), n.d.
Oil on pressed metal
23 ¼ x 29 ½ inches
Collection of Patricia A. Ross

64 PAINTED BOX (covered bridge with figures), n.d.
Oil on wood
Box: 3 high x 6 ¾ inches in diameter
Collection of Patricia A. Ross

65 PAINTED BOX (village scene with sleigh), n.d.
Oil on wood
Box: 3 high x 7 inches in diameter
Anonymous

66 DECORATED BLANKET CHEST, 1934
Painted by Edward W. Redfield
Painted poplar
21⅝ x 35½ x 18⅝ inches
Philadelphia Museum of Art
Gift of Mr. and Mrs. M.S. Gelbach, 1992

67 SUNLIGHT AND SHADOWS, n.d.
Oil on canvas
38 x 32 inches
Signed lower left: "E.W. REDFiELD."
Bucks County Intermediate Unit #22

In 1948 Edward Redfield gave this painting to the Bucks County Traveling Art Gallery. It had become widely known by thousands of children through a public art appreciation textbook known as *Art Stories*, published by Scott, Foresman and Company of Chicago. In 1959 it was included in an exhibition of Redfield's work in Doylestown, Pennsylvania. Two young students wrote to the artist, designating it as their favorite painting.

November 14, 1951

Dear Mr. Redfield,
 My favorite picture was "Sunlight and Shadows." I think it shows one of the plain and beautiful works of nature. It seems so real and true to life that when I first looked at it, I almost thought I could walk right into it. Another thing I liked about it was the deep blue of the winter sky. For some reason when I look at it it makes me feel much nearer to the good things in life.
 Sincerely yours,
 Sally Gott
 Gr 7

Dec. 6. 1951

Dear Mr. Redfield,
 I liked your painting "Sunlight and Shadows" best because it makes me feel as if I were actually inside the painting, also I like the peace and stillness of the untracked snow. It give me the awed feeling that I get when standing in a snowbound forest of being completely alone and away from the outside world.
 Sincerely yours,
 Don Reese Jr.
 Gr 9

1. The exhibition record included for several entries is selective and is not intended to be a complete record.

Chronology

1869 Born December 18, Bridgeville, Delaware. Shortly thereafter, family moves to Camden, New Jersey.

1876 Attends Philadelphia Centennial Exposition, where his drawing of a cow is exhibited in the toddler's class.

Early 1880s Attends Friends School and German turnverein in Camden.

1881–84 Attends art classes at Spring Garden Institute, Philadelphia, and Franklin Institute, Philadelphia.

1887–89 Attends Pennsylvania Academy of the Fine Arts, Philadelphia.

1888 Exhibits *Wissahickon* at Pennsylvania Academy of the Fine Arts Annual Exhibition.

1889 Keeps a journal of his travels with Frank Hays, C. A. Houston, and Alexander Stirling Calder to Great Britain and Paris in August. Visits the Paris Universal Exposition. Attends Académie Julian in Paris, where he studies with Adolphe William Bouguereau and Tony Robert-Fleury.

1890 Travels with Robert Henri to Saint-Nazaire, where they paint *en plein air* along the Mediterranean coast.

1891 Travels with Robert Henri to Brolles, France, where he meets his future wife, daughter of the innkeeper at the Hotel Deligant. Paints local snow scenes and boating subjects. Paris Salon accepts *Road—Forest of Fontainebleau*. Travels to Venice to paint with Henri and William Gedney Bunce.

1892 Solo exhibition at Doll and Richards Gallery, Boston. Returns to United States. Paints lake scenes in North Hector, New York, during the summer. Joins Henri and such other artists as John Sloan, William Glackens, Everett Shinn, George Luks, Walter Elmer Schofield, Alexander Stirling Calder, James Preston, Edward Davis, Charles Grafly, and Hugh Breckenridge for weekly meetings at 806 Walnut Street, Philadelphia.

1893 Returns to London, where he marries Elise Deligant. Couple returns to United States and lives with Redfield's parents in Glenside, Pennsylvania.

1894 Wins awards for *Evening* and *Winter in France* at Art Institute of Chicago. First child, Elizabeth, born.

1895 Juror, Pennsylvania Academy of the Fine Arts Annual Exhibition.

1896 Receives gold medal from Art Club of Philadelphia.

1898 Moves to Center Bridge, Pennsylvania, where he resides until the end of his life. Serves as juror for Pennsylvania Academy of the Fine Arts Annual Exhibition. First child dies. Couple returns to France and lives in village of Alfort.

1899 Solo exhibition at Pennsylvania Academy of the Fine Arts. Birth of son Laurent.

1900 Exhibits *The Bridge at Joinville* and *The Road to Edge Hill* at Universal Exposition in Paris and wins bronze medal. Returns to Center Bridge.

1901 Wins bronze medal at Pan-American Exposition, Buffalo, New York. Serves as chairman of jury for Pennsylvania Academy of the Fine Arts Annual Exhibition and on jury for

Watercolor Annual Exhibition at the Art Institute of Chicago. Solo exhibitions at Art Club of Philadelphia and St. Botolph Club (Boston). Son Horace is born.

1902 Accepts students for the summer at Center Bridge.

1903 Begins spending summer vacations at Boothbay Harbor, Maine. Elected member of Society of American Artists. Receives Pennsylvania Academy of the Fine Arts' Temple Gold Medal for *Winter Evening*. Appointed member of the advisory committee for Louisiana Purchase Exposition.

1904 Serves as juror for Pennsylvania Academy of the Fine Arts Annual Exhibition. Elected Associate, National Academy of Design in New York. Awarded Second Hallgarten Prize from National Academy of Design, where exhibits *Near Boothbay Harbor* and *The Harbor*. Receives Shaw Fund Prize from Society of American Artists for *Boothbay Harbor at Night*. Wins silver medal for *Boothbay Harbor* at Louisiana Purchase Exposition, where serves as member of advisory committee.

1905 *Hillside Farm* receives Jennie Sesnan Gold Medal from Pennsylvania Academy of the Fine Arts for best landscape in its annual exhibition. *The Crest* receives Gold Medal of the Second Class from Carnegie International Exhibition. Daughter Louise is born.

1906 Serves as juror and on painting and hanging committee for Pennsylvania Academy of the Fine Arts Annual Exhibition. Elected Academician, National Academy of Design. Receives Webb Prize from Society of American Artists.

1907 Receives third prize (William A. Clark Award) from Corcoran Biennial, where he exhibits *The Delaware River* and *Lowlands of the Delaware*. Receives Gold Medal of Honor from Pennsylvania Academy of the Fine Arts. Receives award for *Center Bridge* and *The Valley* from Carnegie International Exhibition. Serves as chairman of jury and on painting and hanging committee for Pennsylvania Academy of the Fine Arts Annual Exhibition. Serves as juror for Corcoran Biennial and as juror for Art Institute of Chicago's American Annual Exhibition.

1908 Serves on jury and on selection committee for Corcoran Biennial. Receives Honorable Mention from Paris Salon. *The Island* receives first prize (William A. Clark Award) from Corcoran Biennial. *The Red Barn* receives award from Carnegie International Exhibition.

1909 Serves on jury for National Academy of Design Annual Exhibition and Winter Exhibition. Receives second prize Harris Medal from Art Institute of Chicago, where he exhibits *The White House* and *The Foothills of the Blue Ridge* at American Annual. Awarded third class medal from Paris Salon. Solo exhibitions at Pennsylvania Academy of the Fine Arts, Detroit Museum of Art, Albright Art Gallery, and City Art Museum of Saint Louis. Paints Manhattan nocturnes while living in New York. French government purchases *February* for Luxembourg Museum. Resigns from National Academy of Design.

1910 Receives gold medal from Exposition International de Orte, Buenos Aires, for *Un Pueblo de la Colina*. Solo exhibition at Corcoran Gallery of Art and St. Botolph Club. Son George is born.

1912 Serves on jury and on painting and hanging committee for Pennsylvania Academy of the Fine Arts Annual Exhibition. *The Laurel Brook* receives Lippincott Prize from Pennsylvania Academy of the Fine Arts (best painting in oil by an American artist). *Below the Island* and *Between Daylight and Darkness, New York* win awards at the Carnegie International Exhibition. Daughter Frances is born.

1913 *Cherry Blossoms* and *The River in Winter* win awards at Carnegie International Exhibition. Awarded gold medal from Washington Society of Artists and Potter-Palmer Gold Medal from Art Institute of Chicago.

1914 Serves as chairman of jury committee for Corcoran Biennial. Receives Gold Medal of Honor from Carnegie Institute, where *The Mountain and Brook* and *The Village in Winter* are exhibited in the International Exhibition. Solo exhibition at Memorial Art Gallery, Rochester, New York.

1915 Serves on Jury of Awards and receives Commemorative Medal of Bronze for Distinguished Services for Panama-Pacific International Exposition, San Francisco. Provided gallery to exhibit twenty-one paintings at Panama-Pacific International Exposition.

1916 Serves as juror and on painting and hanging committee for Pennsylvania Academy of the Fine Arts Annual Exhibition. Solo exhibitions at Corcoran Gallery of Art and Grand Rapids Art Association.

1917 Solo exhibitions at Buffalo Fine Arts Academy, Albright Art Gallery, and Worcester Art Museum.

1918 Receives Carnegie Prize from National Academy of Design. Exhibit of works of Redfield and Edmund Tarbell at Corcoran Gallery of Art.

1919 Exhibits in Exposition d'Artistes de l'École Américaine, Luxembourg Museum, Paris (October–November). Resides in Pittsburgh while son Laurent attends Carnegie Technical School. Awarded Altman Prize from National Academy of Design. Serves on juries for Carnegie International Exhibition and Art Institute of Chicago's American Annual Exhibition. Solo exhibitions at Memorial Art Gallery, Rochester, and Nebraska Art Association, University of Nebraska Art Gallery, Lincoln.

1920 Receives Stotesbury Prize for a group of paintings from Pennsylvania Academy of the Fine Arts for the most important contribution to the Annual Exhibition. The group includes *Spring, A Frosty Morning, Coaster,* and *The Day Before Christmas.* Solo exhibition at Art Club of Philadelphia.

1922 *The Valley in Springtime* receives Carnegie Prize in the Winter Exhibition of National Academy of Design (most meritorious oil painting by an American artist).

1923 Serves as chairman of jury committee for Corcoran Biennial.

1924 Solo exhibition at Milwaukee Art Institute.

1925 Solo exhibition at Macbeth Gallery, New York.

1926 Serves on jury of selection, jury of awards, regional advisory committee, and hanging committee of Philadelphia Sesquicentennial International Exposition.

1927 *Cherry Valley* receives Saltus Medal from National Academy of Design.

1928 Receives H. J. Heins Prize, Grand Central Art Galleries, New York. Shares exhibition with Gari Melchers at Corcoran Gallery of Art. Solo exhibition at St. Botolph Club.

1929 Solo exhibitions at Grand Rapids Art Gallery, Detroit Institute of Arts, Art Club of Philadelphia, and Des Moines Association of Fine Arts.

1930 Receives prize from Springfield Art Association. Solo exhibition at Grand Central Art Galleries.

1932 Serves as juror for Corcoran Biennial.

1933 Receives prize from Newport Art Association.

1937 Unanimously reinstated as an Academician at National Academy of Design.

1947 Wife, Elise Redfield, dies. Burns a huge inventory of paintings that he judges as substandard.

1948 Paints *Linekin Bay,* the last work he paints from nature.

1959 Solo exhibition at Woodmere Art Gallery, Philadelphia.

1960 Solo exhibition at Parry's Barn, New Hope, Pennsylvania.

1961 Solo exhibition at Buck Hill Art Association, Buck Hill Falls, Pennsylvania.

1961–62 Solo exhibition at Reading Public Museum and Art Gallery, Pennsylvania.

1965 Redfield dies on October 19 at Center Bridge.

Fig. 44 Certificate from International Exposition of Art, Buenos Aires, November 30, 1910, where Edward W. Redfield was awarded a gold medal. Collection of James A. Michener Art Museum, Doylestown, Pennsylvania.

This compilation of critical responses to the work of Edward W. Redfield is selective. It includes excerpted passages from contemporary newspaper articles, journal articles, letters, and exhibition catalogues dating from 1901 to 1948.

The material has been gathered from the Edward Willis Redfield Papers in the Archives of American Art, the Pennsylvania Academy of the Fine Arts Library, newspaper holdings of the Free Library of Philadelphia and the University of Pennsylvania, as well as archival collections held by members of the Edward Redfield family.

The Edward Willis Redfield Papers, donated to the Archives of American Art by Redfield's grandson Edward Redfield Richardson, contain an extensive clipping file saved by the artist himself. Some of the clippings in this collection lack complete identifying information.

"Exhibition of Mr. Redfield's Paintings at the St. Botolph Club." *Boston Evening Transcript*, April 2, 1901, 9. Review of An Exhibition of Landscapes, By Mr. Edward W. Redfield, of Philadelphia, April 1–20, 1901, at the St. Botolph Club, Boston.

> The exhibition of landscapes painted by Edward W. Redfield of Philadelphia, which was opened at the gallery of the St. Botolph Club, 2 Newbury Street, yesterday, introduces to the Boston public an artistic star almost of the first magnitude....
>
> In painting of French streams, bridges, and suburban riversides, Mr. Redfield manifests a firm grasp of the essential realities and a capacity for the expression of atmospheric phenomena, which are remarkable; but in addition to these merits, his pictures possess qualities of poetical suggestiveness, of imaginative power and of individuality of feeling that are of a high order. The life and movement of the things seen, their pictorial worth, and their mysterious passages, are combined in proportions and relations that form impressive and unified compositions. The final touch of painter-like quality without which all the rest of the ingredients would go for naught, consists of the delicately adjusted and true color values. The expression of air and light, surrounding and permeating every part of the scene, is thus assured.

Chris. "Boston Art Club Exhibit. Lively Interest Manifested on the Opening Day—Some of the Most Striking Pictures." *Boston Sunday Post*, April 7, 1901, 5. Review of An Exhibition of Landscapes, By Mr. Edward W. Redfield, of Philadelphia, April 1–20, 1901, at the St. Botolph Club, Boston.

> There is an exhibition of landscapes by Mr. Edward W. Redfield of Philadelphia at the St. Botolph Club. The club is to be congratulated on the fine show of paintings. The list includes:
>
> "The Ark," beautiful for its fine qualities.
> "Church Road," fine color.
> "River in Paris," full of atmosphere, sentiment and feeling.
>
> "The Bridge," great in color values, warm, soft light pervading through the picture.
> The winter scenes are remarkable for their truthfulness and feeling. The painting of the running water is especially clever.
> Poetry and feeling permeates all through this fine collection of rare paintings. We hope to see them again.

"The Fine Arts ... Opening of the Boston Art Club Exhibition." *Boston Evening Transcript*, January 2, 1904, 6. Review of the Sixty-Ninth Exhibition, Oil Paintings and Sculpture, Boston Art Club, January 1–30, 1904.

Just at the left of Mr. Voorhees's landscape is a winter landscape by Edward W. Redfield, which is remarkably impressive. It is called "Hillside" (14), and shows a river, with snow-covered banks, and cedars in the foreground. Mr. Redfield is one of the most capable landscapists living; his values are admirable; and we much prefer his winter scenes to those of Fritz Thaulow. Over on the south side of the large gallery he has another still more striking work, "Canal at Stockton" (63), which is one of the most vivid examples of actuality, and one of the most brilliant pieces of outdoor painting in the exhibition. It is a wee bit too real, too positive, too aggressive, too clever but few painters go further in the direction of description....

⊞ "Oil Paintings and Sculpture Shown at the Rooms of the Boston Art Club." *Boston Globe,* January 2, 1904, 7. Review of the Sixty-Ninth Exhibition, Oil Paintings and Sculpture, Boston Art Club, January 1–30, 1904.

The "Canal at Stockton" by Edward W. Redfield is handled in a masterly manner. The blue shadow on the snow bank, the trees against the sky, the color of the canal and the luminous snow on the right with the intense sky, make a wonderful color harmony. Another winter scene by this same artist, entitled "Hillside," is also beautifully painted.

⊞ B. J. O. Flower, "Edward W. Redfield: An Artist of Winter-Locked Nature," *Arena* 36, no. 1 (July 1906): 20–26.

Mr. Redfield is a fine type of sturdy American manhood. His life is sincere and simple as are his pictures enthralling in their witchery and compelling power. His love of nature has led him from the crowded, nerve-racking, brain-distracting metropolitan centers to a quiet nook on the picturesque banks of the beautiful Delaware.

Mr. Redfield makes from forty to sixty studies during the winter. If twelve of these satisfy his artistic judgment the year's work has been a success. Sometimes, however, not more than seven or eight pictures are sufficiently excellent to pass his severely critical judgment.

Few are his canvases that reflect nature in her gladsome growing and thrillingly exultant hours. His noblest work pictures the great Mother mantled in her shroud of snow or somber and silent in the recuperative sleep that so resembles death.

He is a man gifted with the imaginative power that enables him to catch the brooding spirit of nature, the soul of the landscape, and to so reproduce it that it is much the same whether one looks on the landscape or on the artist's canvas; and it is the possession of this power that differentiates the artist of genius from the mere technical expert who, though he may reproduce every object visible to the eye with camera like fidelity, is unable to come so *en rapport* with nature herself as to be conscious of the soul of the great Mother. Hence her charm, her witchery, her wonderful essence elude him.... Only the man of genius can do really great art work such as is being done by Mr. Redfield and other of our artists who are laying the foundations for a great American art.

⊞ John E. D. Trask. *Catalogue of the Exhibition of Landscape Paintings by Edward W. Redfield* (Philadelphia: Pennsylvania Academy of the Fine Arts, 1909), n.p. Published in conjunction with an exhibition shown at the Pennsylvania Academy of the Fine Arts (April 17–May 16, 1909), Philadelphia.

Landscape painting to-day holds a higher place than it ever held before. We have moved steadily on and upward since Claude Lorrain. This is especially true in America.

Knowing the romantic charm of the early Englishmen, our men have become as lovingly intimate with Nature as were Corot and his fellows at Barbizon, and respecting the rugged truths of Courbet, have assimilated the higher science of the French Impressionists. With the storehouses of the world brought near to hand by travel's revolution, stimulated at home by a tense and nervous nation which for self-preservation turns more and more to the happy out of-doors, the American landscape painter has seen a finer vision and wrung from his own vibrant sensibilities a fuller note than has stirred the world before.

Among the men whose work may be considered typical of our time no one is more characteristically American than Mr. Redfield. His great successes have been made through the presentation of the aspects of the landscape under climatic and atmospheric conditions peculiarly our own. The national characteristics, vitality and decision, are his in the practice of his art, and in his tireless effort to acquire able craftsmanship he has in his painting developed great frankness and honesty.

His presentations of the ever multiplying beauties of snow-covered country (and by these he is up to the present time best known) have in them such qualities of deep-chested vigor, honesty of vision, of openness, and above all, of respect for the subject at hand, as to have won for him place [sic] with the leaders in his profession. That his field is limited neither by the seasons nor locality, the present exhibition, made up wholly of work done during the past year in France and in America, is full proof.

His study of his subject is carefully analytic and ordinarily deliberate rather than otherwise. His execution, once begun, is rapid almost beyond belief. He paints with a full brush but holds himself strictly to great refinement of color; his amazing virtuosity is, as always, the result of persistent and powerful effort.

⊠ Reginald Cleveland Coxe, "Exhibition of Redfield's Paintings," *(Philadelphia) Public Ledger,* April 18, 1909, 8. Review of solo exhibition at the Pennsylvania Academy of the Fine Arts, April 17–May 16, 1909.

There are on view at the Pennsylvania Academy of the Fine Arts some 46 pictures, mostly landscapes, with here and there a marine, by Edward W. Redfield....

They all show most earnest study, vigorous and a rather original handling, an exquisitely delicate sense of color and composition. These last two qualities are born only in the true artist: The former can be acquired by any diligent student. Mr. Redfield is in the second stage of his life's work. The student period of youth, when all is effort and grinding endeavor, is behind him.... His present work already shows true accomplishment....

The "Evening Sunlight," or the "Canal"[1] rather (33), shows a glow of atmosphere into which one might walk and sit down: you feel it as truly in the distance, as it comes forward to where the picture meets the frame. One cannot tell why a Millet moon will go back thousands of miles beyond the figure in the foreground, but it does, and Millet himself could not explain how he did it. The same is true of this enveloping atmosphere.

Now I come to Mr. Redfield's left-outs, for they exist even as the sun has spots. There must be life in a landscape; shown by figures, or the movement of the wind must be felt in the trees or clouds; something alive....

Our painters of the strongest landscape school in existence today treat the nature they seek to interpret too much like a plaster cast, always ready to be drawn and doing nothing but keeping still. I can best explain it by No. 24. The little canvas shows some corn stacks, or whatever they are called.... These stacks of corn are splendidly painted, the color is charming, yet one asks something more than these—snow and a little suggestion of sunlight—to live with. The curved wings of a few flying crows, a bunny, a laborer going home across fields, would add an idea of life to the scene. We need more than facts to make a poem, and such a picture should be.

The strongest evidence in Mr. Redfield's work of thought and original artistic promise is his application of the modern impressionist's principles and the leaving aside of their mannerisms, which have done so much to cast obloquy and ridicule upon a beautiful, not ugly truth.... So in Mr. Redfield's work one can find the light and color of the impressionists, but none of their mannerisms. He has yet to feel the life in nature, the winds and clouds, the moods that make her so fascinating. It is none the less true, however, that he is a great painter, and will be greater, for he is still young.

1. Also known as *Canal at Lambertville*, ca. 1905–06. Collection of Pearl S. Buck International.

⊞ "Exhibitions Now Hanging: Edward W. Redfield, Paintings." *Bulletin of the Detroit Museum of Art* 3, no. 3 (July 1909): 32–34. Excerpts from an article published on the occasion of Redfield's solo exhibition of forty-one paintings at the Detroit Museum of Art, June 19–August 31, 1909.

> He attempts and succeeds in catching the character of his subject and gives to the world a creation which is beautiful and truthful. The time and place does not influence its merit as a picture. And this is the feeling that Edward W. Redfield has, I know, for in distinguishing his pictures with titles, he does not enlighten one as to these commonplaces, but catalogs them with such names as "Underwood," Grey Day," "The Old Barn," "The Canal," "In the Harbor," etc. They present to the beholder a condition of nature, a phase of winter, a note of atmosphere, a song of the sea, rather than portray a place....
>
> "The Canal" (No. 29)[2] is one of the most restful of pictures, alike in subject and color. It displays a quiet canal, with a canal-boat making its slow journey along the towpath, heralding the approach of spring and another season of traffic, though the winter snows have not entirely yielded, nor has [sic] the trees and the plant life of the fields as yet felt the warming influence of the returning sun.
>
> 2. Also known as *Canal at Lambertville*, ca. 1905–06. Collection of Pearl S. Buck International.

⊞ Frank Jewett Mather Jr. "The Field of Art: The Luxembourg and American Painting," *Scribner's* 47 (March 1910): 381–84.

> It would be easy to miss the meaning of the purchase of Mr. Redfield's "February" by the French Government. For a quarter of a century and more this sort of compliment to American painting has been rather common. It has been accorded, however, upon the tacit condition that our artists should do the French sort of thing. One has only to recall the pioneer Americans at the Luxembourg—Whistler, Sargent, Walter Gay, Tanner, Alexander Harrison, J. McClure Hamilton, Dannat, Henry Mosler, among others—to admit that their work is essentially cosmopolitan. The achievement of these artists, however, intrinsically excellent, lacks national idiom.... Now Mr. Redfield's "February" is emphatically our kind of thing. Its subject is a Pennsylvania tow-path with straining ice below, and beyond a glimpse over a level against which rises a leafless tree. The method too, is ours—a crisp, direct naturalism which is saved from banality by thoughtful selection and elimination. It is the quality of a youthful art. Scandinavian painting shows it clearly. British and Continental landscape tends to display a stronger infusion of decorative or romantic sentiment, or, in the poorer examples, a less reflective realism. At the risk of seeming a benighted philistine, let me insist upon the interest of the subject. The acceptance of our themes by France implies the gradual enrichment of the motives of modern landscape.... The honor paid to Mr. Redfield's "February" announces the end of the probationary period of our landscape.

⊞ George F. D. Trask to Edward Redfield, May 9, 1910. Edward Willis Redfield Papers, AAA, microfilm reel 1182. Describing *Brooklyn Bridge at Night*, a nocturnal cityscape painted by Redfield in 1909:

> I heard about a very beautiful picture of yours being at Schaus gallery. I went there Saturday and saw it. It is the one of the East River and Brooklyn Bridge in the Evening. I do not know if I can file a criticism of your way of painting electric lights or not, but at all events I would like to ask you some questions about them when I see you. The picture, however, is a wonder and I am glad to have had the privilege of looking at it.

⊞ J. Nilsen Laurvik, "Edward W. Redfield—Landscape Painter," *International Studio* 41, no. 162 (August 1910): xxix–xxxvi.

> Among the men who have done most to infuse an authentic note of nationalism into contemporary American art Edward W. Redfield occupies a prominent position. He is the standard bearer of the progressive group of painters who are glorifying American landscape painting with a veracity and force that is astonishing the eyes of the Old World, long accustomed to a

servile aping of their standard. He is a rejuvenating force in our art, the dominant personality of his circle, in whom is epitomized the emancipating struggle of the younger men. The leaders of this new movement, which is quickly changing the established current of American art, are Ernest Lawson, William Glackens, George Bellows, Edward W. Redfield, Elmer Schofield, Rockwell Kent and Gardener Symons.

Like the others of this energetic circle, Mr. Redfield is a realist, who seeks out and depicts with uncompromising, searching strokes the specific, visual aspects of a scene. His power of literal rendition of any particular place is amazing in its topographical veracity. He presents glimpses of nature with all the actuality of a scene viewed through a window, in which his art is a direct antithesis to that of Whistler and his followers, which is nature viewed through a temperament.... His work is highly objective. Always and everywhere his eye is on the ever-changing face of nature, noting the ever-varying aspects of the sky and land, which he has recorded with unerring precision in a long series of brilliant, vibrating canvases....

To-day Mr. Redfield, though only just turning forty, stands as the foremost exponent of a virile, masculine art that strongly reflects the times in which we live. Winter is his most constant theme, upon which he plays variations. No changing phase of an apparently monotonous subject escapes him; each is recorded with a keen eye for differences, as, for example, his suggestion of the dry, powdery snow in the canvas called *The White House* as compared with the soggy, wet, disappearing snow in *The Road to Center Bridge*....

[H]e has learned the great lesson of simplicity, known of the Japanese, who also loved to depict the winter with its bare trees, its sharp horizons, its wide stretches of snow-covered ground, broken here and there only by a clump of weeds or protruding laurel which gives a certain dramatic intensity to an otherwise commonplace scene, as in the case of his *Hill and Valley* or fine majestic *Cedar Hill*, both of which are distinguished by a large simplicity of design....

There is nothing flamboyant or rhetorical in his art. He neither epitomizes nor philosophizes, nor is his work touched with any of that dreamy and speculative hyperestheticism that is emasculating a section of our art.... In his manner and method of painting his work is a reflection of the methods of the impressionists which he has adapted to his own uses. And while his work is intensely local in its subject matter his manner of treatment is thoroughly advanced and modern, expressed with an almost amazing virtuosity—which is, however, the final result of long, persistent effort to acquire complete control of his medium.

⊞ Helen W. Henderson, *The Pennsylvania Academy of the Fine Arts and other Collections* (Boston: L. C. Page and Co., 1911), 141–43.

The influence of the work of Edward W. Redfield upon the landscape of the present day is one of the strongest in the movement of contemporary art. His work is characterized by a tremendous definiteness, a breadth of handling that is most expressive of the modern tendency.

Redfield has painted recently some springtime pictures which show a new departure in subject: they are full of subtleties of colour, of intricacies of method, very different from the old direct way and vastly richer in imagination. His later pictures have a depth, a profundity, which carries the mind beyond the surface of the canvas, deep into the atmosphere of the picture.

⊞ *An Exhibition of Paintings by Edward W. Redfield and a Collection of Works by European Masters* (Rochester, N.Y.: The Memorial Art Gallery, 1914), n.p. Published in conjunction with the exhibition at the Memorial Art Gallery (May 9–June 7, 1914), Rochester.

Among the men whose work is typical of our time and have done much to instill a distinctive note of nationalism in American art Edward W. Redfield deserves a most prominent place. An avowed realist his art is concrete and explicit, depicting with extraordinary truthfulness the aspects of nature. Winter has furnished him with most of his themes; his greatest successes were achieved in the presentation of atmospheric and climatic effects peculiar to this season. Most sensitively alert to the ever-changing phases of his subjects his keen eye records the differences with unerring fidelity—here, deftly suggesting the soggy, wet, melting snow—there,

the dry, powdery surface as it appears in zero weather—again, he successfully gives the effect of a heavy snowfall with thick, gray atmosphere threatening still another storm, while often he pictures the bright, crisp scintillating effect of sunlight as it flits across the snow-covered fields. Mr. Redfield works almost exclusively out of doors. In the Delaware valley and the Pennsylvania hill country around Center Bridge, where he lives, every inch of ground is familiar to him. When he has selected a subject for presentation he studies it most analytically and carefully observes under which atmospheric conditions it appears to best advantage, often going a dozen times to the spot before it seems ripe to him. The painting when once begun is executed with amazing rapidity; such is the virtuosity that most of his canvasses are completed in a single sitting. Thoroughly conversant with the principle of impressionism as discovered by the Frenchmen, he has evolved a style of his own. He works with a full brush, and vigorously in the most direct manner possible, lays in his subject with pure, vibrating and luminous color. Few artists succeed in creating such a perfect illusion of out door light and sense of actuality.

▣ J. Nilsen Laurvik, "Edward W. Redfield," essay in *Catalogue de Luxe of the Department of Fine Arts, Panama-Pacific International Exposition,* vol. I (San Francisco: Paul Elder and Company, 1915), 36–38. This essay is almost identical to Laurvik's article on Redfield appearing in *International Studio* 41, no. 162 (August 1910): xxix–xxxvi.

Among the men who have done most to infuse an authentic note of nationalism into contemporary American art Edward W. Redfield occupies a prominent position. He is the standard-bearer of the progressive group of painters who are glorifying American landscape painting with a veracity and force that is astonishing the eyes of the Old World, long accustomed to a servile aping of their standard.

Like most of his contemporaries, Mr. Redfield is a realist, who seeks out and depicts with uncompromising, searching strokes the specific, visual aspects of a scene. His power of literal rendition of a particular place is amazing in its topographical veracity…. Always and everywhere his eye is on the ever-changing face of nature, noting the ever-varying aspects of the sky and land, which he has recorded with unerring precision in a long series of brilliant, vibrating canvases….

Today Mr. Redfield, though only just turned forty, stands as the foremost exponent of a virile, masculine art that strongly reflects the times in which we live. Winter is his most constant theme, upon which he plays variations. No changing phase of an apparently monotonous subject escapes him; each is recorded with a keen eye for differences, as, for example, his suggestion of the dry, powdery snow in the canvas called *The Green Sleigh,* as compared with the soggy, wet, disappearing snow in *Breaking of Winter,* while in *On the Delaware River* he has successfully presented the hard crust that covers the earth as in a steel jacket….

His color is fresh, alive and beautiful, laid on with a crisp, trenchant touch that bespeaks a robust, masculine vigor. His technical procedure reflects a close and intelligent study of the methods of the Impressionists, which he has adapted to his own uses. And while his art is intensely local in its subject matter his manner of treatment is thoroughly advanced and modern, expressed with amazing virtuosity which is, however, the final result of a long, persistent effort to acquire complete control of his medium.

▣ Eugen Neuhaus, *The Galleries of the Exposition: A Critical Review of the Paintings, Statuary, and the Graphic Arts in the Palace of Fine Arts at the Panama-Pacific International Exposition* (San Francisco: Paul Elder and Company, 1915), 65–66.

Gallery 88. REDFIELD. As a realistic painter of the outdoors, E. W. Redfield holds an enviable position in the field of American art. He is the painter *par excellence*, without making any pretension at being anything else. The joy of putting paint on canvas to suggest a relatively small number of things which make up the great outdoor country, like skies, distance, and foregrounds, is his chosen task. He is the most direct painter we have. With a heavily loaded brush, without any regard for anything but immediate effect, he expresses his landscapes

candidly and convincingly. He is plain-spoken, truthful, free from any trickery—as wholesome as his subjects. His *a la prima* methods embody, to the professional man, the highest principle of technical perfection, without falling into a certain physical coarseness so much in evidence in most of our modern work. His sense of design is keen, without being too apparent, and the impression one gains from his works is that they are honest transcriptions of nature by a strong, virile personality. Winter subjects predominate in his pictures, and he expresses them probably more convincingly than others—though his *Autumn* is marvelous in its richness of colour, and in the two night effects of New York he shows his acute power of observation in two totally different subjects. His art is altogether most refreshing and free from all artificialities.

⊠ "Who's Who in American Art—E. W. Redfield," *Arts and Decoration* 6, no. 3 (January 1916): 135.

Mr. Edward W. Redfield is the original Redfield, the instigator, the incentive of official American landscape painting, the object of which the majority of landscape painting, mirrorwise, is the reflection. He is the original Redfield—the other Redfield's [sic] bear different signatures—and inspecting them carefully one may unearth these signatures and know surely that they are not from the hand of the original Redfield. The original is physically short of six feet in height. But the symbol of him, reached perhaps by politics, rises four feet or more, more or enough to tower above the statesmen of the politicians of our art, and from the pinnacle thus made, to domineer over all official situations. This may be why Mr. Redfield has won all the prizes—it cannot be that any have escaped his efficient scrutiny—offered regularly at the regular exhibitions. He has been the recipient of a considerable amount of praise, at the same time that whispered suspicions and no end of scandal, art scandal be it understood, have hovered about him as persistently as atmosphere....

Everyone knows Mr. Redfield, the artist, as a painter of unusual placidity—the first American to delineate landscape with a No. 12 brush—a broad painter, sometimes described as a rugged one. His pictures and the influence of his pictures are to be encountered everywhere, where landscapes are to be seen. There may be in this something more than the obvious flattery which rides along seated beside imitation. Here again we are at a loss. But, it has been claimed very often by poets that artists, more than any other class of men contain the spirit of eternal youth. If this be true, then the explanation of the imitation of Redfield is within our grasp. Mr. Redfield, in conjunction with painters from Boston, who treat their pupils kindly, is said to have cornered the market of prizes. If this, in turn, be true, and it is among those whispered suspicions, then the summing up is complete. You can arrive at the answer yourself readily—youth, endless school days, prizes.

⊠ Birge Harrison to Edward Redfield, April 2, 1916. Edward Willis Redfield Papers, AAA, microfilm reel 1182.

I simply cannot resist the impulse to congratulate you on your work. You are growing!... Your technique of course has always been of the first order, but in the group which you showed us yesterday there was a remarkable development of the poetic vision, a wonderful brooding sense of beauty which made me forget the marvelous technique without which it would have been impossible.

⊠ *Exhibition of Paintings by Edward W. Redfield* (Grand Rapids, Mich.: Grand Rapids Art Association, 1916), n.p. Published in conjunction with an exhibition shown at the Grand Rapids Art Association (October 5–30, 1916), Grand Rapids.

Mr. Redfield is perhaps the most eminent among all of our realistic landscape painters of today. He portrays the American landscape just as it appears, just as we see it in our everyday journeyings. His pictures are full of national characteristics. They are honest, frank, analytic, but his execution once begun is rapid almost beyond belief. He represents a most forceful way and phase of our landscape art—that is, the realistic phase. It is not imaginative painting, not symbolic painting, not painting imbued with the most subtile [sic] aesthetic qualities; but it is a vigorous, true interpretation of American landscape as the average American sees it.

⊠ "Art Notes," *Baltimore News*, undated newsclipping. Edward Willis Redfield Papers, AAA, microfilm reel 1184. Review of the Seventh Exhibition of Oil Paintings by Contemporary Artists at the Corcoran Gallery of Art, December 21, 1919–January 25, 1920.

> The most brilliantly beautiful landscape in the whole show, according to my own way of thinking is Edward W. Redfield's "Spring," a superb piece of workmanship, riotous in vibrant color and infused with the very spirit of resurgent life. Had it been in the competition I do not know how the jury could have failed to give it first place.

⊠ "Pittsburgh: Poor Place for Painting," undated newsclipping. Edward Willis Redfield Papers, AAA, microfilm reel 1184. Article discusses Redfield's painting in Pittsburgh and his participation as a juror in the 1919 Carnegie International Exhibition.

> "What kind of climate has Pittsburgh for painting?" Mr. Redfield was asked. "Very difficult," he replied. "The moisture in the air and the general smoky conditions are discouraging for oil. The entire state, however, presents most excellent scenery for landscape work. I have been able to produce a few landscape paintings even in the vicinity of Pittsburgh that have been praised rather highly. But on the whole it is rather difficult to mix the paints properly. It seems strange that this peculiar climate should be chosen for the exhibition of something seldom produced here."

⊠ "Art: Redfield in a One-man Show at the Art Club—Examples of Delaware Valley Scenes on Canvas," *(Philadelphia) Public Ledger*, November 21, 1920, Magazine section, 8.

> The painter to quote himself has truly made the Delaware Valley his own backyard and he has redeemed the chill of winter by those intimate touches of village life that throw the glamour of human associations over the most unpromising of subjects. And now that he has added the lush lure of "blossom time" to his gamut of choice, to his calendar year, the varied appeal of his canvasses make this exhibition one of unusual weaving with poesy not wanting....

⊠ Edith Powell, "The 117th Annual at the Academy of Fine Arts Representative of National Art in Oils and Sculpture," *(Philadelphia) Public Ledger*, February 5, 1922, Music and Art section, 12.

> E. W. Redfield's large snow scene represents this painter in full power—and in a very different mood than in his "Boothbay Harbor" in Gallery B. "The First Snow" is large enough to produce on the beholder the feeling of being present, of being enveloped, as would not be possible, whatever its size, were not the strictest fidelity to nature maintained—yet one does not get the slightest impression of a colored photograph as one does from Paxton's smooth interiors in the same room. The children with sleds, the bridge, the houses with the good fire within, and the sleigh winding up the hill, all make for a human interest that is charming, naïve and universal. But the eye is carried up to the murky distance in the background by the canny compositional position, tones and shapes of the various objects. Every inch of the canvas is thoroughly managed, and without the least hint of effort. There is no impediment of paint. Mr. Redfield is the master draftsman, and one looks to him also for truthfulness, good judgment and performance.

⊠ F. Newlin Price, "Redfield, Painter of Days," *International Studio* 75, no. 303 (August 1922): 402–10.

> Redfield has no love for the heart of the town, the pageantry of the city streets, the receptions and teas and social whirl.... He is in truth, just what he seems to be, direct, keen, a fine companion and thorough workman, a man of the hills and the mountain streams.

> With nature he lives, very much a part of her moods and transitions. When the floods have passed and the sun warms the earth, he is very busy with his garden and the blossoms that he loves to paint—peach and pear and apple, and the snow white cherry trees against the hills with the river beyond. There is nothing manufactured about his art, no over refining.... He wants to portray nature, and as one day is so different from another in atmosphere and light,

it has been his effort to record that actual day, rather than some impression that might evolve in the studio. So you will find some of his paintings named after a day, "March First," "March Second," or "The Day Before Christmas." They are in reality portraits of days.

◨ F. Arline de Haas, "Edward Redfield Qualifies as a Lightning Painter Making Fourteen Canvases in Fifteen Days' Work," *(Philadelphia) Public Ledger*, August 17, 1924, 10.

"The spring this year was fine for painting," said Redfield…. "There was a great play of color, and the late winter gave it a freshness. I have painted winter so much, and yet I never tire of it. But in those first days of May and June everything seemed so paintable that I want to get out and get it down on canvas."

Then there are a number of canvases from Boothbay Harbor, Me., where Redfield spent a part of his time during June and July. Here are paintings very different in subject from the winter canvases, paintings of water, the harbor, the little boats and the white birch trees.

Here is the deep blue of the bay, the points of land jutting out into the water, the town on the distant shore, and the fishermen's huts on the edge of the shallow beach; whitecaps lashed by the frenzied winds into leaping dashing wavelets, rocking the boats tied in their land moorings. They are fresh and vigorous, these canvases, brushed with the tang of salt air, wind swept spaces violently active.

"Water is hard to paint," says Redfield. "I've been trying to get the movement of it; the feel of the wind playing over the harbor; the color; the life. I've only been going up there painting water for a few years now. Maybe after seven or eight years of painting water I'll be able to get what I want. But out of fifteen days' work up there I got fourteen canvases; so that wasn't so bad."

Fourteen canvases out of fifteen days' work, and there would have been fifteen, Redfield explained, "only one day the wind was so strong that it was impossible to moor the easel and keep the canvas in place." Few artists work so passionately and so devotedly. But Redfield knows landscape. There is no hesitancy about his work; no deliberation. He is certain of the placement of things, of his medium. He knows what he wants to paint, and he paints it.

The certainty, that vigor is characteristic of the personality of Redfield. To look at his painting is to see the reflection of the character of the artist. He says what he means, says it quickly, says it well, and then stops. That is all in his paintings. For Redfield completes his largest canvases and many of them are tremendous in size—in about seven hours. His smaller canvases are completed in from four to five hours.

"I don't care how you paint," says Redfield. "It's the production that counts. It may take you seven hours to complete a canvas. But when it is finished, it satisfies, then the painting is justified. For the end justifies the means. As for myself, I would rather go out and finish my painting on the spot, that is all."

"But whatever the painting is when it is finished, I don't care, just so long as it doesn't have to be explained. That's not art—that's conversation. Painting and literature are two different things. The writer presents a picture through words, and if the picture is really presented he doesn't need paint to illustrate his meaning. The artist presents his subject directly to the physical eye. And words should not be required to explain it."

"ANY ART that requires explaining is not good art, in my opinion. The artist must put himself into the painting, understand and have an all consuming love for his work. That is to me the glaring failure of so-called modern art. It's sensational, and sensationalism has nothing to do with art…."

◨ *Academy Notes*. Albright-Knox Gallery, Buffalo Fine Arts Academy 19, no. 2 (July–December 1924): 47, http://www.albrightknox.org/arc/an/1924–53.htm.

Richness of effect is obtained with ease from the master brush of Edward W. Redfield. The first American landscape to be purchased by the French government for exhibition in company with

Whistler, Sargent, and other Americans at Luxembourg Gallery was "February," by Redfield. In the eighteenth Annual Exhibition of American Paintings, three of his finest productions are to be seen at the Albright Art Gallery. They are "Hill Top and Valley," The Upper Delaware," and "Spring Blossoms."

⊞ J. K., "Redfield to Exhibit at Art Gallery: Eleven Pictures by Famous Artist Will Be on View at Institute on First of Month," *Milwaukee Journal,* October 25, 1924, newsclipping. Edward Willis Redfield Papers, AAA, microfilm reel 1184.

"Laurel Run" is a winter scene quite different from the one of falling snow. Here Mr. Redfield seems to disclose the mysteries of some tangled place deep in far woods where a stream tumbles over stones between banks of broken snow. There are flashes of light on the hurrying water, gleam of golden leaves in the undergrowth, and green still crowning the brookside bushes. Here is the tang and zest of winter, even as in the other were the quiet and its peace.

⊞ Clyde H. Burroughs, "Institute shows Redfield's Winter and Spring Scenes." [*Detroit Saturday Night*, June 8, 1920–handwritten annotation. Annotated date appears to be erroneous. Redfield's work was the subject of a solo exhibition at the Detroit Institute of Arts in June 1929.] Edward Willis Redfield Papers, AAA, microfilm reel 1184.

A "ONE-MAN" exhibition of 35 paintings by Edward W. Redfield is the June attraction at the Art Institute. The Detroit Institute of Arts has not held a "one-man" exhibition of the works of Edward W. Redfield since the purchase of *Grey Days* from the W.C. Yawkey Fund in 1909, when this American painter had just reached the full maturity of his powers. At that time he was something of an innovator, a vigorous personality and an incisive realist.

In his earlier painting, Mr. Redfield confined himself largely to winter-bound scenes like his *Winter Day* in this exhibition or the *Village in Winter*, showing the dead grasses proving through the sunlit snow and relieved by the blue river beyond. It was this phase of his work which brought him a bonze medal at the Paris Exposition in 1900 and the Temple gold medal at the Pennsylvania Academy of the Fine Arts in 1903.

As a snow painter he differed from many of his predecessors, who softened the rigors of winter with a romantic point-of-view. His was a bald and truthful portrayal of crusty snows and wintry blasts to brave which made the blood tingle, yet there is always in his pictures the … [hint] of coming spring in the warm sunlight which leaves long blue shadows upon the snow. His pictures were liked for their truthful portrayal of a seasonal experience and other snow painters followed his example, giving rise to quite a coterie of realists.…

In the meantime, the range of his painting gradually increased. He became interested in the luxuriant spring that follows hard upon the heels of winter and these pictures such as the *Cherry Valley* or *April Buds* are painted with the same realism. Gorgeous they are in the fresh green and purple tints of spring and livened by white and pink blossoms of fruit trees, yet there is a suggestion of lingering cold in the atmosphere and in the chill blue waters in the valley.

Nearly every large art museum in the country as well as the Luxembourg in Paris possesses a picture by this virile American artist, whose highly localized portrayals are in accord with the universal.

⊞ "Folks Worth Knowing in the Delaware Valley," *Lambertville (N.J.) Record*, October 24, 1929.

I once spent a day with Edward Redfield scouting around the country looking for antiques. The vigorous tirelessness of the man, in such a tiresome pursuit, was typical of the enigmatic life he lives—both in play and in work. Even in repose there is an aura of force emanating from him. He is sixty years of age and his hair and mustache are powdered with gray. But his intense brown eyes are ageless, and the rugged animation of his physique lives in the vivid stimulating landscapes he paints.

That vigor, for instance, was exhibited when he bought outright a plot of ground overlooking the Delaware at Pt. Pleasant in order to preserve it and paint the beauty of its surroundings. He had painted there many times, and loved it. Then came a rumor that this ground—three acres belonging to Michael Mullen—was to be subdivided and built with bungalows. He couldn't bear the thought, and he immediately bought it.

When I spoke of it the other day he replied with actual reverence in his voice. "There is a real 'church': go there at sundown and watch the changing colors in earth and sky and water, it is a place to worship!"

And then to prove the many facets of beauty the site commands, he brought out canvas after canvas, all painted from points within a radius of a few hundred yards—the Delaware in Winter, snow-clad hills, blossom-decked trees, haunting greens of summer and colorful scenes of Autumn. "And that isn't all," he said. "There are others scattered all over the country."

Of course Redfield is most widely known for his snow scenes. He was the first American painter to glorify the beauty of snow-clad hills and trees, ice-bound streams and the cold majesty of winter skies, and win renown by it. Not only that, but he did it in the face of advice to "drop it!" Fritz Thaulow had done winter landscapes in France. "He told me," said Redfield, "that the public didn't like snow scenes, and that I had better give them up."

But Thaulow was an "indoor" painter—he worked from memory and photographs, Redfield painted in the midst of things—he felt the biting cold of snow scenes as he pictured them, and that atmosphere of realism was conveyed to his canvas. He loved such scenes too much to give them up simply because the public didn't like them. And this urge he felt was so subtlely imparted to his subjects that it wasn't long before he had made the public like them....

Doesn't all that sound formidable? But Redfield isn't formidable when you know him. Of course there are legends of his gruffness, but he is one of the most human individuals I ever knew—human and lovable. He is a busy man—a man with unusual animation and vitality— and it is only natural that he has no time for dilettantes and busy-bodies. But his heart is as big as his vigorous body—and as gentle as the lovely flower garden he painted this summer on the coast of Maine, together with an incredible number of canvases he brought back....

⊞ Dorothy Grafly, "Redfield: Subject of One Man Show at the Art Club: Subtle Studies of Snow, Vigor in Nature," *(Philadelphia) Public Ledger*, December 8, 1929, Art, Resorts, Tours, and Travel section, 9.

Redfield's art is the result of a single objective. He cares intensely for that objective and his work is marked by convincing sincerity. It does not try to be other than it is, nor is it groping for something to say. It strikes out directly and without compromise....

"Things that influence an artist most in his development are often not really associated with any of the schools he may have attended," said Edward W. Redfield as he was assembling his canvases in the Art Club gallery.

"I was 15 years old when I entered the schools of the Academy; and even at that age I had come under an influence that is, perhaps, the most dominant even today in the shaping of my canvases.

"There was a man named Rolfe—I can't even remember his first name now—who made crayon portraits over solar prints. He had a studio on Arch Street and I went to him to prepare myself to enter the Academy. From him I learned the one-go shot—the value of beginning and finishing what I had to do at a single sitting. Almost all my work I have accomplished in this manner...."

In 1898 he settled at Center Bridge, along the Delaware, in a house situated between the river and the canal. In the early spring when ice began to break, the Redfield family moved upstairs and listened to miniature ice-bergs crashing against the walls in what were normally the living quarters.

For three successive years Redfield not only painted winter, but had intimate experience with chunks of it floating around at flood season in his own house….

Snow as Redfield paints it is subtle and ever changing, sensitive in color quality and in play of light and shade. It is snow with sense of the land beneath it, and the dome of the sky above it. In a Redfield landscape all parts are proportionally related. There are fine perspective and a feeling for the out-of-doors that can only come through long years of direct contact.

For Redfield there is beauty in reality: in the world as he sees it and feels it. Thus he paints it, neither attempting to twist it to suit his fancy nor to geometrize it. His clouds are wisps that hold their place in the dome of the sky. They are never hard little white balls, nor fluted cotton batting. His skies have depth, and the sense of air-filled space, supported by the delicate and subtle tonal differentiation of varying degrees of blue intensity. "Overlooking the Valley," one of the exquisitely handled snow scenes, is eloquent of the painter's ability. From the snowy foreground hill the eye is drawn down to the distant light blue river curving past lavender-wooded hills. There is a rustle of crisp little brown winter leaves on the bare foreground trees. There is the accent of pointed cedars. The trees on the hill are spindling, wind-bent and bare. There is a chill in the sunlight, and the dome of the light blue sky pulsates in color quality. The reproductive finesse of the technique is forgotten in the sincere conviction that here is beauty in nature. And it is the beauty, not the actual scene, that the painter is attempting to recreate. Because he himself, is emotionally sensitive to its subtleties and its charm his art carries the intensity of his conviction.

In his winter landscapes he achieves varying effects. Now it is hard, shining, crusted snow, the icy hard packed snow that shapes definite embankments and holds long slim tree shadows; now it is light fluffy snow, newly fallen with soft light glints and sun warmth. "River Hills," " Snow Drift," "Lumberville," and "Winter Brook" are all eloquent of these variations on a winter theme.

But there comes a time when the earth is swollen with snow water and only remnants of white winter lie in road ruts and hill hollows. The brown of earth is churned by passing wheels, and the country roads undulate with choppy moisture. "Early March" speaks for the thawing season, and leads one on to spring and the delicate color haze of early blossoms.

Spring in the Delaware Valley is another opportunity for the artist who is sensitive to natural beauty. In his spring landscapes Redfield is always conscious of the moist land and the warmth of sunshine. But there is still a slight chill in the blue of the sky. "April Buds" hold the nice balance between seasons, while "Schneider's Inn" on the low road by the river at Point Pleasant and "Heralds of Spring" on Point Pleasant hillsides, have in their pigments the lush sense of green growing things, and the fresh breezy delicacy of young blossoms and trees just waking from bare winter.

In 1902 Redfield first began his summer pilgrimages to Maine. Winter and spring in the Delaware Valley left a long period of months that were, to him, lost opportunity. He was not interested in the summer greens, and his enthusiasm wilted under the valley sun. New England was more bracing, and there was new fascination in its blue seas that were not always blue and almost never consistently so. The old-fashioned moss-grown stone houses of the Pennsylvania countryside expressed in such canvases as "Country Life" and "Winter Sunlight" gave place to the color subtleties of lavender gray shingles echoed by lavender-gray rocks, and punctuated now and again by the accent of flower gardens. It was an entirely different country with a new flavor….

For Redfield loves the sea and a house by the sea. He has his own home in Boothbay Harbor and he grooms his own boat. He enjoys more tools than a paint brush and he can turn the legs of a Windsor seat with as much facility as he can turn a wave in a marine. Anything that requires skill of and interest of design attracts Redfield's attention. In his studio he has carpentering tools as well as brushes, and one of his latest achievements is the fashioning of a Windsor love seat, with nicely proportioned hand-turned legs.

His interest in designing and making things extends also to hooked rugs one of which titled "The Wedding" will be added to his exhibition of paintings.

⊠ "Redfield's Show at the Art Club," newsclipping. Edward Willis Redfield Papers, AAA, microfilm reel 1184. Review of Redfield's 1929 solo exhibition at the Art Club of Philadelphia.

An unusual composition of the same artist occupies a prominent place in the gallery. It represents "The Burning of Center Bridge," a theatrical night scene which was painted from memory the morning after the conflagration. All the other paintings were painted direct from nature and completed in from three to nine hours. In this picture of the fire Redfield shows a group of spectators and the firefighters on the bank of the river silhouetted against the flames from the burning bridge. The result is quite impressive.

⊠ "Exhibition Notes, Edward Redfield," *The Arts,* January 1930. Edward Willis Redfield Papers, Archives of American Art, microfilm reel 1184. Review of Redfield's solo exhibition at Grand Central Art Galleries.

His greatest strength is perhaps that he has Americanized impressionism. I, for one, doubt if this result is due to any intellectual theorizing. I suspect that the Americanization of impressionism has come about in Mr. Redfield's long productive output through very simple processes. Obviously he likes to paint; equally obviously he looks upon paint as his job. Since he is a painter and is a normal healthy man endowed with energy he does his job just as well as he can, flinching at no obstacles of weather or of technical adjustments....

[H]e is a first rate, honest, and able maker of pictorial statements of what he sees in the American landscape.

⊠ Helen W. Henderson, "Redfield in New York," January 11, 1930, newsclipping. Edward Willis Redfield Papers, AAA, microfilm reel 1184.

This is Redfield's first one-man show in New York. It comes in part from his recent showing at the Art Club in Philadelphia....

"It is difficult to write an appreciation of the work of an artist whose art has been appreciated for so many years." This phrase comes from the introduction to Warshawsky's exhibition, in the Newhouse galleries, but is especially true of Redfield. He has enjoyed all the honors in many parts of the world. He is represented in all the local museums as well as the Luxembourg of Paris. His pictures have been extensively bought by private collectors. His career is one of uninterrupted success. We have spoken for years of his prodigious energy, the amazing vitality of his canvases, their truth to nature. Sometimes in the past he seemed to search more deeply into the mysteries of the subject to seek to grasp more of the intellectual content of art and from time to time has produced such a canvas as "The Grey Veil" (not here shown), which was an immense advance over the usual output and showed the artist on the heights, still climbing, still seeking to see further and know more.

⊠ Newsclipping. Edward Willis Redfield Papers, AAA, microfilm reel 1184. [Handwritten in script: "By Cortissoz/ N.Y. Herald Tribune/ Jan 12."] Review of exhibition of landscape paintings by Redfield held at Grand Central Art Galleries, New York, January 7–31, 1930.

Their outstanding merit springs from the artist's directness in the notation of his impressions. He is a forthright realist, objective in the last degree but so vivid is he in the registration of truth that the sentiment as well as the tangible phenomena of his subjects find expression in his work. He, like Brush, is a master of his craft. Tree and ground forms are vigorously drawn, local color is accurately stated, and his picture is invariably well built. Many of his paintings, those of wintry scenes, are in a rather bleak key, but in a few, like the "October Breeze" or the "White Islands," he lets himself go in a delightful pursuit of the glamour of color. He is most persuasive of all in the interpretation of landscape character, especially where it is accented by architecture. There is something very appealing about a design like the "Winter Sunlight" or the "Other Days," with their gray buildings lifted above the snow. One is carried into an intimacy with the very heart of an American scene. There is so much good workmanship in

these landscapes and so winning a veracity that we wish certain things might be added to Mr. Redfield: a trace of subtlety and, in his surfaces, a finer quality. But their integrity as they stand leaves a deep impression.

⊠ "Redfield's Canvasses, Demonstrate American Point of View," *New York Eagle*, January 12, 1930, newsclipping. Edward Willis Redfield Papers, AAA, microfilm reel 1184. Review of exhibit at Grand Central Art Galleries.

It is a curious thing that in the several recent efforts made to isolate leading tendencies in American art, Edward Redfield's contribution should have been so consistently ignored. The ... paintings, which comprise his recent one-man show at the Grand Central Galleries are convincing verification of the opinion long held by the writer, that Mr. Redfield's work, in its straightforward, often sensitive realism, is not only typical of a clearly defined traditional form of Americanism, but in common with all genuinely felt aesthetic reactions to life when combined with technical mastery, constitute a vital contribution to contemporary art.

The subject matter is, as always, informal aspects of the American country side. Monhegan landscapes having been added to the more usual views about New Hope. This is American landscape as it appeared to Thoreau and Whitman and as it appears to those Americans who find the rocks and sea of the Maine coast, the fields and woods of Massachusetts and Pennsylvania as aesthetically and emotionally stirring as the storied paintings localities of Europe. That Mr. Redfield expresses this reaction in direct terms, uncomplicated by currently emotional and technical stylisms, is another evidence of his American characteristics ingrained in the face of whatever temporary externalities and European borrowings may be superimposed.

⊠ *Art Digest*, clipping. Edward Redfield file, Pennsylvania Academy of the Fine Arts Library. [Typewritten annotation: mid-January 1930.]

When the Grand Central Art Galleries, New York, were arranging the present exhibition of 46 of Edward W. Redfield's paintings, the artist rather facetiously wrote to the management that he wasn't counting on getting much publicity, because: "I haven't anything to offer except a normal life and paintings that are too readily understood by the ordinary observer; no puzzle pictures and no bananas."

But Mr. Redfield got plenty of publicity of the most wholesome kind, from both the radical side and the conservative side of the camp. The Brooklyn *Eagle* modernists said: "The paintings are convincing verification of the opinion long held by the writer that Mr. Redfield's work, in its straightforward often sensitive realism, is not only typical of a clearly defined traditional form of Americanism, but, in common with all genuinely felt esthetic reactions to life when combined with technical mastery, constitutes a vital contribution to contemporary art." The modernistic *Post*: "He exemplifies the more familiar tradition of American painting since he is first and last a landscape painter, depicting the American scene with directness, spontaneity and an unforced note of delight in each new theme."

The conservative *Herald Tribune*: "He is a forthright realist, objective in the last degree, but so vivid is he in the registration of truth that the sentiment as well as the tangible phenomena of his subjects, finds expression in his work. He is a master of his craft. Tree and ground forms are vigorously drawn, local color is accurately stated, and his picture is invariably well built."

⊠ Frank Jewett Mather to Edward Redfield, [?Jan] 23, 1930. Edward Willis Redfield Papers, AAA, microfilm reel 1183.

"Overlooking the Delaware" is stunning—quite takes my breath away.... You take a very modest view of your talent, but I'm sure you'll be remembered, as will a handful of your contemporaries who have captured the brightness and charm of appearances, long after the kids who are making rakimus as they call it, are forgotten.

⊞ Charles V. Wheeler, "Redfield's One-Man Show," *American Magazine of Art* 21, no. 3 (March 1930): 139–42. Review of one-man show, which moved from the Art Club of Philadelphia to Grand Central Art Galleries in New York, January 7–31, 1930.

These paintings, forty in number, have with one exception, been made during the past five years. Redfield paints directly from nature, but he has a remarkable memory for the changing conditions of light and shade, a memory which stands him in good stead during his manual labor of putting paint upon canvas with brushes stiff but flexible enough to respond to the nervous brain messages finding their way to the sensitive fingers and then to the canvas on which is re-created an effect that becomes true and complete to you and to me when we see the picture at a distance of several feet to the rear of the painter when at work....

At the Philadelphia Art Club the hanging and arrangement were excellent; each picture was framed differently and appropriately; the whole group was brought together in a unified, decorative scheme.

Here the dimensions of the single exhibition room were so limited that the wall spaces presented one long surface opposite the entrance doors, a shorter surface at each end of the room and two still smaller areas at either side of the doors. In this case the artist arranged his pictures in groups of center-pieces important in size flanked by double rows of smaller pieces in such a manner that a variety of effect of color spots and of darker and lighter mass spots made harmonious units without disturbing the grand balance of the whole wall or the room itself.

That was an artful manner of treating a one-man show but, in the rooms of the Grand Central Art Galleries, the paintings were given a better showing because two galleries were used and the paintings hung in a single line....

Redfield is particularly interested in certain artistic crafts which flourished in our colonial settlements but which died out years ago. The hook-rug, influenced but not copied, takes on new life and possibilities under his knowledge and taste. He kindly lets us see in this exhibition the last of a series of six rugs which he made with the help of Madame Redfield. This was the "Village Wedding," a bright-colored example which suggested new glories for our walls and floors. He also exhibited a neatly made unpainted "Windsor Settle," which he produced by means of his own lathe and plane. He is proud of his carpentry and he might have seen an example of his own fabricated and painted Dutch wedding chest, which, enriched by decorative harmonies of fruits, flowers, animals, bird, etc., in gold and colors is covetable indeed. The furniture and the hooked rugs Mr. Redfield produces he can never afford to sell because they take so much more time to make than to paint a landscape, and landscape painting is his life work.

⊞ Homer Saint-Gaudens to Edward Redfield, November 27, 1937. Edward Willis Redfield Papers, AAA, microfilm reel 1183.

Bless you for your canvas. It adds strength and stability to an uncertain world. It is a tough life trying to get the right of it and argue out things on their merits so when I have one foot firmly planted on a base as substantial as yours, I am more happy.

⊞ Albert Sterner to Edward Redfield, February 6, 1939. Edward Willis Redfield Papers, AAA, microfilm reel 1183.

Today I ventured forth and went to a jury meeting at the Grand Central Galleries.... How refreshing it was to come suddenly upon your brave blossom picture painted, as you always paint, from the shoulder. It is splendid—full of fresh air and running water and breeze. Nelson and I stood for quite a while before it and I told him something about "just *values* and fine *seeing*."...

⊞ "Center Bridge Artist Found Fame in Solving Problems," *Trenton (N.J.) Evening Times*, November 16, 1948.

As a "pioneer" artist Redfield had a number of problems to solve. The parallel lines of river bank and skyline seemed monotonous on canvas. "How to break up those lines. From what angle to paint the river. This was the kind of stuff I had to dig out myself," says Redfield.

He had studied art for eight years at the Pennsylvania Academy and in Paris. But he says he felt he "had it all to learn" when he first started to paint nature on his own. "Of course you have to learn the trade of drawing so that you've got something to tell your message with. But real art comes from feeling—loving your work. Therefore, I've never felt that art could be taught," he explains.

"But nature will teach you sooner or later if you have any sense at all," says Redfield who started out to paint nature as he saw it. " I didn't think so much of the pictorial quality of the finished painting as I did of trying to master the thing I was painting."

"That meant long hours of standing in the snow trying to put on canvas such things as the freshness of the first snowfall. It also meant learning such elementary things as how to dress for an all day painting session in the snow...."

"They accuse the old school of 'copying' nature. If you think nature can be copied, just try it. For one thing you'll find the light and shadows change completely in the five to seven hours it takes to make a painting. To paint a scene correctly, it may be necessary to shift a tree or leave a tree out, something the camera can't do. I have never felt that I painted a scene just right. I always feel there is something more to learn."

⊠ "Notable Winter Scenes by Edward W. Redfield to Feature March Show," unidentified newsclipping. Edward Willis Redfield Papers, AAA, microfilm reel 1184. Review of an exhibition of Redfield paintings at the Grand Rapids Art Gallery. The passages quoted from Charles Wheeler's 1925 monograph on Redfield suggest that this review was written after the monograph was published. Redfield's work was featured in a solo exhibition at the Grand Rapids Art Gallery in March 1929.

In the main gallery is a collection of paintings by Edward W. Redfield, well known American landscape painter whose winter scenes are among his most effective work....

Redfield has long since gained a position as one of the important landscape painters of the country. His aim in every landscape is to set forth the individuality of a single day or time of day on the canvas, and his work is always done at one comparatively brief setting. His preparation for a painting, it is explained, consists of preliminary careful study of his setting and the selection of the lighting as determined by the time of day. This study is made preferably the day before he paints. The work itself is done with the sureness and speed of a master of his medium.

"The brush effects," writes one critic of his work "include amazing feats in the exact placing of fat gobs of color lifted into painted peaks by pulling the brush away. The purity of color and the fact that Redfield avoids the possible chemical reactions resulting from the mixing of paints on the palette leads us to assume that his pictures will survive in brilliant condition for longer periods than have the works of the old masters. Redfield alone knows how he has progressed in his command of materials and handicraft to attain this remarkable skill."

His winter pictures, another admirer says are "notable for the animation with which he imbues this leafless season.

"His keen appreciation of the latent power buried under the snow and ice and hidden in the gaunt leafless trees infuses a sense of life," writes this critic: "The barrenness of the aspect gives no hint of a dead world—Nature is simply accumulating forces as she sleeps."

⊠ Unidentified newsclipping. Edward Willis Redfield Papers, AAA, microfilm reel 1184.

Ferargil Galleries

Mr. Redfield is one of those painters who seem to remain untouched by what we can only describe as the magic implicit in their medium. He handles pigment if not brutally, then at all

events with no obvious sensitiveness to its inherent charm. A tone with him is not a subtle thing, a thing of depth, of nuances, to be recorded with a certain tenderness. It is rather an affair of what he sees in nature, and he sees nature in a dry, almost harsh light.

⊠ Unidentified newsclipping. Edward Willis Redfield Papers, AAA, microfilm reel 1184.

This passion for snow Mr. Redfield shares with many of his contemporaries, such as Symonds, Carlson and Rosen. But he treats it in his own individual way. It is nearly always blue white, probably with tones of lavender. Nearly every artist has his particular "palette"—that is, his own range of colors, which may be found to predominate in most all of his works. Mr. Redfield is particularly fond of ochres, which appear in the golden glints of little brooks, in the wood tangles besides the brooks and in rocks and roads. The lavender tones of his snow appear in the distant hills and in the smoke haze that hangs over his views of Pittsburgh. He is … apt to choose a "low skyline"—that is, a view in which relatively little of the sky is seen. While Mr. Redfield is an impressionist, he is relatively conservative—distinctly a member of the older school of modern painters. Every artist paints nature through the prism of his own personality, but Mr. Redfield paints more realistically than many. It is interesting to contrast his work with that of Mr. Rosen, whose pictures are highly decorative in line and composition, and Birge Harrison whose paintings are usually highly poetic in mood.

⊠ *Baltimore Evening Sun*, undated newsclipping. Edward Willis Redfield Papers, AAA, microfilm reel 1184. Review of Redfield exhibition at the Peabody Gallery.

[T]here are wonderful spring scenes in an entirely unfamiliar Redfield mood, pictures with extraordinary depth and tender atmosphere, works that scintillate with light and vibrate in their freely executed technical delicacy. The mode is free and extraordinarily modern and these pictures carry far, yet they are strangely approachable. Mr. Redfield has a style quite his own. Apparently working in infinite details a closer inspection of the canvas reveals the fact that those details are after all, merely suggested but with such an amazingly sure touch that the sense of values is always quite perfect. No finer exhibition has been brought here for years. This is the kind of thing that one will return to again and again finding in it always new delights, new beauties, new inspirations.

⊠ Unidentifed newsclipping. Edward Willis Redfield Papers, AAA, microfilm reel 1184.

The strong-armed realist in Redfield is the true American type, who has evolved a breadth and vigor of brush-work suitable to American subjects. He is probably one of the last truly American types because most of the leaders of American painting who have followed him have had European ancestors and their work has more or less translated into American subject matter the impressionism of Monet or the post-impressionism of Cezanne. Of course, to this statement are many exceptions to be found definite individualists like George Bellows, Arthur B. Davies and Albert Ryder.

⊠ "A Talk with Edward Redfield," unidentified newsclipping. Edward Willis Redfield Papers, AAA, microfilm reel 1184.

Boothbay, Me. Sept 23

Two important elements of painting are simplicity and vigor. To a marked degree these characteristics are possessed by Edward Redfield. When he enters a room one not only feels the bigness and vigor of his person but the bigness and honesty of his personality….

He almost at once began to speak of his work. "Yes," he said "I am trying out some new subjects which are quite different from those with which my public is acquainted. But it's all the same … as I have no theories about painting—no theories that I can express with words, only with paint."

Mr. Redfield believes an artist should see something beautiful and try to reproduce it. His thought should be as simple, fresh, and frank as a child. Then when an idea does strike him he should paint it with all his might thinking only of the thing he wishes to express and not at all of his mode of expression. Then his public will feel the beauty of the artist's impressions and he will not need theories.

Mr. Redfield thinks a real artist paints because he cannot help painting. If he has to read and study the theories of other men to produce, he hasn't much within himself to say and the little that he does say on his canvasses will be … stupid. Theories are worthless rubbish and to spend time reading or talking theories is wasteful, Mr. Redfield declares.

In an exhibition of modern paintings he continued, there is usually someone there to explain the canvasses….

"Now I choose to be just the opposite. If my canvases don't explain at a glance what they are meant to be, they are bad—utterly worthless. I absolutely miss my point. Why anyone of ordinary intelligence can understand my work without explanation."

Probably the fact that Mr. Redfield's painting is so instantly felt and retained by his public makes him not only one of the most popular but also one of the leading American painters.

1895 Pennsylvania Academy of the Fine Arts Annual Exhibition

1898 Pennsylvania Academy of the Fine Arts Annual Exhibition

1901 Pennsylvania Academy of the Fine Arts Annual Exhibition, Chairman, Painting and Hanging; Art Institute of Chicago, Watercolor Annual Exhibition

1904 Pennsylvania Academy of the Fine Arts Annual Exhibition, Painting

1906 Pennsylvania Academy of the Fine Arts Annual Exhibition, Painting and Hanging

1907 Pennsylvania Academy of the Fine Arts Annual Exhibition, Chairman, Painting and Hanging; Corcoran Biennial; Art Institute of Chicago, American Annual Exhibition

1908 Corcoran Biennial, Selection Committee

1909 National Academy of Design Annual Exhibition and Winter Exhibition

1912 Pennsylvania Academy of the Fine Arts Annual Exhibition, Painting and Hanging

1914 Corcoran Biennial, Chairman

1915 Panama-Pacific International Exposition, San Francisco, Jury of Awards

1916 Pennsylvania Academy of the Fine Arts Annual Exhibition, Painting and Hanging

1919 Carnegie International Exhibition; Art Institute of Chicago, American Annual Exhibition

1923 Corcoran Biennial, Chairman

1926 Philadelphia Sesquicentennial Exposition, Jury of Selection, Jury of Awards, Regional Advisory Committee, and Hanging Committee

1932 Corcoran Biennial

Honors, Medals, and Prizes

1894 *Evening* and *Winter in France* win awards at the Art Institute of Chicago.

1896 Gold medal, Art Club of Philadelphia.

1900 Bronze medal, Universal Exposition, Paris. *The Bridge at Joinville* and *The Road to Edge Hill* are Redfield's entries.

1901 Bronze medal, Pan-American Exposition, Buffalo, New York, where exhibits *The Mill at Saint Maur; Charenton Bridge; Twilight, Paris; The Last Boat;* and *Evening.*

1903 Elected member of the Society of American Artists. *Winter Evening* awarded Temple Gold Medal, Pennsylvania Academy of the Fine Arts, for best painting in the exhibition.

1904 Elected associate member of the National Academy of Design. Awarded Second Hallgarten Prize from the National Academy of Design, where exhibits *Near Boothbay Harbor* and *The Harbor.* Awarded Shaw Fund Prize from Society of American Artists for *Boothbay Harbor at Night.* Serves as member of advisory committee for Louisiana Purchase Exposition and awarded silver medal for *Boothbay Harbor* at Louisiana Purchase Exposition, Saint Louis.

1905 *Hillside Farm* is awarded Jennie Sesnan Gold Medal by the Pennsylvania Academy of the Fine Arts for best landscape in its annual exhibition. *The Crest* receives Gold Medal of the Second Class from the Carnegie International Exhibition.

1906 Elected Academician, National Academy of Design. Receives Webb Prize from the Society of American Artists.

1907 Receives third prize (William A. Clark Award) from the Corcoran Biennial, where he exhibits *The Delaware River* and *Lowlands of the Delaware*. Receives Gold Medal of Honor from the Pennsylvania Academy of the Fine Arts. Receives award for *Center Bridge* and *The Valley* from the Carnegie International Exhibition.

1908 Receives Honorable Mention from the Paris Salon. *The Island* receives first prize (William A. Clark Award) from the Corcoran Biennial. *The Red Barn* receives award from the Carnegie International Exhibition.

1909 Receives second prize Harris Medal from the Art Institute of Chicago, where he exhibits *The White House* and *The Foothills of the Blue Ridge* at the American Annual. Awarded third class medal from the Paris Salon.

1910 Receives gold medal from Exposition International de Orte, Buenos Aires, for *Un Pueblo de la Colina*.

1912 *The Laurel Brook* receives Lippincott Prize from the Pennsylvania Academy of the Fine Arts (best painting in oil by an American artist); *Below the Island* and *Between Daylight and Darkness, New York* win awards at the Carnegie International Exhibition.

1913 *Cherry Blossoms* and *The River in Winter* win awards at the Carnegie International Exhibition. Awarded gold medal from Washington Society of Artists and Potter-Palmer Gold Medal from the Art Institute of Chicago.

1914 Receives Gold Medal of Honor from the Carnegie Institute, where *The Mountain and Brook* and *The Village in Winter* are exhibited in the International Exhibition.

1915 Provided gallery to exhibit twenty-one paintings at the Panama-Pacific International Exposition. Serves on Jury of Awards and receives Commemorative Medal of Bronze for Distinguished Services.

1918 Awarded Carnegie Prize from the National Academy of Design.

1919 Awarded Altman Prize from the National Academy of Design.

1920 Receives Stotesbury Prize from the Pennsylvania Academy of the Fine Arts for a group of paintings judged as the most important contribution to the Annual Exhibition. The group includes *Spring, A Frosty Morning, Coaster,* and *The Day Before Christmas*.

1922 *The Valley in Springtime* receives Carnegie Prize in the Winter Exhibition of the National Academy of Design.

1926 Serves on Jury of Selection, Jury of Awards, Regional Advisory Committee and Hanging Committee for the Philadelphia Sesquicentennial Exposition.

1927 *Cherry Valley* receives Saltus Medal from the National Academy of Design.

1928 Receives H. J. Heins Prize, Grand Central Art Galleries.

1930 Receives prize from Springfield Art Association.

1933 Receives prize from Newport Art Association.

1963 Receives Certificate of Merit from the National Academy of Design.

Solo Exhibitions

1892 Doll and Richards Gallery, Boston

1899 Pennsylvania Academy of the Fine Arts, Philadelphia (March 22–April 6)

1901 Art Club of Philadelphia (March 2–17); Saint Botolph Club, Boston (April 1–20)

1909 Pennsylvania Academy of the Fine Arts (April 17–May 16); Detroit Museum of Art (June 19–August); Albright Art Gallery, Buffalo (October 10–November 8); City Art Museum of Saint Louis (opened November 14)

1910 Corcoran Gallery of Art, Washington, D.C. (January 3–23); Saint Botolph Club (April 18–30)

1914 Memorial Art Gallery, Rochester, New York (May 9–June 7)

1916 Corcoran Gallery of Art (March 14–April 9); Grand Rapids Art Association, Grand Rapids, Michigan (October 5–30).

1917 Buffalo Fine Arts Academy, Albright Art Gallery (January 11–31); Worcester Art Museum, Worcester, Massachusetts (March 4–April 1)

1919 Memorial Art Gallery (April); Nebraska Art Association, University of Nebraska Art Gallery, Lincoln (November 15–30)

1920 Art Club of Philadelphia (November 17–December 5)

1924 Milwaukee Art Institute (November 1–30)

1925 Macbeth Gallery, New York (March 3–23)

1928 St. Botolph Club (October 30–November 17)

1929 Grand Rapids Art Gallery, Grand Rapids, Michigan (March 1–31), Detroit Institute of Arts (June); Art Club of Philadelphia (December 5–25); City Library Gallery, Des Moines Association of Fine Arts, Des Moines, Iowa (February 3–28).

1930 Grand Central Art Galleries, New York (January 7–31)

1959 Woodmere Art Gallery, Philadelphia (November 1–22)

1960 Parry's Barn, New Hope, Pennsylvania (October 30–November 27)

1961 Buck Hill Art Association, Buck Hill Falls, Pennsylvania (March 23–June 27)

1961–62 The Reading Public Museum and Art Gallery, Reading, Pennsylvania (December 3–January 28)

1968 Grand Central Art Galleries (April 16–June 14); Newman Art Galleries, Philadelphia (October 23–30)

1972 Pennsylvania State Museum, Harrisburg, Pennsylvania (March 31–May 13)

1973 Grand Central Art Galleries (July 3–31)

1982 Grand Central Art Galleries (November 22–December 17)

1975 Holicong Junior High School, Holicong, Pennsylvania

1976 Sussex County Court House, Georgetown, Delaware (November 1–5)

1981 Rutgers University, New Brunswick, New Jersey (March 9–April 18)

1987–88 Allentown Art Museum, Allentown, Pennsylvania (September 20–January 10); Butler Institute of American Art, Youngstown, Ohio (February 14–April 2)

2004–05 James A. Michener Art Museum–New Hope, New Hope, Pennsylvania (May 1–January 9); Sewell C. Biggs Museum of American Art, Dover, Delaware (January 26–April 26, 2005)

Memberships

Art Club of Philadelphia

Society of American Artists

Philadelphia Sketch Club (1903–05)

National Institute of Arts and Letters, New York

National Academy of Design

Salmagundi Club

Grand Central Art Galleries

Fellowship of the Pennsylvania Academy of the Fine Arts

American Academy of Arts and Letters

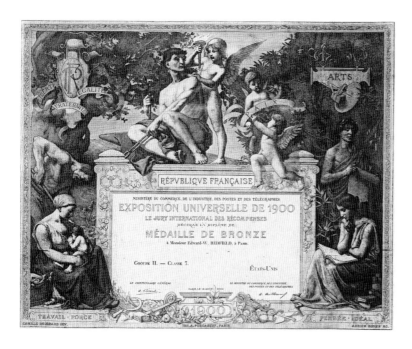

Fig. 45 Certificate awarded to Edward W. Redfield confirming that he was awarded a bronze medal for his entries in the 1900 Universal Exposition, Paris.

Bibliography

Academy Notes. Albright-Knox Gallery, Buffalo Fine Arts Academy 19, no. 2 (July–December 1924): 47, http://www.albrightknox.org/arc/an/1924-53.htm.

Adams, Brook. "American Studio Talk." *International Studio* 7 (June 1899): xiii–xiv.

Boston Evening Transcript, "Exhibition of Mr. Redfield's Paintings at the St. Botolph Club," April 2, 1901, 9.

———, "The Fine Arts … Opening of the Boston Art Club Exhibition," January 2, 1904, 6.

Boston Globe, "Oil Paintings and Sculpture Shown at the Rooms of the Boston Art Club," January 2, 1904, 7.

Boyle, Richard J. *American Impressionism.* Boston: Little, Brown, 1974.

Bregler, Charles. "Thomas Eakins as a Teacher." Part 1. *The Arts* 17, no. 6 (March 1931): 378–86.

Brinton, Christian. *Impressions of the Art at the Panama-Pacific Exposition with a Chapter on the San Diego Exposition and an Introductory Essay on the Modern Spirit in Contemporary Painting.* New York: John Lane Company, 1916.

Brownell, William Charles. "The Art Schools of Philadelphia." *Scribner's Monthly* 18 (September 1879), in Charles Harrison and Paul Wood with Jason Gaiger, eds., *Art in Theory, 1815–1900* (London: Blackwell Publishers, 1998), 648–51.

Carr, Chris. "Bucks County's Living Legend, Edward Redfield." *Panorama* 5, no. 10 (October 1963): 11–27.

Cheney, Martha Candler. "The Making of an Artist: Some Recollections of Edward W. Redfield, N.A." *Bucks County Traveler* (May 1953): 21–28.

Chris. "Boston Art Club Exhibit. Lively Interest Manifested on the Opening Day—Some of the Most Striking Pictures." *Boston Sunday Post.* April 7, 1901, 5.

Clark, Eliot. "American Painters of Winter Landscape." *Scribner's* 72, no. 6 (December 1922): 763–68.

Coxe, Reginald Cleveland. "Exhibition of Redfield's Paintings." *(Philadelphia) Public Ledger,* April 18, 1909, 8.

Dabakis, Melissa. *Visualizing Labor in American Sculpture: Monuments, Manliness, and the Work Ethic, 1880–1935.* Cambridge: Cambridge University Press, 1999.

de Haas, F. Arline. "Edward Redfield Qualifies as a Lightning Painter Making Fourteen Canvases in Fifteen Days' Work." *(Philadelphia) Public Ledger,* August 17, 1924, 10.

Delaware Valley News (Milford and Frenchtown, N.J.), "$500 For a Painting by This Neighbor—Edward Willis Redfield Was the First Artist to Discover the Valley—Yet He's Neighborly," April 27, 1934.

Denny, Sandra. "Thomas Anshutz: His Life, Art and Teachings." Master's thesis, University of Delaware, 1969.

Dyer, Walter A. "Two Who Dared—How a Well Known Artist and his Wife Cut Loose from the City and Started Life Anew in the Country with No Capital—the Building of a Studio Home." *Country Life in America* 13 (December 1907): 194–97.

Eldredge, Charles. "Connecticut Impressionists: The Spirit of Place." *Art in America* 62, no. 5 (September–October 1974): 84–90.

"Exhibitions Now Hanging: Edward W. Redfield, Paintings." *Bulletin of the Detroit Museum of Art* 3, no. 3 (July 1909): 32–33.

Falk, Peter Hastings, ed. *The Annual Exhibition Record of the Art Institute of Chicago, 1888–1950.* Madison, Conn.: Sound View Press, 1990.

———. *The Annual Exhibition Record of the National Academy of Design, 1901–1950.* Madison, Conn.: Sound View Press, 1991.

———. *The Annual Exhibition Record of the Pennsylvania Academy of the Fine* Arts. Vol. II (1876–1913), Vol. III (1914–1968). Madison, Conn.: Sound View Press, 1989.

———. *The Biennial Exhibition Record of the Corcoran Gallery of Art, 1907–1967.* Madison, Conn.: Sound View Press, 1991.

———. *Record of the Carnegie Institution's International Exhibitions, 1896–1996.* Madison, Conn.: Sound View Press, 1998.

Fletcher, J. M.W. *Edward Willis Redfield: An American Impressionist, 1869–1965: The Redfield Letters, Seven Decades of Correspondence.* 2 vols. Lahaska, Pa.: JMWF Publishing, 2002.

———. *Edward Willis Redfield, 1869–1965: An American Impressionist, His Paintings and the Man behind the Palette.* Lahaska, Pa.: JMWF Publishing, 1996.

Flower, B. J. O. "Edward W. Redfield: An Artist of Winter-Locked Nature." *Arena* 36, no. 1 (July 1906): 20–26.

Folk, Thomas C. *The Pennsylvania Impressionists.* Madison, N.J.: Farleigh Dickinson University Press; London: Associated University Presses, 1997.

Garland, Hamlin. *Crumbling Idols: Twelve Essays on Art Dealing Chiefly with Literature, Painting and the Drama.* Edited by Jane Johnson. Cambridge, Mass.: The Belknap Press of Harvard University Press, 1960.

"General Biographical Information." Edward W. Redfield's application form for membership reinstatement to the Salmagundi Club, May 12, 1947. Private collection.

Gerdts, William H. *American Impressionism.* 2nd ed., expanded. New York: Abbeville, 2001.

Grafly, Dorothy. "Redfield: Subject of One Man Show at the Art Club: Subtle Studies of Snow, Vigor in Nature." *(Philadelphia) Public Ledger*, December 8, 1929, Art, Resorts, Tours, and Travel section, 9.

Harrison, Charles, and Paul Wood with Jason Gaiger, eds. *Art in Theory, 1815–1900.* London: Blackwell Publishers, 1998.

Henderson, Helen W. *The Pennsylvania Academy of the Fine Arts and other Collections.* Boston: L. C. Page and Company, 1911, 141–43.

Kirby, C. Valentine. *A Little Journey to the Home of Edward Redfield.* Bucks County Series, Unit 3. Doylestown, Pa.: Public Schools of Bucks County, 1947.

Lambertville (N.J.) Record, "Folks Worth Knowing in the Delaware Valley," October 24, 1929.

Laurvik, J. Nilsen. "Edward W. Redfield—Landscape Painter." *International Studio* 41, no. 162 (August 1910): xxix–xxxvi.

Lears, T. J. Jackson. *No Place of Grace: Antimodernism and the Transformation of American Culture, 1880–1920*. 1981. Reprint, Chicago: University of Chicago Press, 1994.

Mather, Frank Jewett, Jr. "The Field of Art: The Luxembourg and American Painting." *Scribner's* 47 (March 1910): 381–84.

Neuhaus, Eugen. *The Galleries of the Exposition: A Critical Review of the Paintings, Statuary, and the Graphic Arts in the Palace of Fine Arts at the Panama-Pacific International Exposition*. San Francisco: Paul Elder and Company, 1915.

New Hope (Pa.) Gazette, "President Carter and His Family May Soon Have a Daily Reminder of What New Hope Looked Like a Couple Generations Ago," April 28, 1977, 5.

Pène du Bois, Guy. "The Boston Group of Painters: An Essay on Nationalism in Art." *Arts and Decoration* 5, no. 12 (October 1915): 457–60.

———. "The Pennsylvania Group of Landscape Painters." *Arts and Decoration* 5, no. 9 (July 1915): 351–54.

Perlman, Bennard B., ed. *Revolutionaries of Realism: The Letters of John Sloan and Robert Henri*. Princeton, N.J.: Princeton University Press, 1997.

Peterson, Brian H., ed. *Pennsylvania Impressionism*. Doylestown, Pa.: James A. Michener Art Museum; Philadelphia: University of Pennsylvania Press, 2002.

(Philadelphia) Public Ledger, "Art: Redfield in a One-man Show at the Art Club—Examples of Delaware Valley Scenes on Canvas," November 21, 1920, Magazine section, 8.

Pitz, Henry C. "Edward Redfield: Painter of a Place and Time." *American Artist* (April 1959): 28–33.

Pollock, Barbara. "Famous American Artist Interviewed in 1963 at His Center Bridge Home." *Lambertville (N.J.) Beacon*, July 16, 1981.

———. "A Visit with Edward W. Redfield." *(Philadelphia) Sunday Bulletin Magazine*. August 4, 1963.

Powell, Edith. "The 117th Annual at the Academy of Fine Arts Representative of National Art in Oils and Sculpture." *(Philadelphia) Public Ledger*, February 5, 1922, Music and Art section, 12

Price, F. Newlin. "Redfield, Painter of Days." *International Studio* 75, no. 303 (August 1922): 402–10.

Pyne, Kathleen. *Art and the Higher Life: Painting and Evolutionary Thought in Late Nineteenth-Century America*. Austin: University of Texas Press, 1996.

Redfield, Dorothy Hayman. Notes for interview on "The Louise Collins Show," WBUX Radio, May 1, 1987. Private collection.

Redfield, Edward Willis. Audiotaped interview by Robert H. Lippincott for the *Bucks County Realtor Magazine*. March 4, 1963. Private collection.

———. Journal. 1889. Private collection.

———. Journal. 1949. Private collection.

———. Papers. Archives of American Art, Smithsonian Institution. Washington, D.C.

———. "Three Score and Five." 1963. Private collection.

———. "What America Means to Me." n.d. Typescript. Private collection.

Rogers, Fairman. "The Schools of the Pennsylvania Academy of the Fine Arts." *Penn Monthly* 12 (June 1881): 453–62.

Scott, William B., and Peter M. Rutkoff. *New York Modern: The Arts and the City*. Baltimore: Johns Hopkins University Press, 2001.

Shaler, N. S. "Landscape as a Means of Culture." *Atlantic Monthly* 82 (August 1898): 777–85.

Trenton (N.J.) Evening Times, "Center Bridge Artist Found Fame in Solving Problems," November 16, 1948.

Van Dyke, John C. *Nature for Its Own Sake: First Studies in Natural Appearances*. New York: Charles Scribner's Sons, 1898.

van Rensselaer, Mariana Griswold. "Fifty-Seventh Annual Exhibition of the National Academy of Design." *American Architect and Building News* 11, no. 329 (April 15, 1882): 175–76.

Varnedoe, Kirk. *A Fine Disregard: What Makes Modern Art Modern*. 1990. Reprint, New York: Abrams, 1994.

Ward, C. F. A. "Artists in the County, Edward Redfield." *Bucks County Traveler* (June 1955): 21.

Wheeler, Charles V. "Redfield." *American Magazine of Art* 16, no. 1 (January 1925): 3–8.

———. *Redfield*. Washington, D.C., 1925.

———. "Redfield's One-Man Show." *American Magazine of Art* 21, no. 6 (March 1930): 139–42.

Whitman, Walt. *Specimen Days and Collect*. 1883. Reprint, Mineola, N.Y.: Dover Publications, 1995.

"Who's Who in America Art—E. W. Redfield." *Arts and Decoration* 6, no. 3 (January 1916): 135.

Exhibition catalogues

Pennsylvania Academy of the Fine Arts, Philadelphia. *Exhibition of Paintings by E. W. Redfield* (March 22–April 5, 1899).

The Buffalo Fine Arts Academy, Albright Art Gallery, Buffalo, N.Y. *Catalogue of the Exhibition of Fine Arts, Buffalo, 1901*.

Trask, John E. D. *Catalogue of the Exhibition of Landscape Paintings by Edward W. Redfield*. Philadelphia: Pennsylvania Academy of the Fine Arts, 1909. Published in conjunction with Exhibition of Landscape Paintings by Edward W. Redfield shown at the Pennsylvania Academy of the Fine Arts (April 17–May 16, 1909), Philadelphia.

The Buffalo Fine Arts Academy, Albright Art Gallery, Buffalo, N.Y. *An Exhibition of Oil Paintings by Edward W. Redfield* (October 10–November 8, 1909).

The City Art Museum of Saint Louis, Saint Louis, Mo. *A Collection of Oil Paintings by Mr. Edward W. Redfield, N. A.* (opened November 14, 1909).

The Corcoran Gallery of Art, Washington, D.C. *Exhibition of Paintings by Edward W. Redfield* (January 3–23, 1910).

The Memorial Art Gallery, Rochester, N.Y. *An Exhibition of Paintings by Edward W. Redfield and a Collection of Works by European Masters* (May 9–June 7, 1914).

Trask, John E. D., and J. Nilsen Laurvik, eds. San Francisco. *Catalogue de Luxe of the Department of Fine Arts, Panama-Pacific International Exposition*. 2 vols. San Francisco: Paul Elder and Company, 1915.

The Corcoran Gallery of Art, Washington, D.C. *Exhibition of Paintings by Edward W. Redfield* (March 14–April 9, 1916).

The Grand Rapids Art Association, Grand Rapids, Mich. *Exhibition of Paintings by Edward W. Redfield* (October 5–30, 1916).

Buffalo Fine Arts Academy, Albright Art Gallery, Buffalo, N.Y. *Catalogue of an Exhibition of Paintings by Edward W. Redfield* (January 11–31, 1917).

Worcester Art Museum, Worcester, Mass. *Exhibition of Paintings by Edward W. Redfield* (March 4–April 1, 1917).

The Corcoran Gallery of Art, Washington, D.C. *Exhibition of Paintings by Edward W. Redfield and Edmund C. Tarbell* (April 25–May 21, 1918).

Musée National du Luxembourg, Paris. *Exposition d'Artistes de l'École Américaine* (October–November 1919).

The Art Club of Philadelphia, Philadelphia. *Catalogue of Paintings by Edward W. Redfield* (November 17–December 5, 1920).

Milwaukee Art Institute, Milwaukee, Wisc. *Catalogue of an Exhibition of Paintings by Edward W. Redfield* (November 1–30, 1924).

Philadelphia. *Sesquicentennial Exposition. Paintings, Sculpture and Prints in the Department of Fine Arts* (June 1–December 1, 1926).

The Corcoran Gallery of Art, Washington, D.C. *Special Exhibition of Paintings by Gari Melchers and Edward W. Redfield* (March 3–April 8, 1928).

City Library Gallery, Des Moines Association of Fine Arts, Des Moines, Ia. *Exhibition of Paintings by Edward W. Redfield* (February 3–28, 1929).

Grand Rapids Art Gallery, Grand Rapids, Mich. *One Hundred and Fifty-Third Exhibition: Paintings by Edward W. Redfield* (March 1–31, 1929).

The Art Club of Philadelphia, Philadelphia. *Catalogue of an Exhibition of Landscape Paintings—Edward W. Redfield* (December 5–25, 1929).

Grand Central Art Galleries, New York. *Catalogue of an Exhibition of Landscape Paintings by Edward W. Redfield* (January 7–31, 1930).

Woodmere Art Gallery, Philadelphia. *Exhibition of Paintings and Crafts by Edward W. Redfield* (November 1–22, 1959).

Parry's Barn, New Hope, Pa. *An Exhibition of Paintings and Crafts by Edward W. Redfield* (October 30–November 27, 1960).

Buck Hill Art Association, Buck Hill Falls, Pa. *An Exhibition of Paintings by Edward W. Redfield* (March 23–June 27, 1961).

The Reading Public Museum and Art Gallery, Reading, Pa. *An Exhibition of Paintings and Crafts by Edward W. Redfield* (December 3, 1961–January 28, 1962).

Grand Central Art Galleries, New York. *A Retrospective Exhibition of the Work of Edward W. Redfield, N.A.* (April 16–June 14, 1968).

Newman Galleries, Philadelphia. *Edward W. Redfield, A Retrospective Exhibition of His Work* (October 23–30, 1968).

Winer, Donald. *A Retrospective Exhibition of the Work of the Great American Impressionist Edward Willis Redfield of Pennsylvania.* Harrisburg, Pa.: The William Penn Memorial Museum, 1973. Published in conjunction with A Retrospective Exhibition of the Work of the Great American Impressionist Edward Willis Redfield of Pennsylvania shown at the William Penn Memorial Museum (March 31–May 13, 1973), Harrisburg.

Holicong Junior High School, Holicong, Pa. *An Exhibition of Paintings by Edward W. Redfield* (1975).

Philadelphia Museum of Art, Philadelphia. *Philadelphia: Three Centuries of American Art*. Published in conjunction with Bicentennial Exhibition shown at the Philadelphia Museum of Art (April 11–October 10, 1976), Philadelphia.

Sussex County Court House, Georgetown, Del. *Redfield 1869–1965* (November 1–5, 1976).

Gerdts, William H. *American Impressionism*. Seattle: University of Seattle, 1980. Published in conjunction with the exhibition American Impressionism shown at the Henry Art Gallery (January 3–March 2, 1980), Seattle; Fredrick S. Wight Gallery, University of California (March 9–May 4, 1980), Los Angeles; Terra Museum of American Art (May 16–June 22, 1980), Evanston, Ill.; Institute of Contemporary Art (July 1–August 31, 1980), Boston.

Foster, Kathleen A. *Daniel Garber, 1880–1958*. Philadelphia: Pennsylvania Academy of the Fine Arts, 1980. Published in conjunction with the exhibition Daniel Garber 1880–1958 shown at the Pennsylvania Academy of the Fine Arts (June 27–August 24, 1980), Philadelphia.

Folk, Thomas. *Edward Redfield*. New Brunswick, N.J.: Rutgers University, 1981. Published in conjunction with the exhibition Edward Redfield shown at Rutgers University (March 9–April 18, 1981), New Brunswick.

Hunter, Sam. *American Impressionism: The New Hope Circle*. Fort Lauderdale, Fla.: The Museum of Art, 1985. Published in conjunction with the exhibition American Impressionism: The New Hope Circle shown at The Museum of Art (December 3, 1984–January 27, 1985), Fort Lauderdale.

Folk, Thomas. *Edward Redfield: First Master of the Twentieth Century Landscape*. Allentown, Pa.: Allentown Art Museum, 1987. Published in conjunction with the exhibition Edward Redfield: First Master of the Twentieth Century Landscape shown at the Allentown Art Museum (September 20, 1987–January 10, 1988), Allentown, and The Butler Institute of American Art (February 14–April 2, 1988), Youngstown, Ohio.

Weinberg, H. Barbara, Doreen Bolger, and David Park Curry. *American Impressionism and Realism: The Painting of Modern Life, 1885 to 1915*. New York: The Metropolitan Museum of Art, 1994. Published in conjunction with American Impressionism and Realism: The Painting of Modern Life shown at the Metropolitan Museum of Art (May 10–July 24, 1994), New York.

Randall C. Griffin. *Thomas Anshutz: Artist and Teacher*. Huntington, N.Y.: Heckscher Museum, 1994. Published in conjunction with the exhibition The Art of Thomas Anshutz shown at the Heckscher Museum (September 3–November 20, 1994), Huntington.

Peters, Lisa N. *Visions of Home: American Impressionist Images of Suburban Leisure and Country Comfort*. Carlisle, Pa.: The Trout Gallery, Dickinson College, 1997. Published in conjunction with the exhibition Visions of Home shown at the Trout Gallery, Dickinson College (April 4–June 14, 1997), Carlisle.

Fischer, Diane P., ed. *Paris 1900: The "American School" at the Universal Exposition*. New Brunswick, N.J.: Rutgers University Press, 1999. Published in conjunction with the exhibition Paris 1900: The "American School" at the Universal Exposition shown at the Montclair Art Museum (September 18, 1999–January 16, 2000), Montclair, N.J.